HISTORIC PHOTOS OF
TACOMA

TEXT AND CAPTIONS BY NICK PETERS

TURNER
PUBLISHING COMPANY
NASHVILLE, TENNESSEE PADUCAH, KENTUCKY

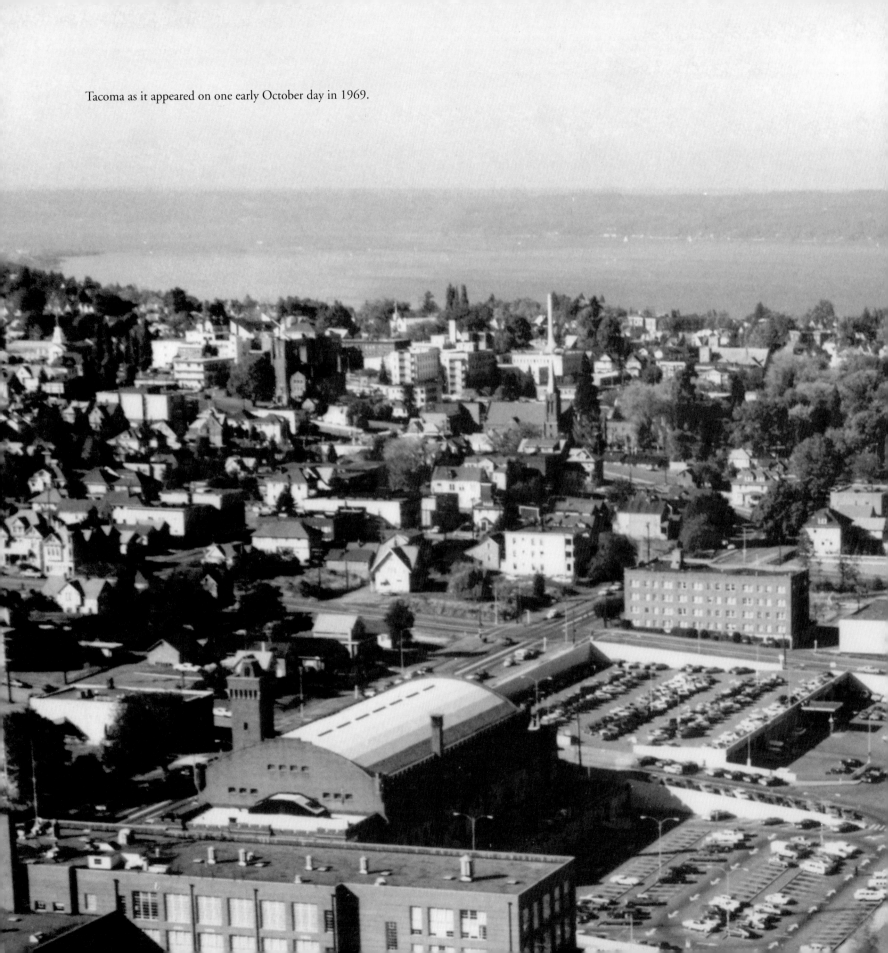

Tacoma as it appeared on one early October day in 1969.

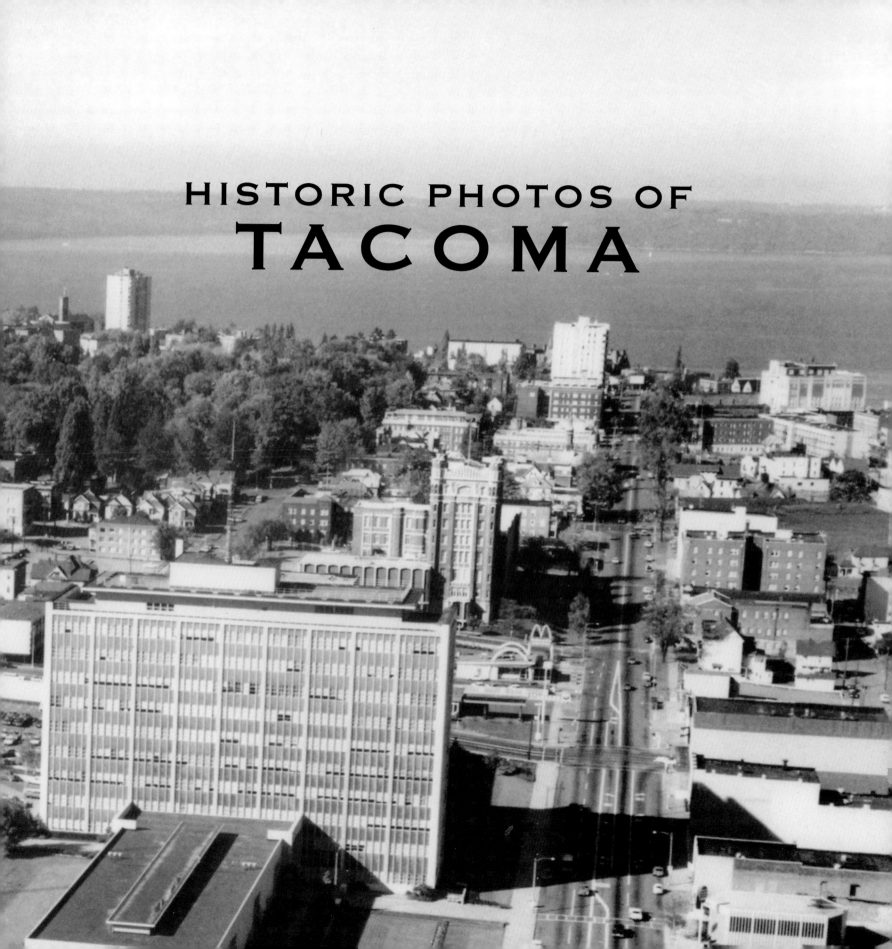

HISTORIC PHOTOS OF
TACOMA

Turner Publishing Company

200 4th Avenue North • Suite 950 412 Broadway • P.O. Box 3101
Nashville, Tennessee 37219 Paducah, Kentucky 42002-3101
(615) 255-2665 (270) 443-0121

www.turnerpublishing.com

Historic Photos of Tacoma

Library of Congress Control Number: 2007923664

ISBN-13: 978-1-59652-334-0
ISBN: 1-59652-334-4

Printed in the United States of America

07 08 09 10 11 12 13 14 15—0 9 8 7 6 5 4 3 2

CONTENTS

Centennial Queen Sally Hagen waves graciously to the large audience at the historical pageant "By These Waters" on July 2, 1969. She is a passenger in a horse-drawn carriage gliding past costumed performers. The queen, chosen a few days earlier along with a court of six princesses, would participate in many activities associated with the Centennial celebration.

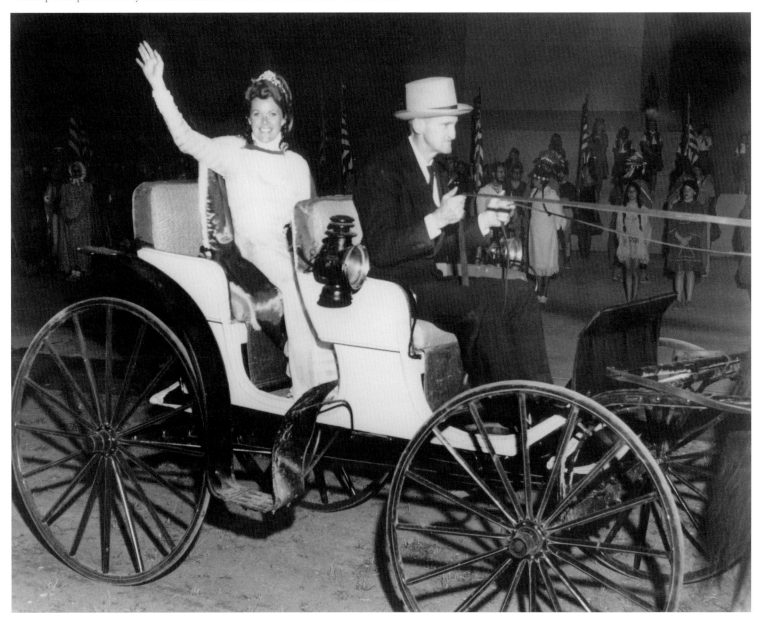

Acknowledgments

This volume, *Historic Photos of Tacoma,* is the result of the cooperation and efforts of many individuals and organizations. It is with great thanks that we acknowledge the valuable contribution of the following for their generous support:

The Library of Congress
The Tacoma Public Library
University of Washington Libraries

We would also like to thank our writer, Nick Peters, for valuable contributions and assistance in making this work possible.

The goal in publishing this work is to provide broader access to a set of extraordinary photographs. The aim is to inspire, provide perspective, and evoke insight that might assist officials and citizens, who together are responsible for determining Tacoma's future. In addition, the book seeks to preserve the past with respect and reverence.

With the exception of touching up imperfections caused by the vicissitudes of time and cropping where necessary, no other changes have been made. The focus and clarity of many images is limited to the technology of the day and the skill of the photographer who captured them.

We encourage readers to reflect as they explore Tacoma, stroll along its streets, or wander its neighborhoods. It is the publisher's hope that in making use of this work, longtime residents will learn something new and that new residents will gain a perspective on where Tacoma has been, so that each can contribute to its future.

—*Todd Bottorff, Publisher*

PREFACE

"Eureka! I found it!" shouted Job Carr, a twice-wounded Civil War veteran, on Christmas Day in 1864 when he first landed at Commencement Bay. Thus begins the story of Tacoma, named by developer Morton McCarver for Mount Rainier 58 miles away—early known as Mount Tacoma, after *tacobet,* the word of the indigenous Puyallup for "mother of waters."

Tacoma was supposed to be the grandest city on Puget Sound. Both Seattle and Tacoma, thirty miles apart, have deep natural ports and were pretty much equal in their assets and their liabilities. Tacoma even enjoyed favor for a while, in 1873 bagging the first railroad terminus on Puget Sound. In 1887, George Francis Train, a promoter and journalist from New York, anointed Tacoma the "City of Destiny," heralding the arrival of the Northern Pacific at the new terminus. By the turn of the century, Tacoma was indeed a thriving and exciting place. Not to be outdone, however, the stalwart entrepreneurs who settled Seattle were a powerful force to be reckoned with. They rolled up their sleeves in a bid to outdistance their sibling.

Cities, composed of citizens, are flawed, and Tacoma was no exception. Frederick Law Olmstead, who designed Central Park in New York City, Golden Gate Park in San Francisco, and Volunteer Park in Seattle, also designed an avant-garde plan for the entire city of Tacoma in 1876, but his visionary ideas were dismissed. In 1885, city officials dealt with economic issues by rounding up minority residents and putting them on a train for Portland, Oregon. The "Tacoma Method" of handling the races was denounced nationally and locally.

In 1900, after the Weyerhaeuser company exhausted the timber around Minneapolis, its offices moved to Tacoma, and soon Tacoma was famous as the lumber capital of the world. The "City of Destiny" also became the capital of doors. Wooden doors made in Tacoma opened and closed in buildings, offices, and homes worldwide.

Tacoma has always been recognized as a city of beautiful homes and impressive estates. Ambrose Russell, a talented architect from Scotland and graduate of the Ecole des Beaux Arts in Paris, designed many of the city's regal addresses. The Tacoma Country Club, founded in 1893, is the second-oldest country club in the nation. (Only Brookline, Massachusetts,

founded in 1887, is older.) The city also boasts one of the largest parks in the country, 650 acres of still mostly wilderness on the shores of Puget Sound. Point Defiance Park includes Fort Nisqually (built on the Nisqually River in 1832 and moved into the park in 1934) and a fine zoo that features an aquarium with a trained whale, an aviary with exotic birds from around the world, a snake house, and a monkey house.

Famous Americans who began life in Tacoma include singer and actor Bing Crosby and the cartoonist Gary Larson.

Tacoma is home to three impressive universities: the University of Puget Sound, Pacific Lutheran University, and, since 1990, the University of Washington Tacoma. The latter sits on 46 acres in downtown Tacoma and comprises rehabilitated turn-of-the-century warehouses and imaginative new buildings. The American Institute of Architects has given the university numerous awards. Tacomans delight in Johnny's Ocean Foods, an unrivaled retail and wholesale operation. Another favorite is the Antique Sandwich Company. The owners, sisters-in-law from Seattle, roast their own turkey for sandwiches and make delicious soups and pastries from scratch. Finally, Tacoma boasts a public library heavily relied on by residents.

Seattle is a larger city, but these days more and more Tacomans, when they think about the merits of their city, echo the words of old Job Carr: "Eureka! I found it!"

Tacoma in 1881 as viewed from what is now the 800 block of Fawcett Avenue. The two-story white house in the foreground fronts St. Helens Avenue. The stately white house to its right, built in 1879, was the home of Theodore Hosmer. The Northern Pacific Railroad land office is the large frame building to the right of the Hosmer House. The city's magnificent Broadway Theater was built on this site after the Tacoma Land Office moved.

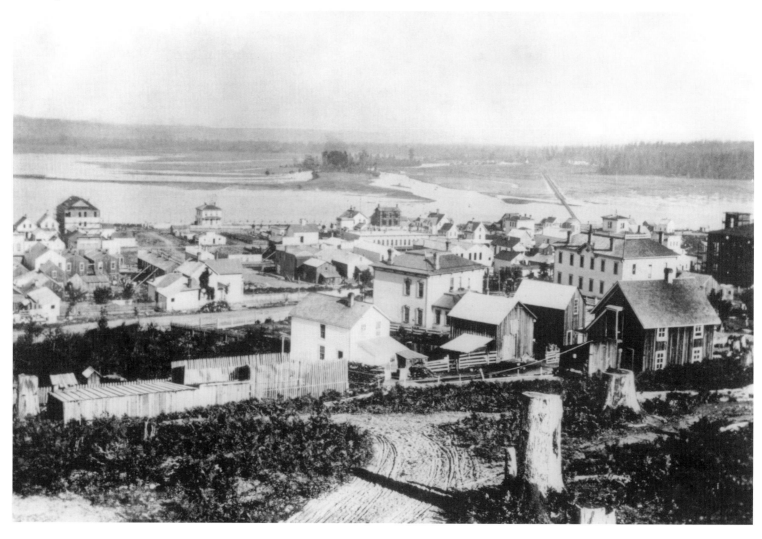

FRONTIER BOOM TOWN

(1870s–1899)

The Washington Territory, which included Oregon and parts of Idaho and Montana at various times, was created in 1853. That same year Nicholas DeLin built a sawmill at the head of Commencement Bay, but the Indian wars that broke out in 1855 caused the earliest settlers to evacuate their property and take refuge in Steilacoom and Olympia. When Job Carr, a Civil War veteran from Indiana, and developer Morton McCarver arrived a few years later, the settlement began to grow much more rapidly, especially after the Northern Pacific Railway chose Tacoma for its only terminus on Puget Sound.

In 1884 the glorious Tacoma Hotel, designed by Kim, Meade and White, renowned architects of New York, opened replete with $30,000 of furniture from Wanamakers. Until it was tragically destroyed by fire in 1935, the hotel was unrivaled in the Northwest and on the West Coast. In 1890 the Tacoma Theater, a red-brick Richardsonian structure (arguably the most beautiful public building in the city), elegantly graced Broadway at South 9th Street. It, too, succumbed to fire in 1966.

Annie Wright Seminary, founded by railroad tycoon Charles Wright in 1884, opened its doors with 94 female students. George Francis Train's Race-Around-the-World was seen as Tacoma's greatest publicity stunt up to that time. And Fay Fuller earned the distinction of being the first woman to climb Mount Rainier. (In 1870, Hazard Stevens, the first governor of the Washington Territory, and P. B. Van Trump had successfully climbed the mountain.) By the 1890s, the city's population had surpassed 36,000.

In 1892, Tacoma's intense and long-lasting love affair with international trade began with the arrival of the *Phra Nana,* the first steamer from the Orient.

Allen C. Mason, a dynamic businessman and a tireless Tacoma promoter, personally paid for ads in newspapers in other parts of the country that invited people to move to Tacoma. Soon he was a millionaire, but, like many others, he lost all of his property and capital in the national financial panic of 1893.

The young city swelled with pride and considerable relief as Pacific Avenue was paved in 1895.

Sporting topcoats and bowler hats, a large group of railroad men pose dockside at the plankway of a steamship, ca. 1880s.

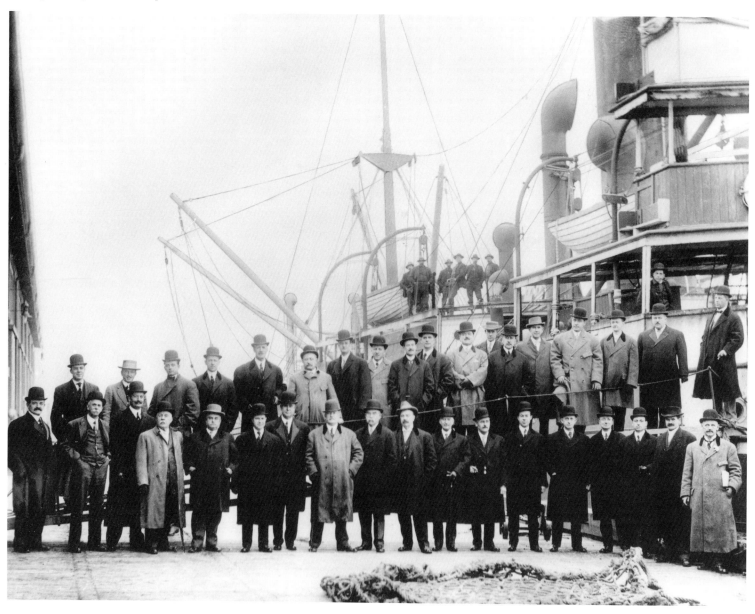

Francis E. Cook published the *Tacoma Herald* inside this wooden structure from 1877 to 1880, shown here in 1878. The building was located at Nine Point on Rainier Street, a street that was vacated then obliterated in 1883.

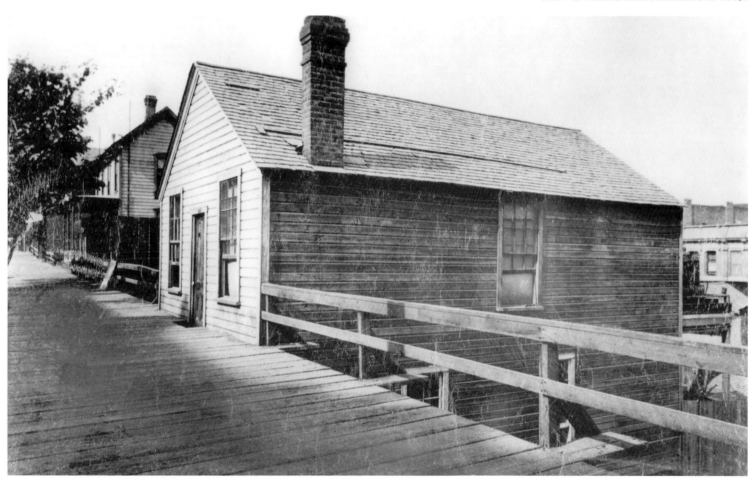

Five men stand in front of Halstead House on Pacific Avenue ca. 1879–1885. One of the city's nicest hotels, it featured a covered walkway leading to the "water closet" behind the building.

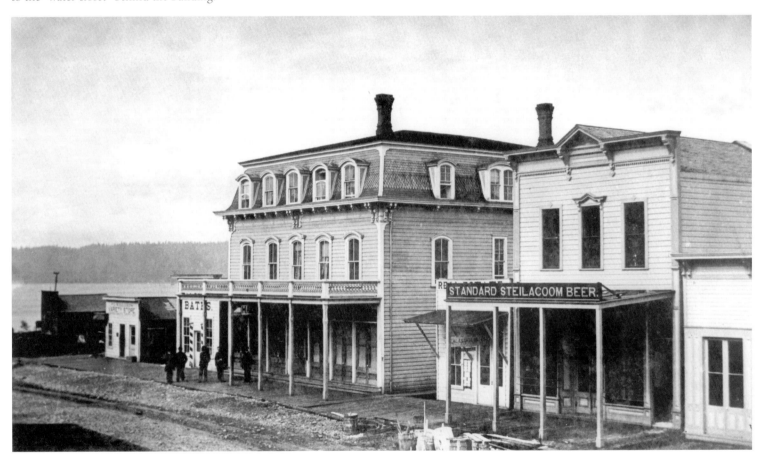

Tacoma's Twenty-Seven on November 3 1885. Fueled by racism and fear, the "Committee of 27" led a mob that forced the Chinese population of Tacoma onto trains bound for Portland, Oregon. The homes of the Chinese were looted then burned to the ground. The "Committee" included Tacoma mayor, Jacob Robert Weisbach (seated at center, full beard), as well as the sheriff, a city councilman, and a judge. Most Tacomans blamed the Chinese for the city's economic recession. A trial was held, but all charges were dropped.

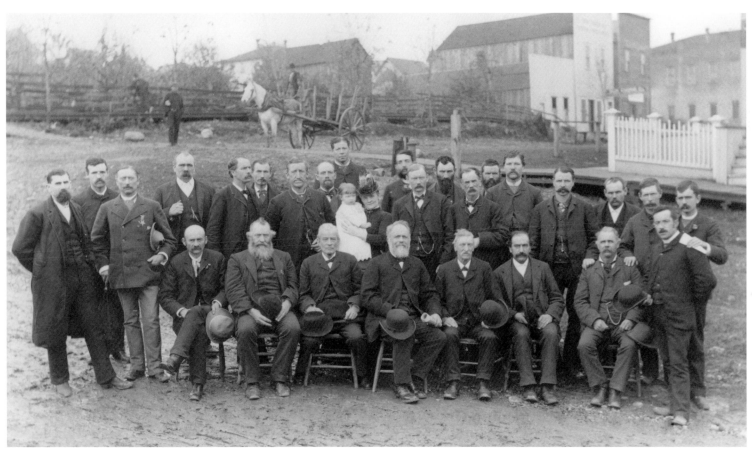

Just visible behind Tacoma Street Railway Car #1 is a line of Northern
Pacific coal cars (1887).

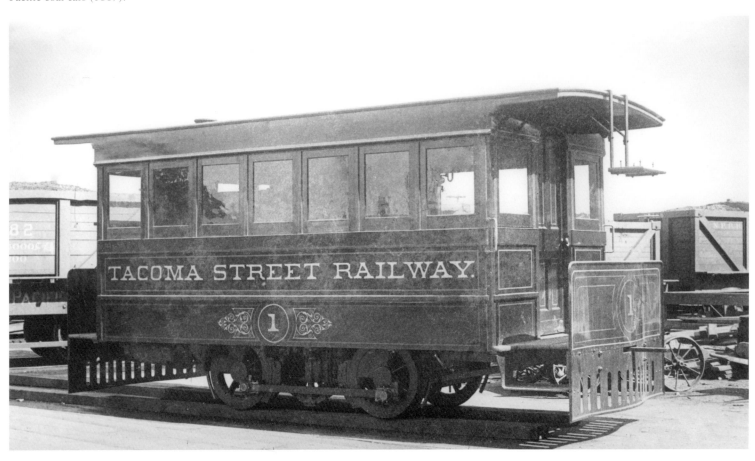

Pacific Avenue as it appeared in 1887, facing north from the corner of 11th and Pacific. The Northern Pacific Headquarters Building is under construction at the far end of the block. Tacoma's Old City Hall will not be built for another four years.

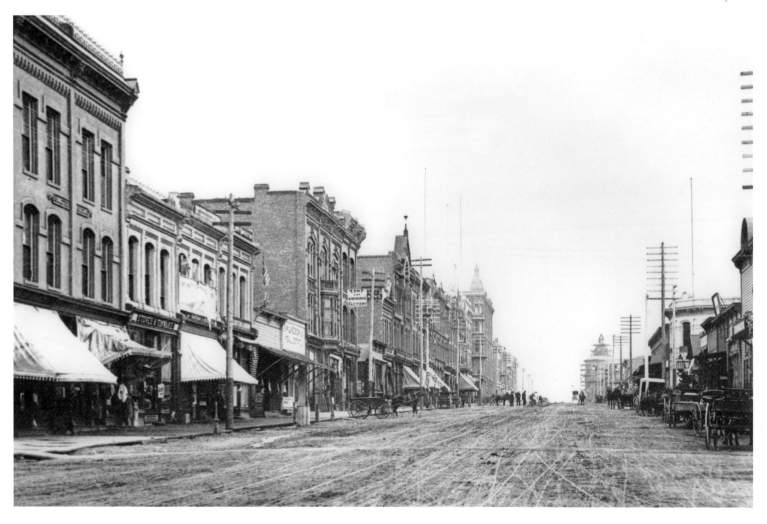

A group of Puyallup Indians gather on the shores of Puget Sound to gamble. They appear in this mid 1880s image to be playing an Indian bone game, where two teams of 10-12 sit opposite each other.

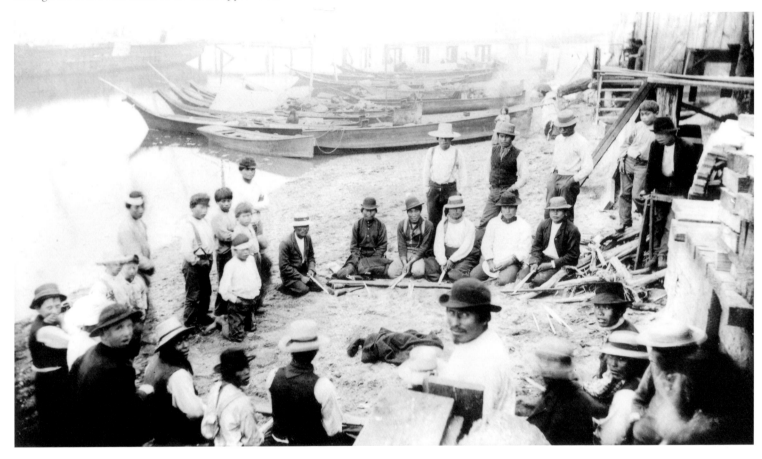

St. Luke's Episcopal Church stands at 602 Broadway ca. 1887. Built in 1883 of gray sandstone from the Wilkeson quarries, it was dismantled in 1934 and reassembled stone by stone at 3601 N. Gove.

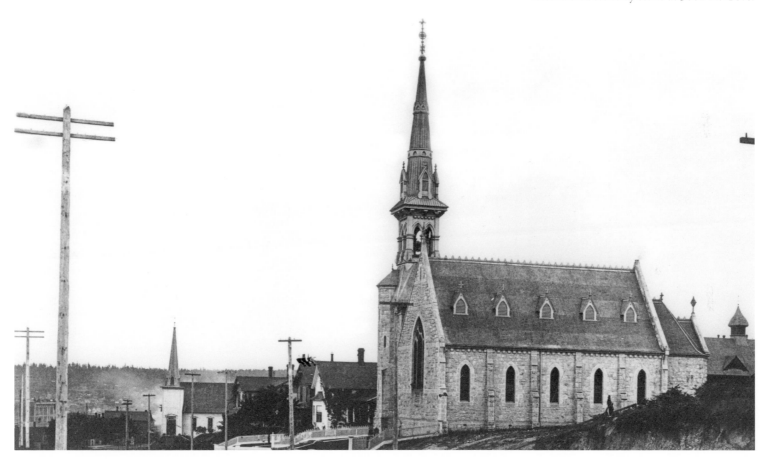

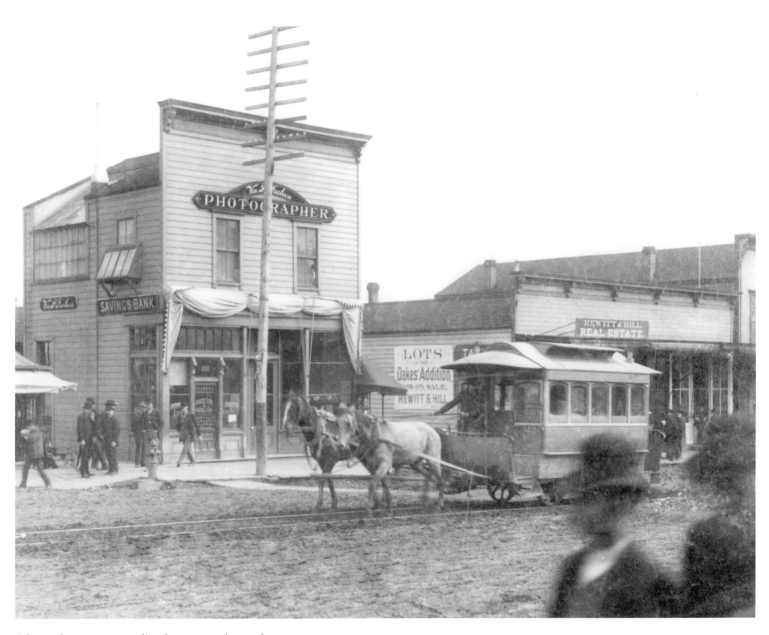

A horse-drawn streetcar plies the route at the southeast corner of Pacific Avenue and 11th Street, ca. 1888. William P. Jackson's photography building at 1101 Pacific Avenue, and Hewitt and Hall Real Estate, 1105 Pacific Avenue, are visible in the background. An ad for the Oakes Addition refers to plans for an upscale residential district, replete with streets named with Puyallup words. The project was canceled as result of the panic of 1893.

Two ships sit docked next to the Tacoma coalbunkers while three more ships lie at anchor in Commencement Bay in 1888. The enormous bunkers along the waterfront enabled Tacoma to briefly be the leading coal station on the Pacific Coast. In 1879-80, the Northern Pacific built a branch railroad up the Puyallup River Valley and opened Pierce County coal fields in Wilkeson, Carbonado, and Fairfax. The first commercial coke company, Tacoma Coal and Coke, was established in 1888.

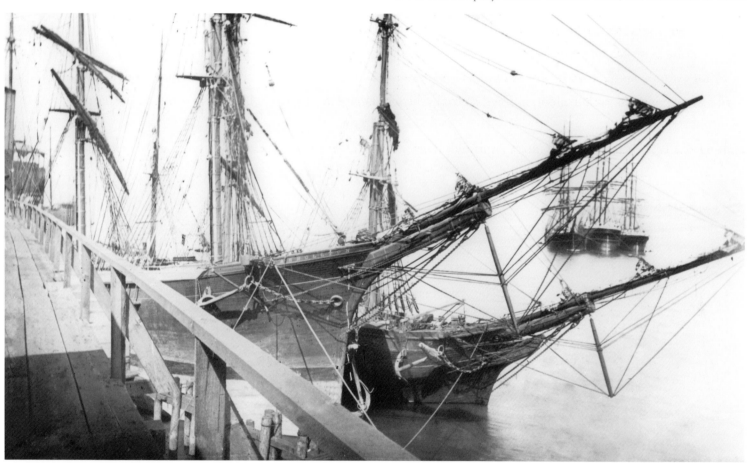

In 1888, a horse-drawn wagon sits in front of the Fife Hotel, at 742-50 Pacific Avenue, shortly after it was built on the northwest corner of 9th and Pacific Avenue. The structure was demolished in 1925.

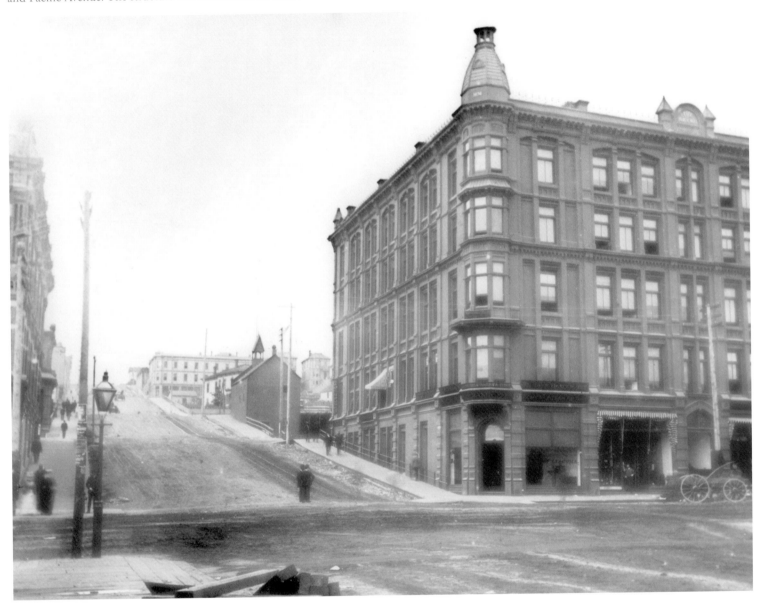

At the grocery at 1525 East J Street in 1888, mud cakes the wheels of the Montague and Weyand horse-drawn buggy. These wholesalers delivered their products throughout the fledgling city.

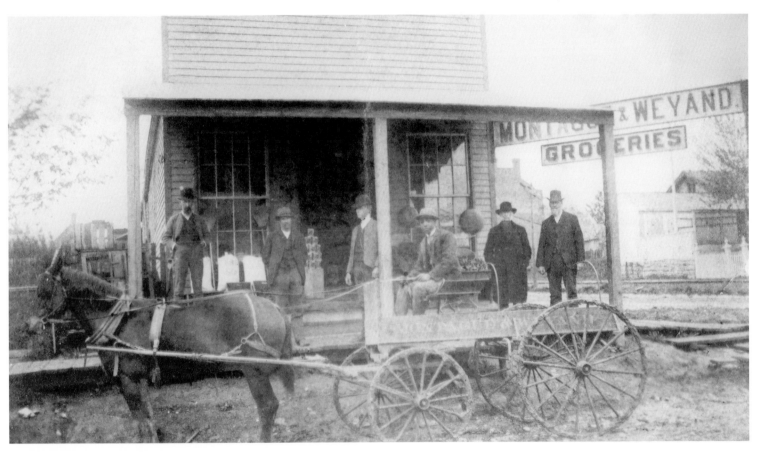

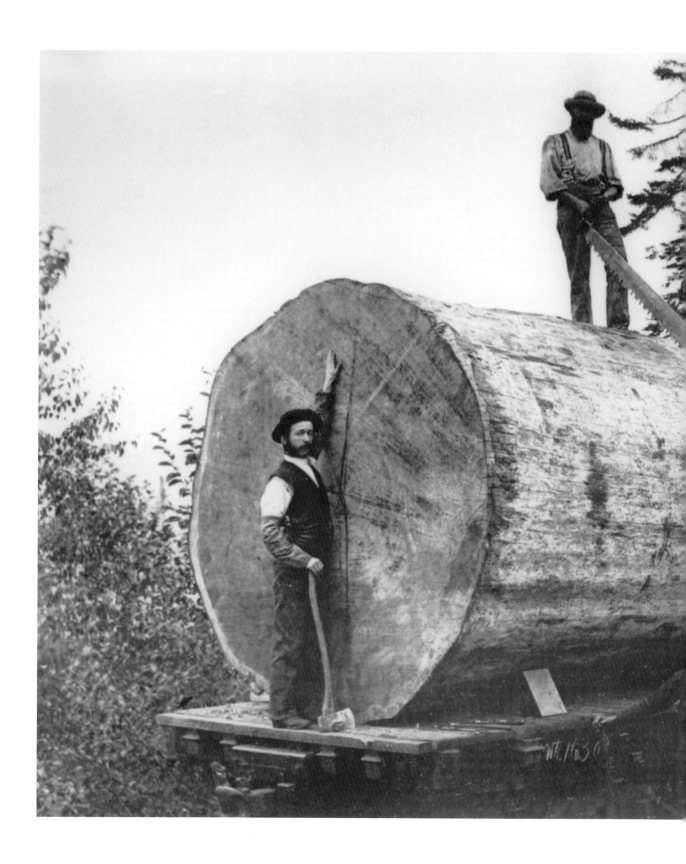

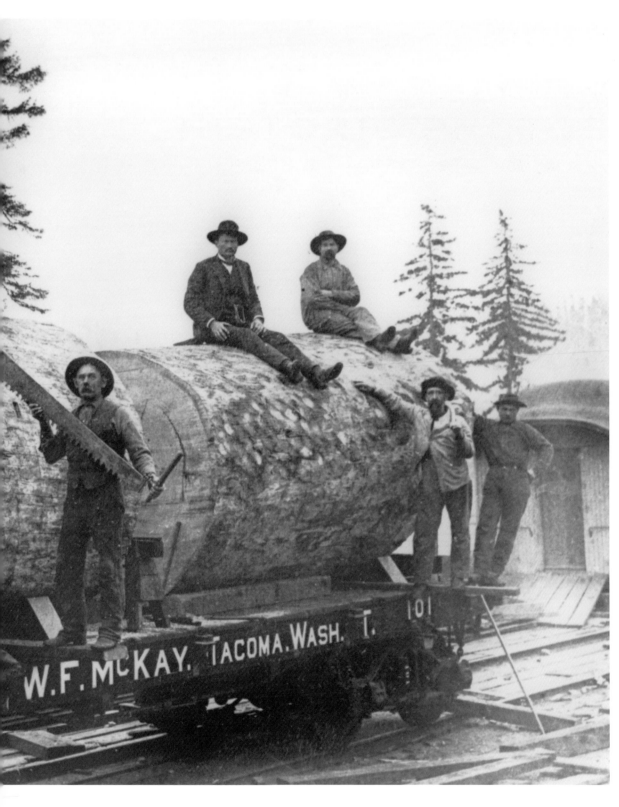

Eight loggers pose with two large sections of a log sitting on a flatbed railroad car. On the side of the car are the words W. F. McKay, Tacoma, Wash. The logger at left reaches upward to indicate the log's enormous diameter. (1888)

A view of Pacific Avenue in 1888, facing north. At left is the Tacoma News. The News and the Daily Ledger, both founded in 1883, were the two biggest papers in Tacoma at the time. The *Ledger* was a morning paper and the *News* was an evening paper. Both were sold to Samuel Perkins, who ultimately sold them to the News Tribune. Horse-drawn carriages and wagons fill the unpaved street.

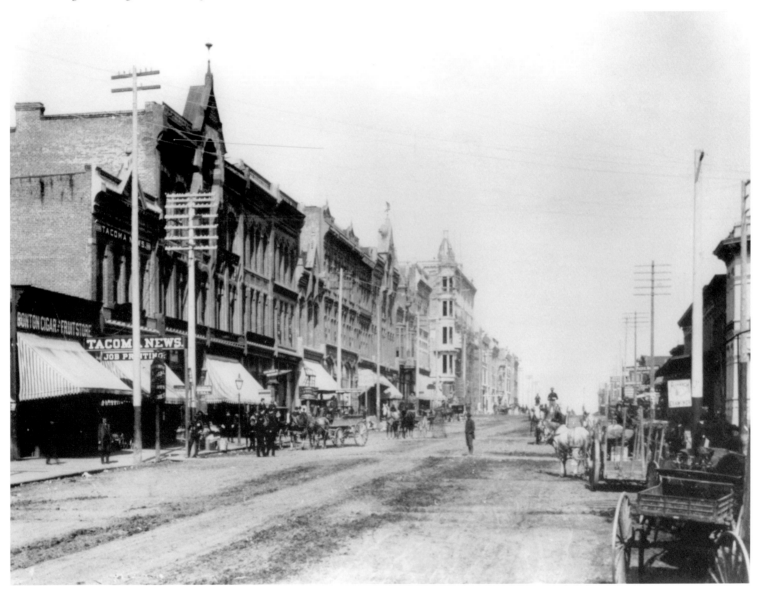

Organized in 1885, the Tacoma police department poses for the photographer in this image from 1899.

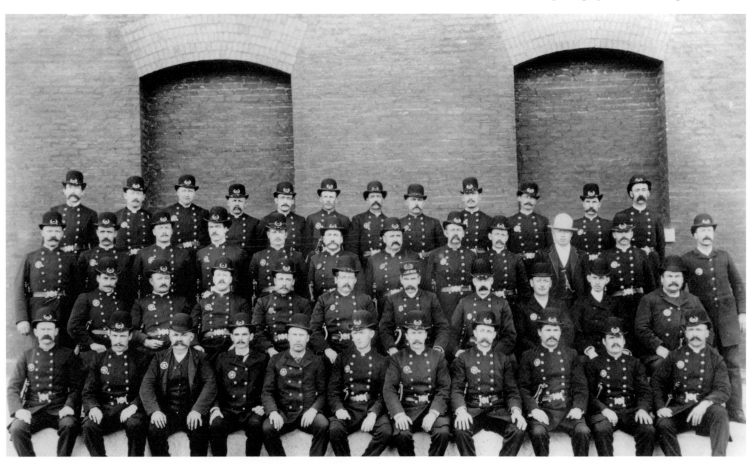

Emerson School, at 246 St. Helens, was built in 1889 and offered both elementary and high school classes. After the school closed in 1913, the building housed soldiers during World War I. It was leveled in 1920.

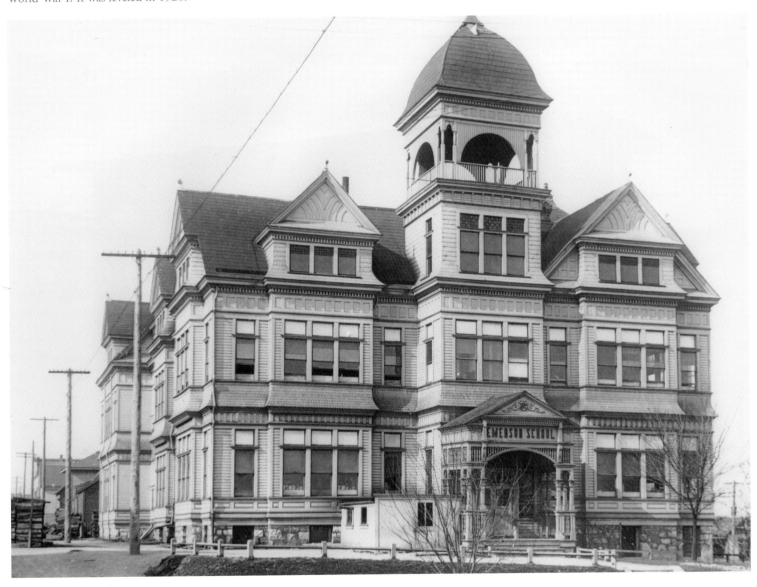

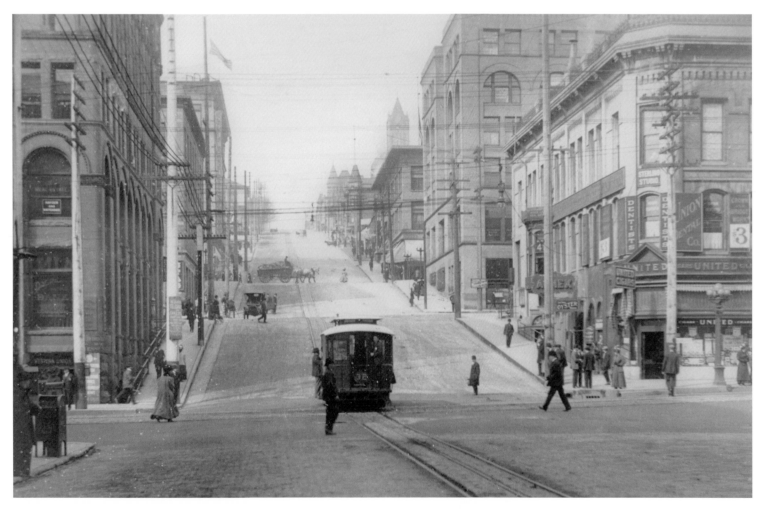

Tacoma Fire Department Engine Co. #3, at North G and McCarver streets, displays its steam pumper engine and hose wagon in 1889. Captain Amil Krantz, in charge of at least five men, faced expenses of $5,887.76 for salaries—plus $336.10 for oats and $8.05 for carrots.

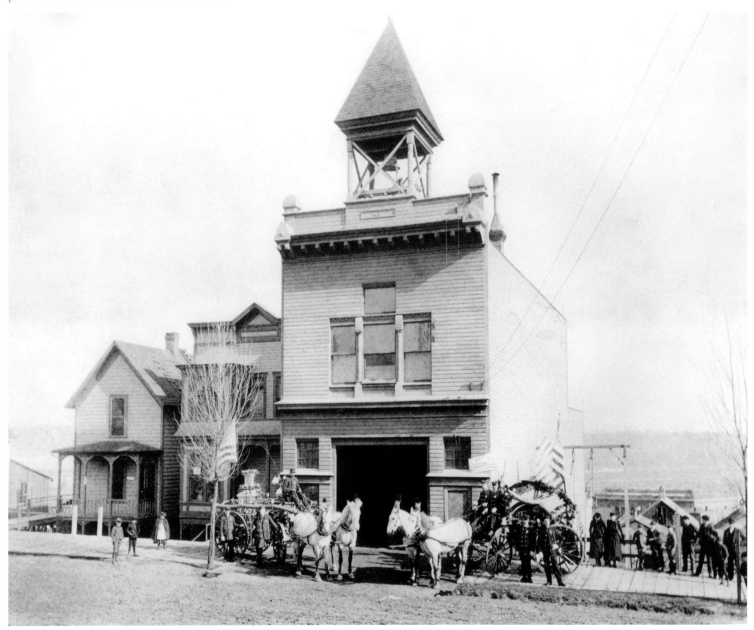

Tacoma firemen at Fire Station #2 pose in the station's sleeping quarters to demonstrate a response to an alarm. With speed crucial to their mission, firemen had to be prepared to respond at all hours of the day or night. (ca. 1890s)

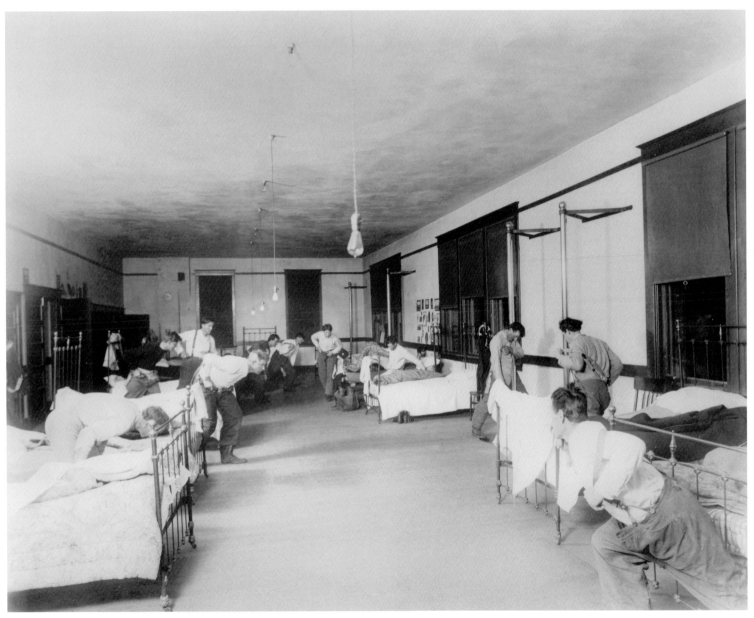

A parade marches down Pacific Avenue in 1890. At bottom are six men on horseback followed by a drum major and a marching band.

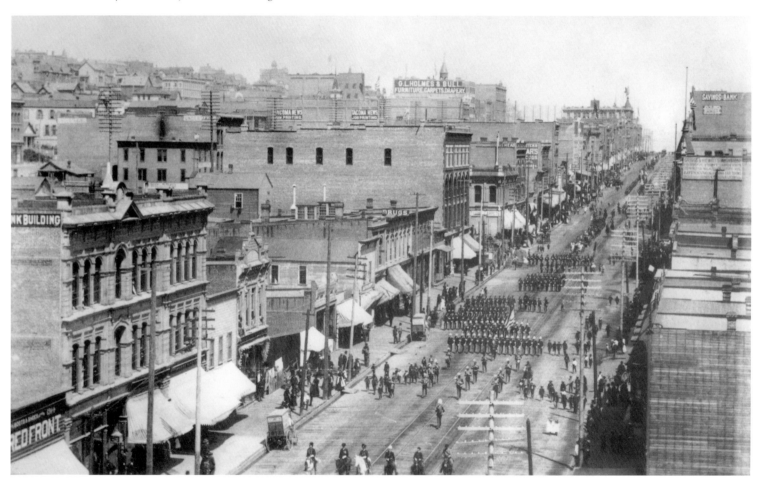

The first boathouse in Tacoma, pictured here in 1890, was located on the City Waterway, now the Thea Foss Waterway. The 16 x 30–foot wooden structure was built by Andrew Foss to house his growing family after arriving from Norway in 1889. His industrious wife, Thea, began the family business by investing the family fortune, $5, in a used rowboat—and thus Foss Tug and Launch Co. was born.

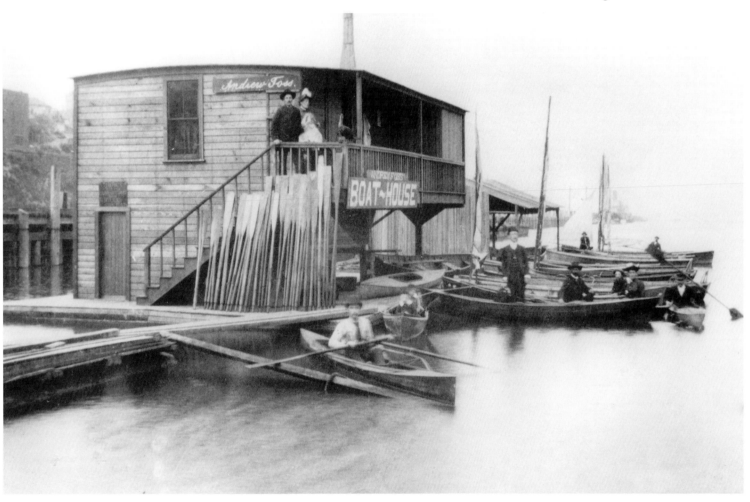

The Charles Berger Carriage Manufacturing & Supply Company at
1502-04 Commerce Street around 1890. Employees, some in leather
aprons, pose outside the blacksmith and wagon-making company. Board
sidewalks run down the hill beside the building and the Waveney Hotel
is visible in the background at right.

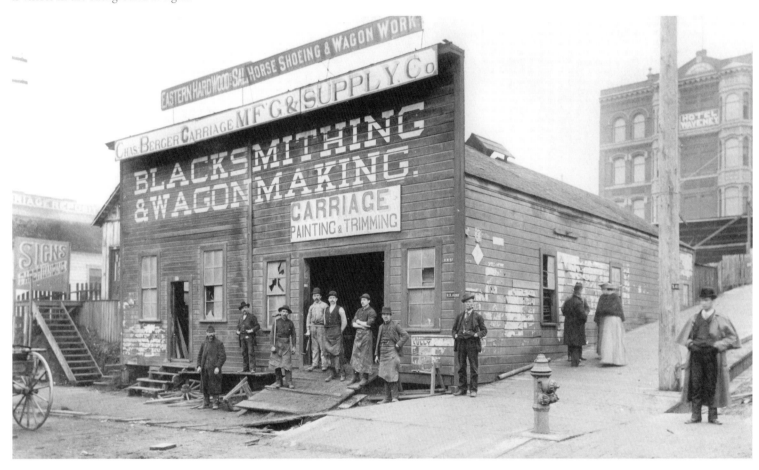

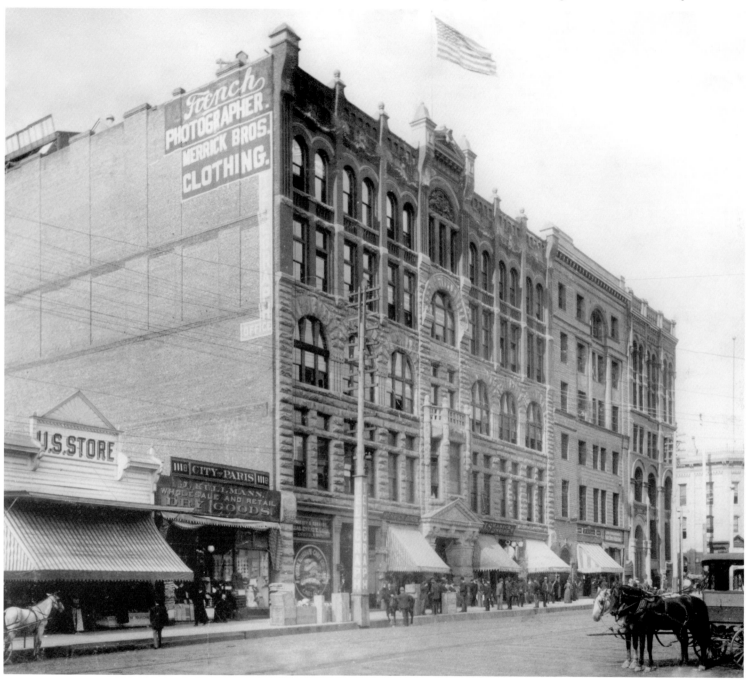

The California Block, constructed in 1899 at 1110-16 Pacific Avenue. Arthur French, listed as photographer and crayon artist in the 1892 City Directory, lived and worked in the building. He captured this image of the solid Romanesque structure.

The Annie Wright Seminary, named for the daughter of Northern Pacific Railway president Charles B. Wright who arrived in Tacoma in the 1880s, opened in September 1884 with 94 girls as students. Designed by Boone & Meeker and built by F. W. Lewis in 1883, the stately school with sharp gables and turrets survived until 1924. After it was leveled, only its gymnasium and another building remained. These buildings were leased by the Tacoma Drama League in 1925.

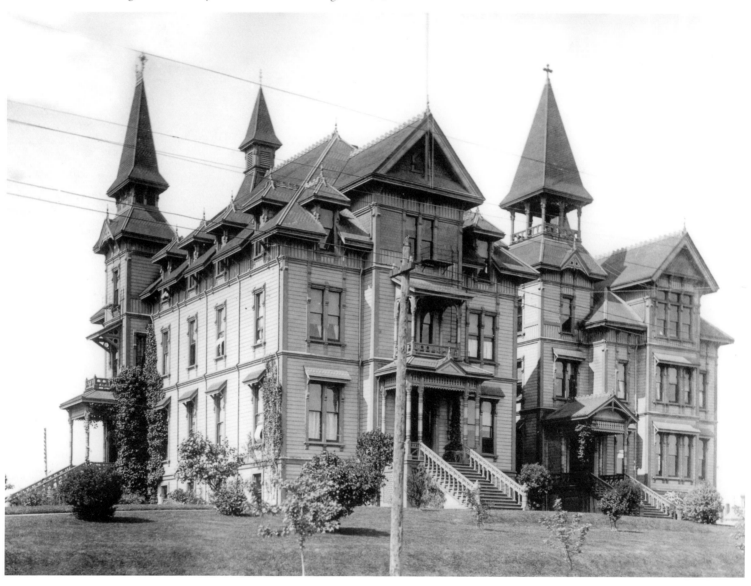

Statues of "dancing maidens" donated to the city by Clinton P. Ferry flank the Division Street entrance to Wright Park, shown here ca. 1891. The 1890 double house built for Charles E. Clancey, and the Queen Anne–style home of John Holgate, constructed in 1889, overlook the park from the 100 block on South G Street.

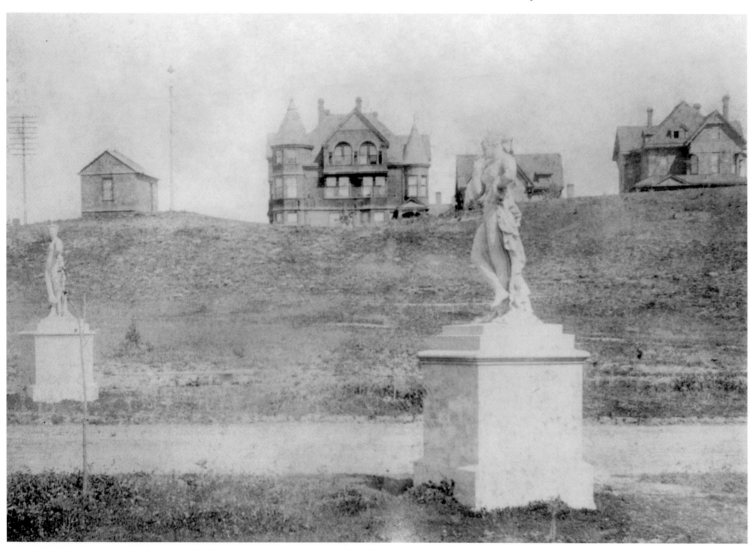

The LaMotte & Watkins Grocery Store, "My Store," in 1891, advertises fresh oysters and Pittsburgh coal. The four men standing in front of the store at 2402 Pacific Avenue are (1eft to right) Mr. Lenard, a farmer; Charles E. Ecklund, a clerk at the store who later went to Alaska to seek his fortune; Herschel Rawlings, the store's bookkeeper and eventually a Tacoma dentist; and Robert K. Taylor, a sales clerk who moved to Seattle.

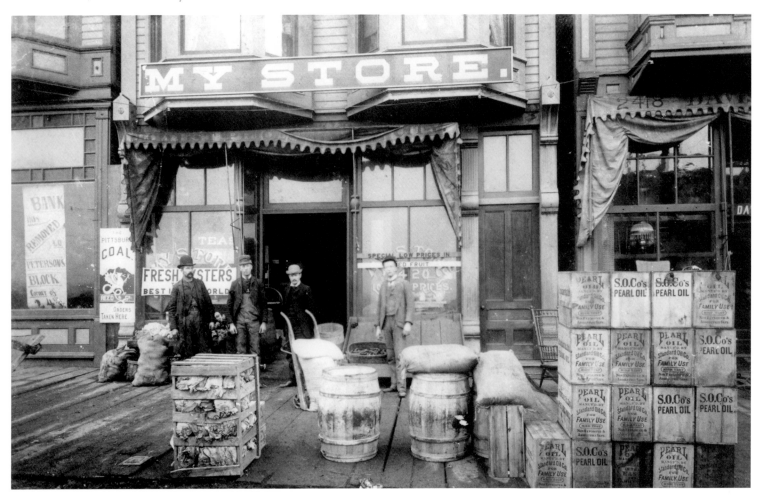

North End real estate developer Allen C. Mason completed the Point Defiance Line trolley system in 1890, later selling it to Tacoma Railway & Power Co. The car stopped at North 45th and Orchard streets, where passengers were required to pay a second nickel to continue on to Point Defiance Park. The stop became known as "Poor Man's Corner" for the many riders who departed there and walked to the park to save the nickel.

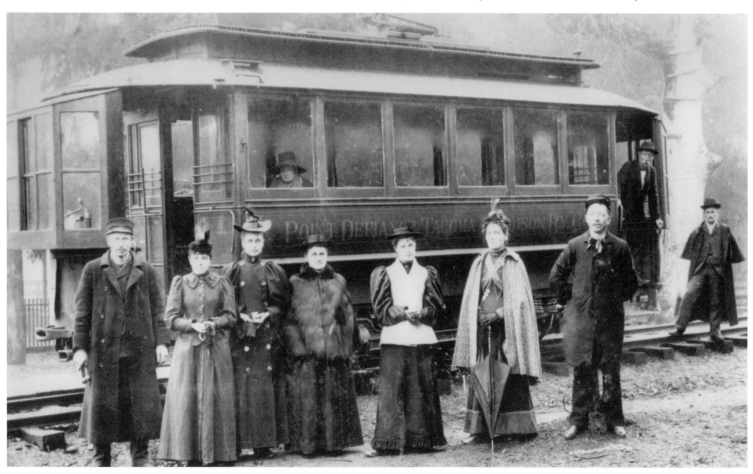

Built in 1890 on the corner of 19th and Pacific, the Garretson-Woodruff-Pratt building housed People's Department Store until 1895, when it moved to 1101-07 Pacific Avenue. In the twenties Sears and Roebuck moved in, and the University of Washington Tacoma occupies the building today. People's Store closed in 1983.

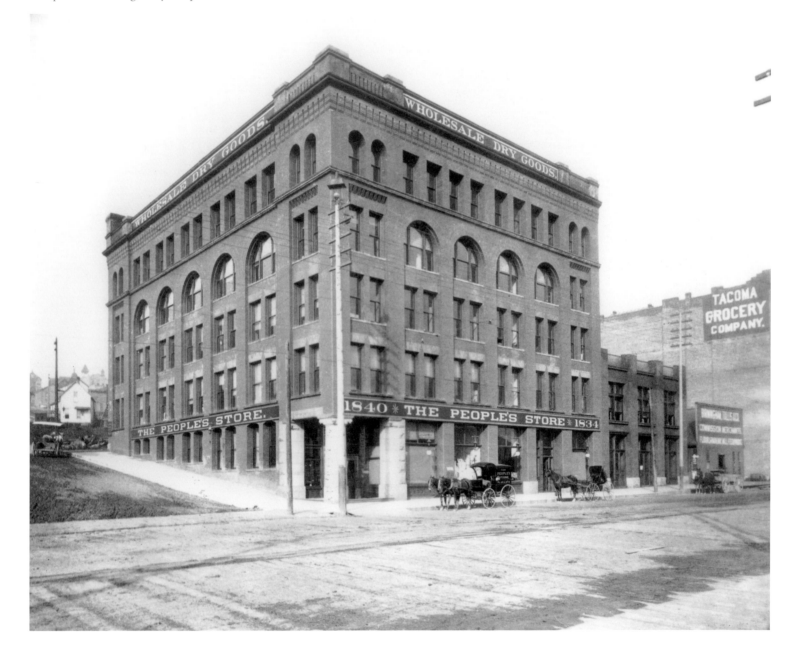

A Griffin Transfer Co. moving wagon stops for the photographer in 1893. With offices at 1105 Pacific Avenue, the company maintained a yard and residence at 813 South J Street. Founder Frederick L. Griffin came west in 1889 to make his fortune. Able to purchase a wagon and horse, he started delivering fuel wood that he cut himself. The company also dealt in coal and ice, eventually becoming the Griffin Fuel Company, the oldest and largest dealer in fuel west of Chicago.

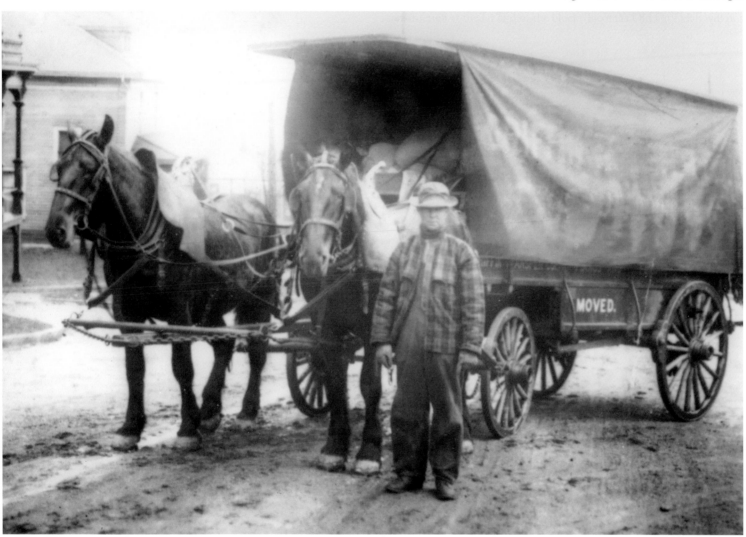

North End developer and Tacoma promoter Allen C. Mason built his own mansion at 4301 North Stevens Street in 1892. Designed by architects Hatherton & McIntosh, the palatial home was built solely of material from Washington State. Mason was forced to give up the mansion as a result of the financial panic of 1893.

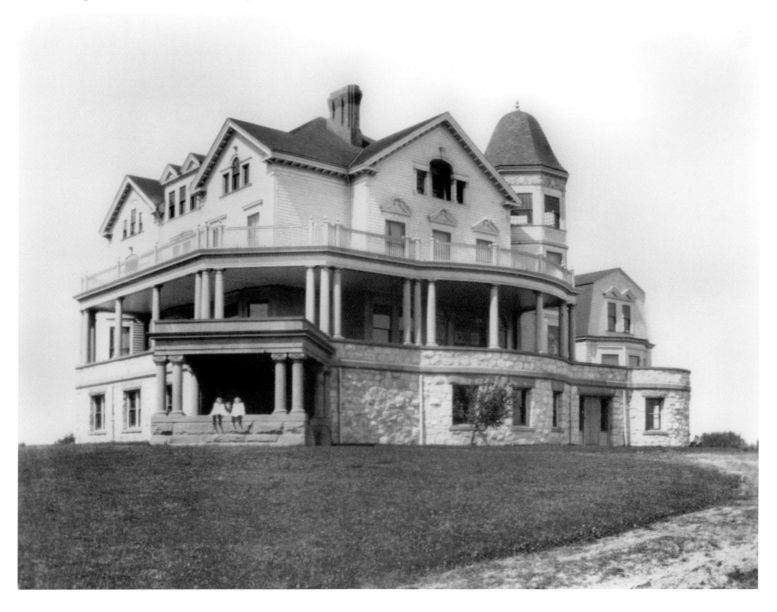

Late the evening of November 28, 1894, a large landslide carried part of the Northern Pacific Railway Company's warehouse, its freight office, adjoining stockyards, the pump house, and the home of H. H. Alger into Commencement Bay. Both the night watchman and the Alger daughter lost their lives. The company's safe, rumored to contain $10,000 in cash and $25,000 in securities, was never found.

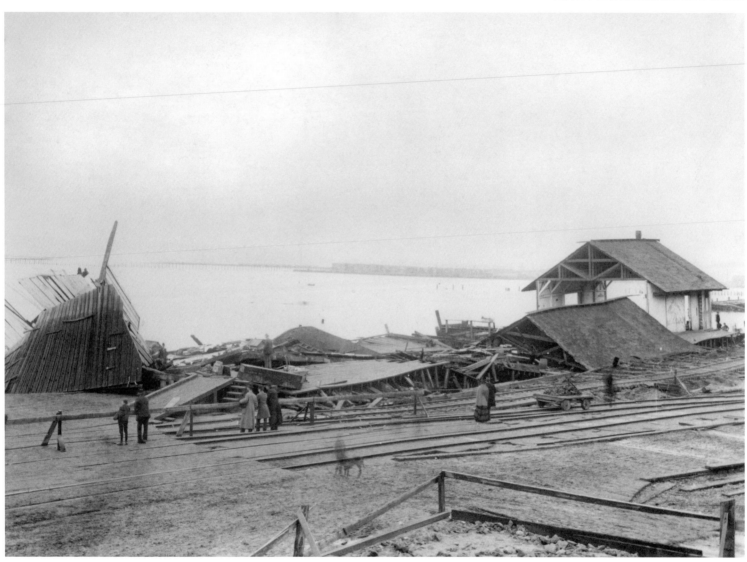

On May 17, 1895, Tacoma's Scandinavians celebrate the 81st anniversary of Norwegian independence with a small parade, outdoor concerts, a picnic, and games. As Leif Eriksson, Charles Evens commands a boatful of stern-looking Norsemen, likely somewhere between South 13th and South 15th on Tacoma Avenue. Armed with swords and shields, they are "Bound for Wineland."

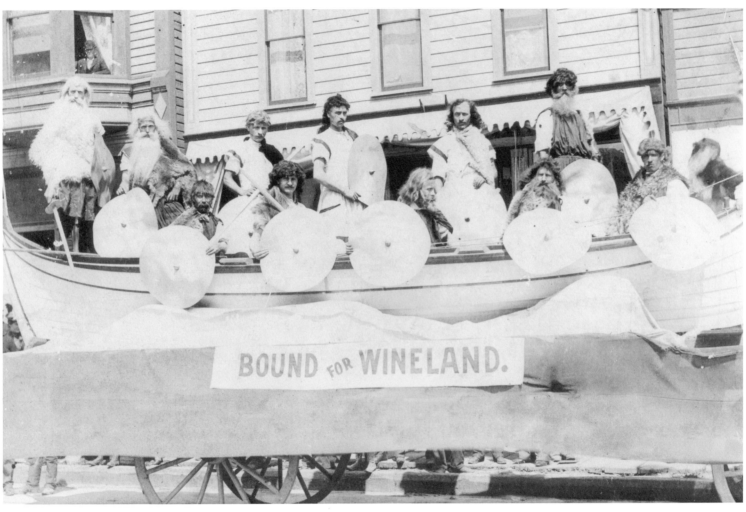

Working men dig up
a street in front of the
Northern Pacific offices
on Pacific Avenue and
4th Street.

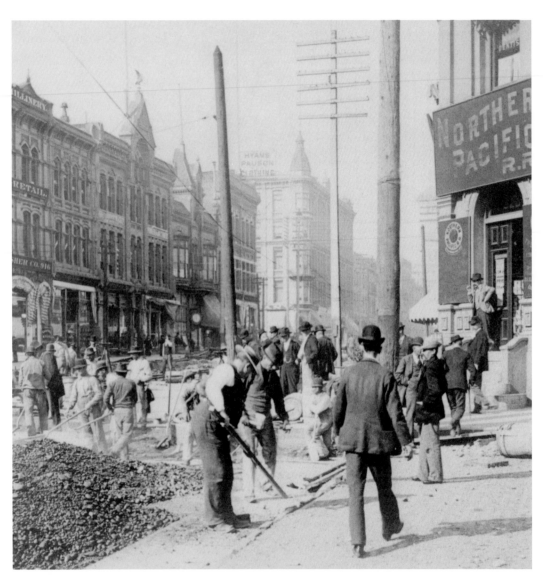

Coddling a large dog, a woman believed to be Grace R. Moore reads in the law offices of her husband, Henry K. Moore, ca. 1896. Grace and several acquaintances formed a reading circle to share their love of books, which led to the formation of the Mercantile Library, Tacoma's first circulating library. The library was initially housed in the Moores' home with Mrs. Moore serving as librarian.

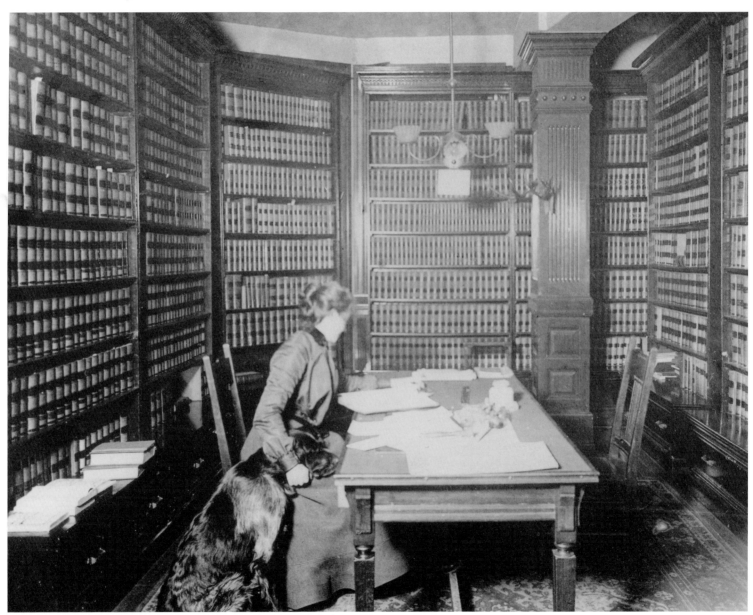

Employees and a bicycle delivery boy pose on the steps of the Pierce County Court House in 1898. Built in 1892, the three-story courthouse was a copy of the courthouse in Pittsburgh, Pennsylvania. Plans for the structure included everything from secret staircases to a hanging room. The building was demolished in 1959 and replaced with a parking lot for the modern County-City building.

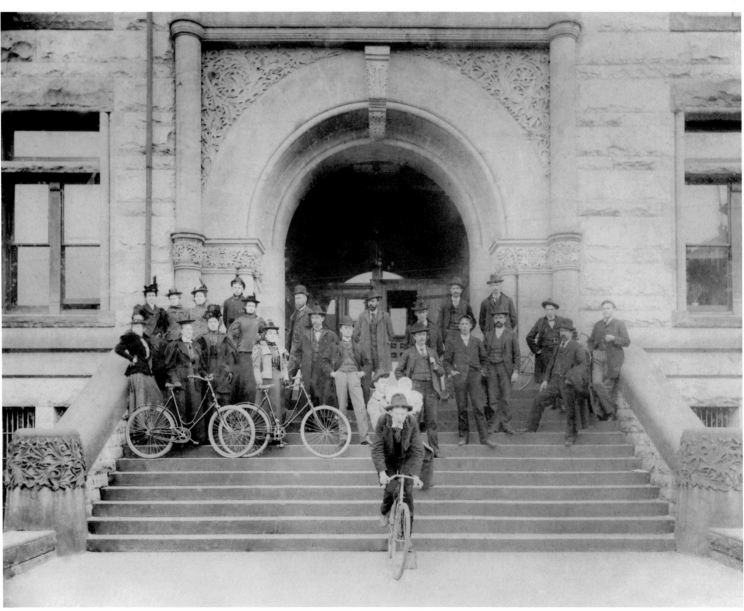

Deer at Point Defiance Park ca. 1899.

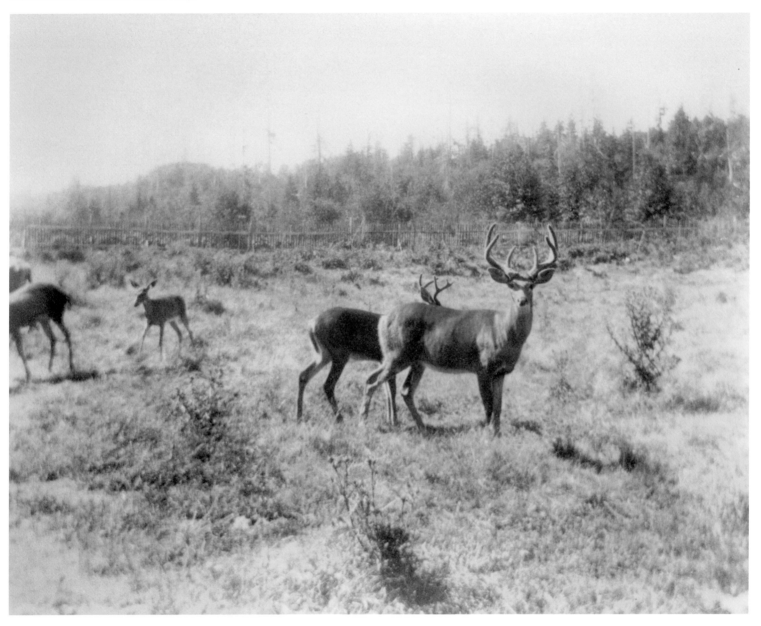

"Watch Tacoma Grow"

(1900–1919)

In 1900 Frederick Weyerhaeuser opened an office in the Northern Pacific Building on Pacific Avenue. The newly arrived lumber baron, working with the Northern Pacific's Sam Hill (a neighbor on Summit Avenue back in Minneapolis where both families hailed from), had amassed 900,000 acres at $6 an acre. Weyerhaeuser was a wealthy capitalist. And Tacoma obviously had an abundance of old-growth trees that were ripe for cutting. Soon Tacoma was the "Lumber Capital of the World" and Ruston Way had become a line of sawmills all the way out to the Ryan Smelter.

In 1905 the city adopted the slogan "Watch Tacoma Grow," for reasons not unfounded. A wheat warehouse was built on the shores of Commencement Bay that was the largest in the world. Within a few years the Interurban rail line was operating back and forth between Seattle. Union Depot (arguably the most beautiful depot in the Northwest) was up and running. A municipal power plant was completed in La Grande at a cost of $2,354,884, with a maximum capacity of 32,000 horsepower. The Green River gravity system, also costing more than $2 million, gave the city a capacity of 40,000 gallons of water. The Eleventh Street lift bridge was completed at a cost of $530,000. And Brown and Haley, the developers of Almond Roca, one of the largest gift confectioneries in the United States, was born. The bones of the city were being knit together. By 1915, the city could boast a population estimated at 104,000.

In 1909, a commission form of city government replaced the mayor and city council. Government corruption ran rampant until the system was repealed in 1953. The police department faced its own challenges. In 1908, the department purchased its first motor-driven patrol wagon. Each of the drivers of the horse-drawn wagons was offered a job driving the new vehicles, but two of them refused and quit. Schools were built. The South End of the city, jealous of the splendor of Stadium High School, demanded and got a fine new red-brick English Gothic school, Lincoln High. And Tacoma General and St. Joseph's hospitals opened their doors.

In 1917 Camp Lewis, later Fort Lewis, was constructed to train troops for service in World War I. Tacomans were eager to have the Army in the area because of the economic boost that it would provide the local economy. To reach their goal the ambitious citizens of the young city and Pierce County amassed 70,000 acres and gave it to the U.S. Army.

Tacoma ushered in the new century with a momentous 4th of July celebration. An estimated 50,000 people came to the city to participate in the event. Festivities turned to disaster on the morning of the 4th when an overcrowded streetcar plunged into the ravine at South 26th and C streets, instantly killing 37 passengers and maiming many others on board.

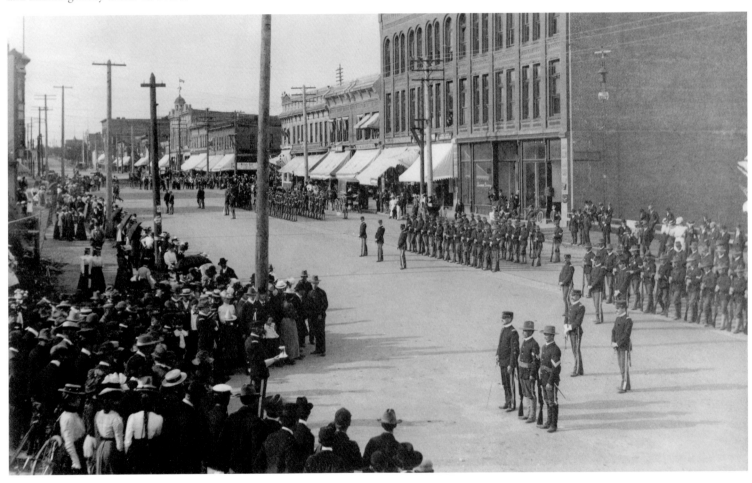

Here in 1900, Thomas Overland, proprietor of Overland's Furniture, stands at the entrance to his store on Tacoma Avenue. Overland later moved to 1137-39 Broadway, expanding his business to offer a complete array of home furnishings.

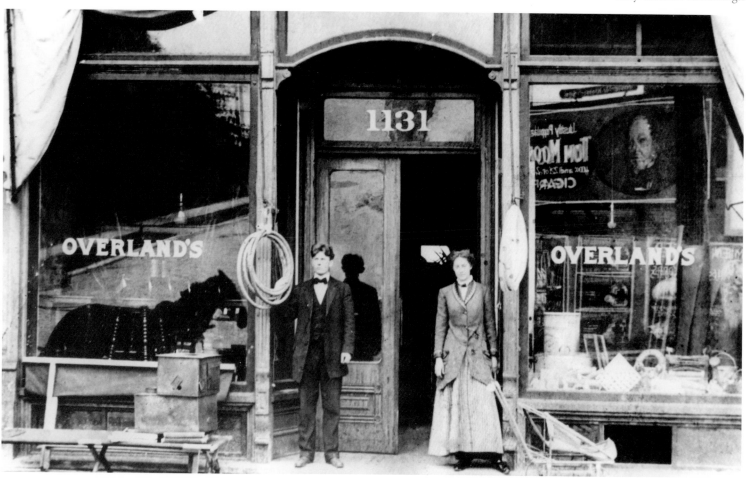

A view of Pacific Avenue near 9th Street ca. 1900. Old City Hall is visible near the center and the Northern Pacific Headquarters building is to its right. Originally known as the Fife (1887), the Hotel Donnelly was listed in the 1893-94 City Directory and was one of the oldest hotels in the city. The Grand Theatre, on the northeast corner of Pacific Avenue and South 19th Street, opened in 1905.

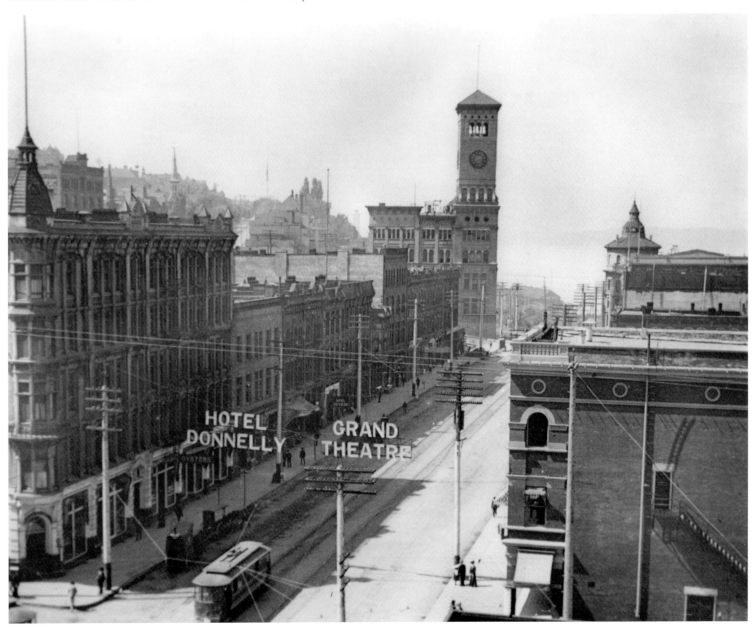

German immigrant Henry Mahncke, with partner Charles Muehlenbruck, built the Berlin Building in 1892 at 1021-23 Pacific Avenue. It was a dream come true for Mahncke, a Tacoma baker since 1882, but a dream short-lived. He lost everything in the Panic of 1893, becoming a janitor and elevator operator in the building he had owned. Mahncke later built a successful career in real estate, dying in 1937. The Berlin was demolished in 1920 to make way for the Washington Building.

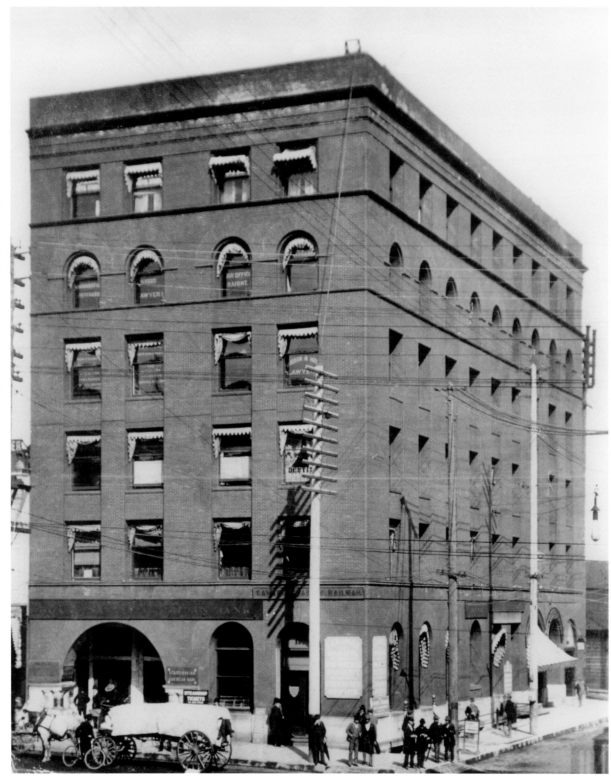

In 1900, Emil Kilese, William Klitz, and John Smith incorporated the
Columbia Brewing Company. Pictured here is the entire brewery staff.

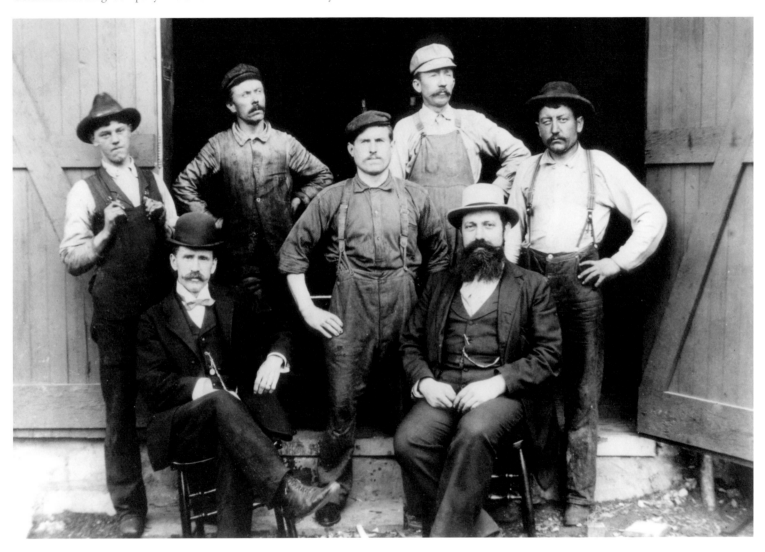

Someone is having a birthday in 1900. Bertha Breesemann, at far right, and two other women stand beside a picnic table with birthday cake and other party foods.

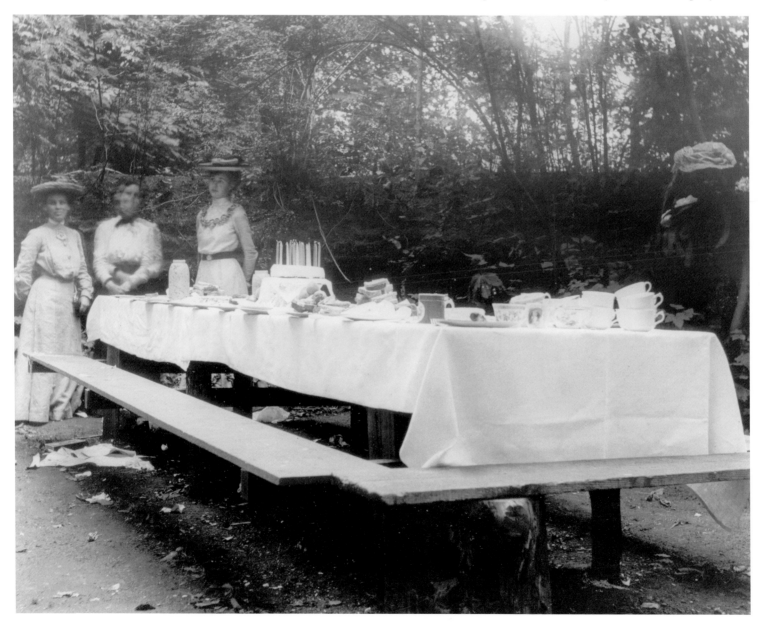

Identified as the Manitou Park home of someone associated with the streetcar system, a small house sits covered with snow and icicles in 1908.

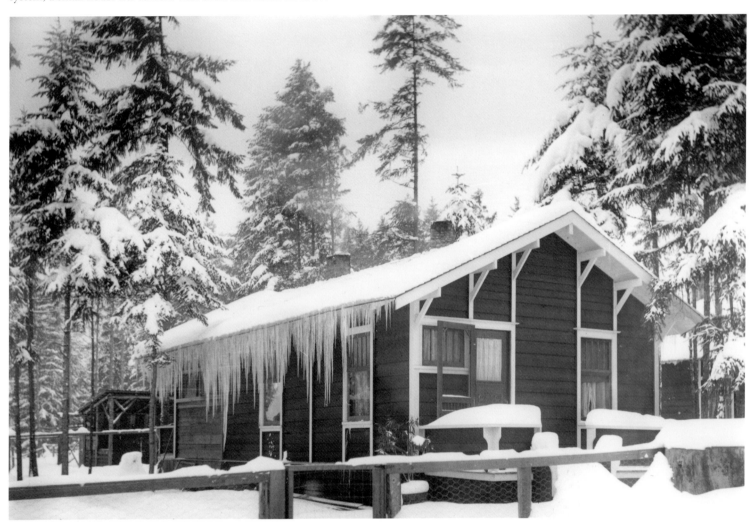

The Lincoln Elementary School class of 1901. Built at 1610 South K Street in 1887, the school was originally called West, but was renamed in honor of President Abraham Lincoln in 1889. Begun as a two-room school with two grades, by 1890 it had four grades and five teachers. The building was demolished in 1938.

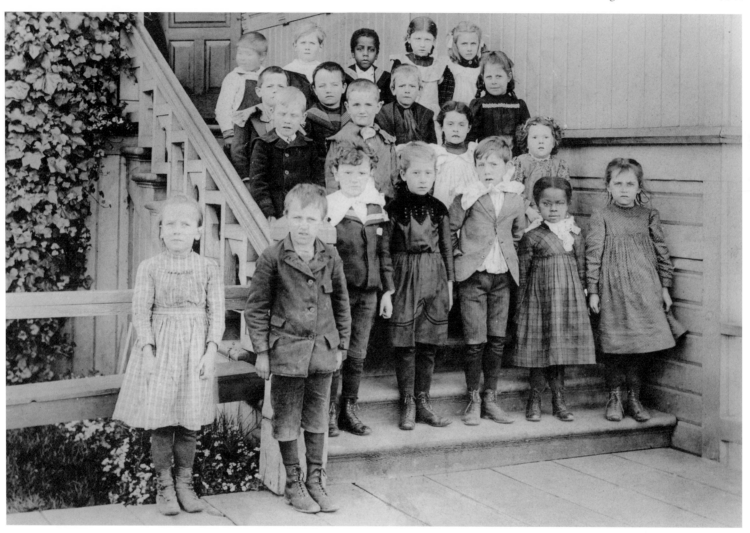

Amid wildflowers and a waterfall, E. J. Breesemann and his sister, Bertha,
enjoy a visit to Snoqualmie Falls in 1903.

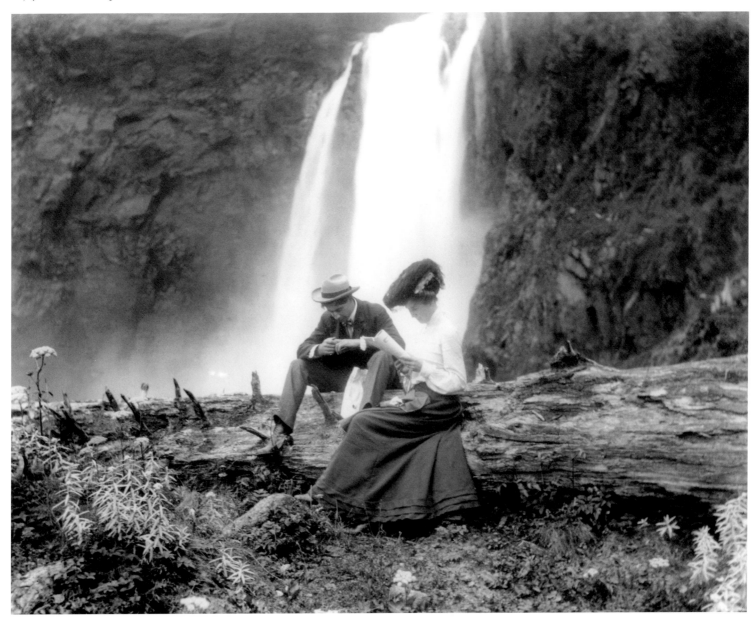

Harness gleaming and bedecked in garlands, the huge bays of Chemical Engine Co. No. 1 are ready to participate in the Tacoma Rose Carnival Parade on June 22, 1905. In addition to the parade, the three-day festival included band concerts, water pageants, a children's parade, and a carnival ball.

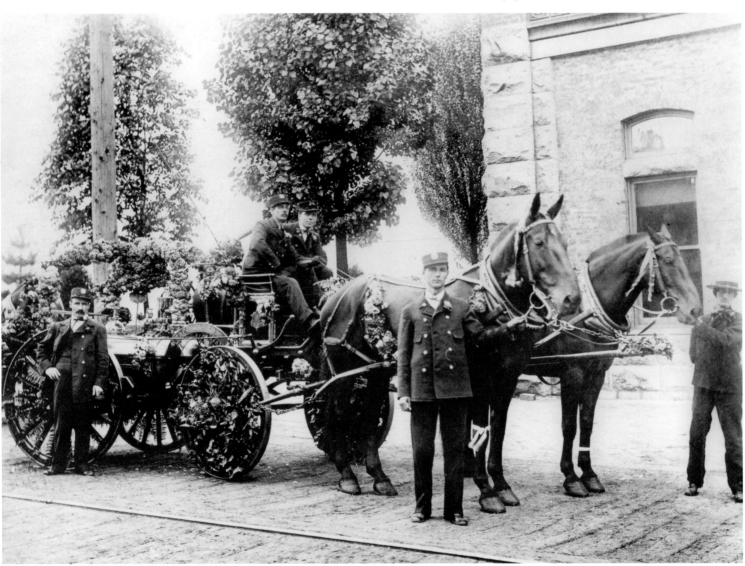

Pacific Avenue, facing north from the corner of South 13th Street. Electric streetcars ply the middle of the wide street while horse-drawn buggies and carts stay closer to the curb. A laundry wagon can be seen at lower-right.

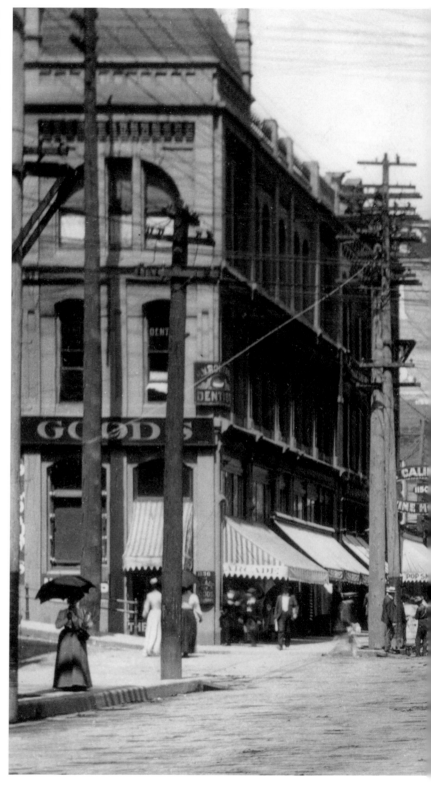

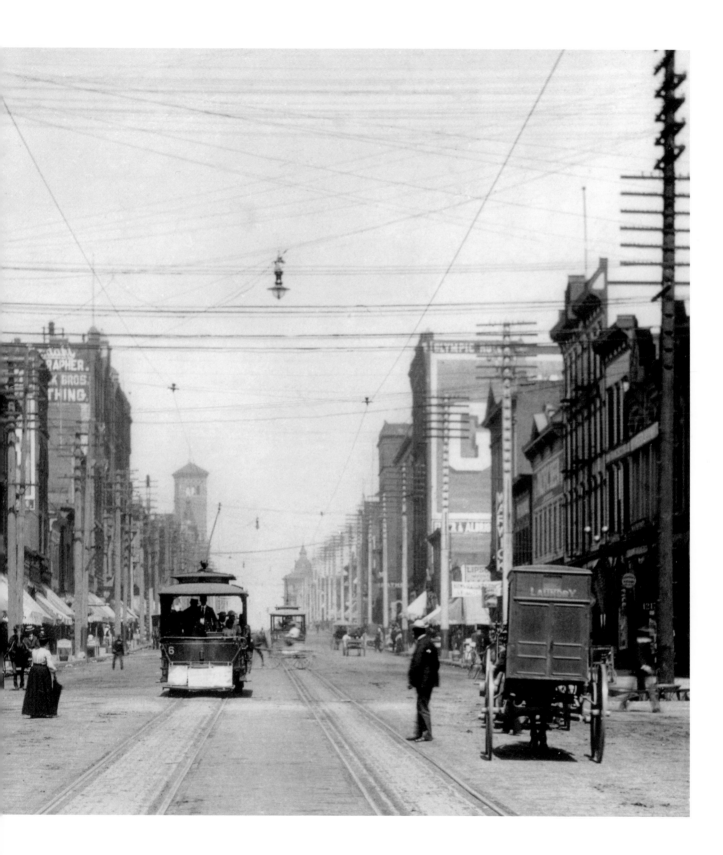

Four men and a boy pose for the photographer in front of a furniture
store in South Tacoma. Posters fill the windows of the store, one of them
advertising a program at the Savoy Theater. (1907)

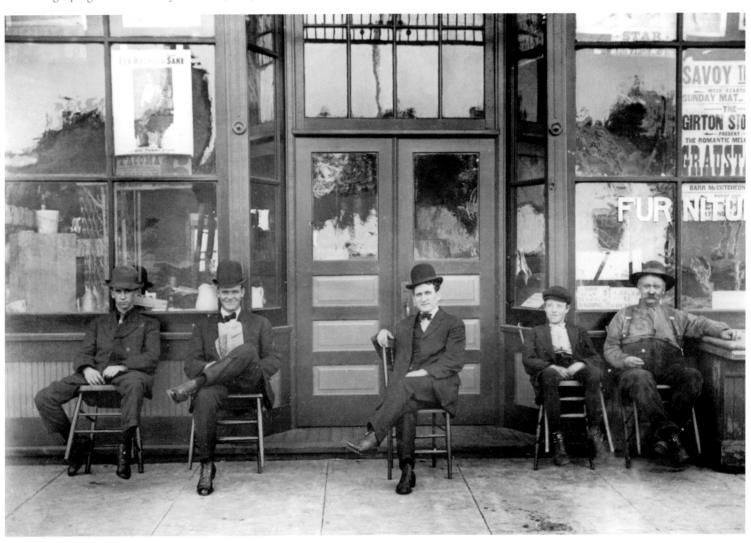

Pipe is laid in South
Tacoma in 1908.

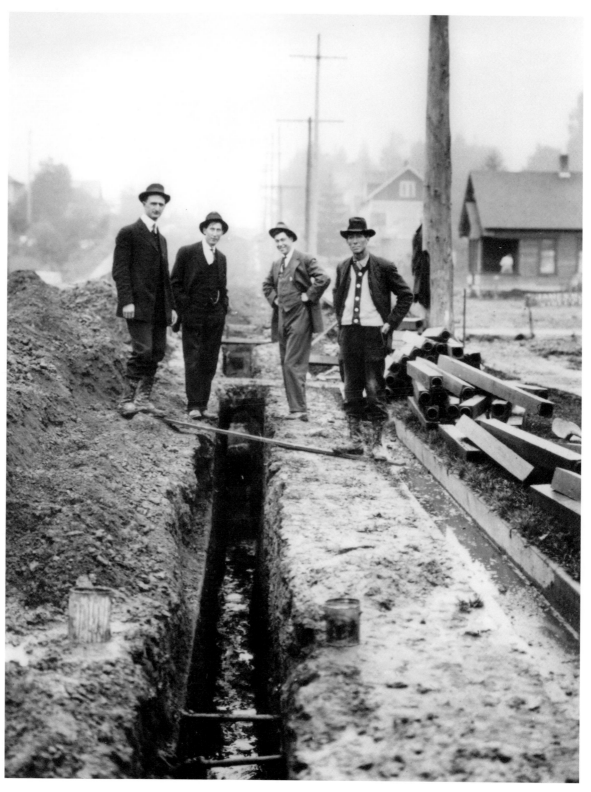

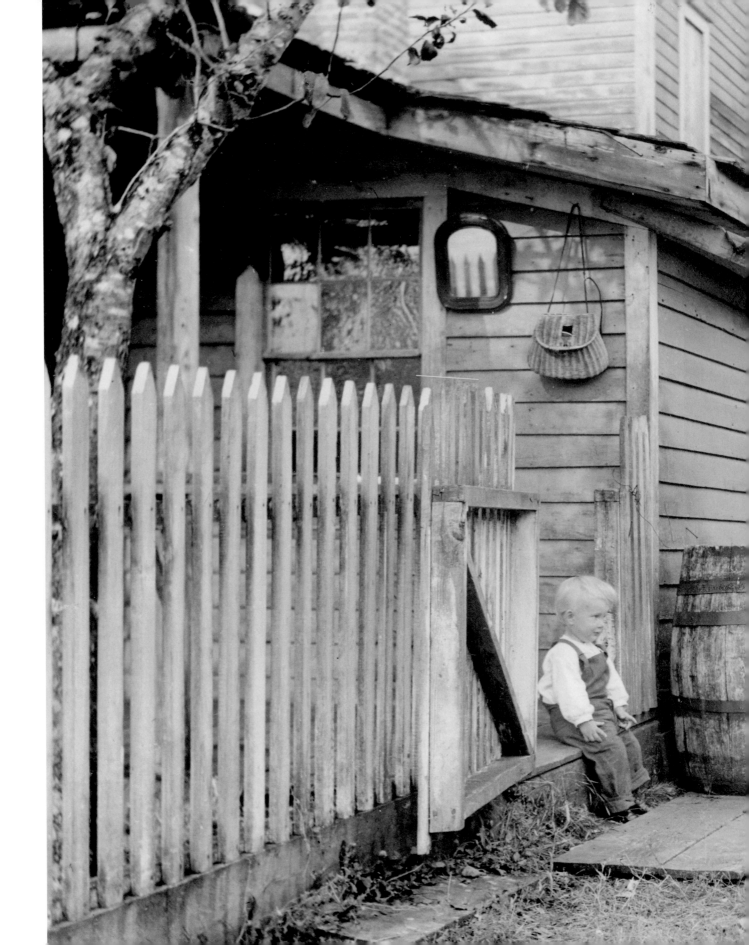

In 1907, Kenneth B. Stoever, two, sits on a step next to an open gate at the Breesemann homestead in Spanaway. The family dog is resting near a rain barrel, and a fishing creel hangs on an outside wall of the two-story frame house. A mirror next to the creel reflects the family's front-yard picket fence.

"All kinds of ter-baccer" are sold here at 5046 South Tacoma Way in 1907. According to the sign in the window, a picnic will be held at American Lake on July 27. This building was later remodeled to become a Knights of Pythias temple.

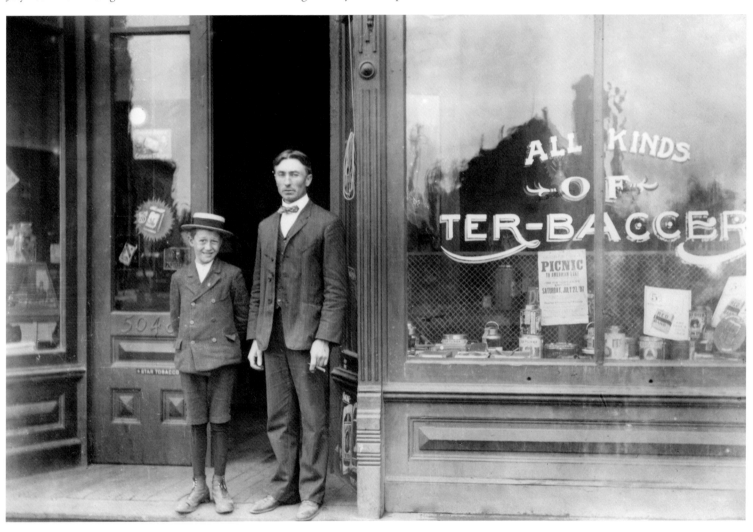

It's an icy day inside a Tacoma ice plant ca. 1908.

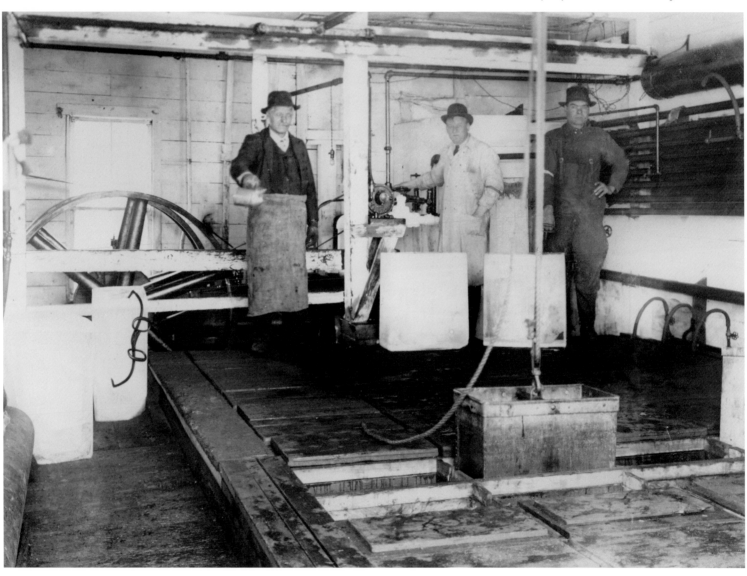

The Tacoma Steam Laundry makes the rounds in 1908.

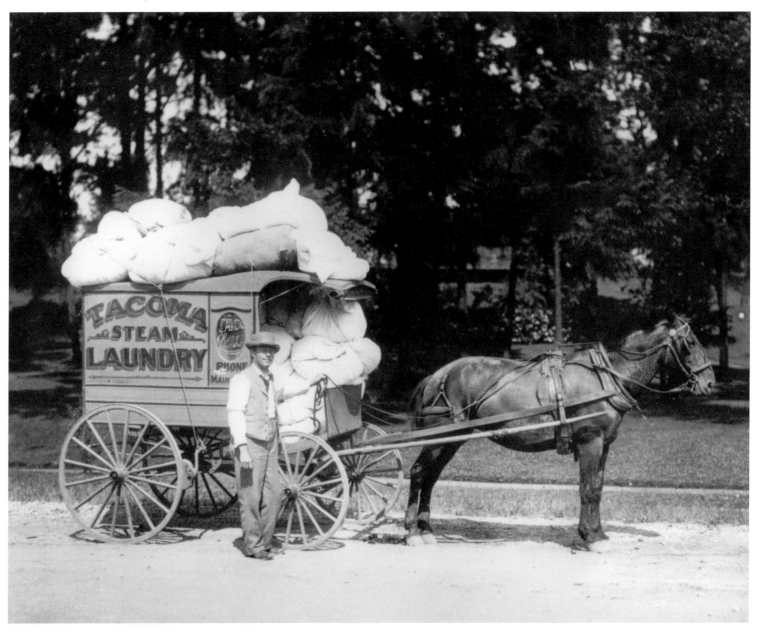

Men dig a ditch along what is now the 5200 block of South Tacoma Way ca. 1908. The task at hand is to run a pipeline, probably water pipe. A. E. Thompson & Sons and Smith Hardware Co. are among other businesses visible in this image.

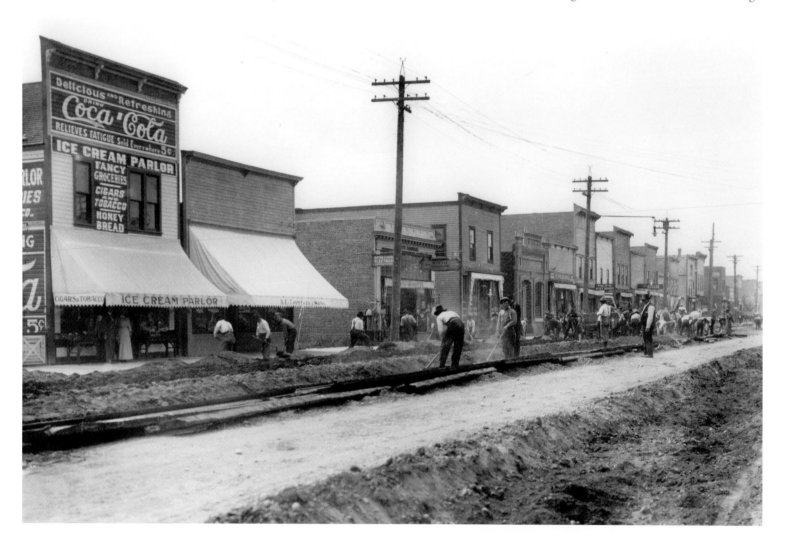

A whole smoked pig and other cuts of meat tantalize a group of men, women, and children crowded into a butcher shop around 1908—probably in South Tacoma. Four butchers in white aprons are visible behind the counter at left.

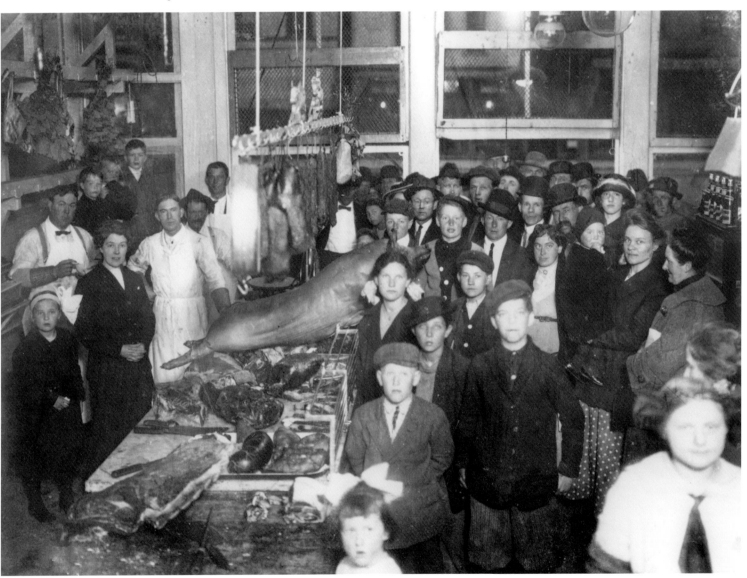

A line of workers (at right) trudging through the snow leaves the Northern Pacific Shops in South Tacoma ca. 1908. Started as Edison Car Shops in 1890, the complex of buildings at 5200 South Proctor became the Northern Pacific Shops in 1895. The shops were responsible for all repair work on Northern Pacific cars and locomotives west of the Mississippi River.

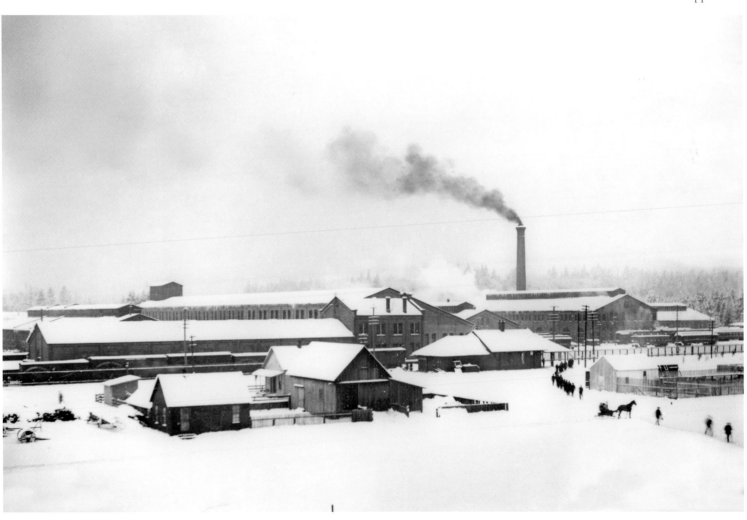

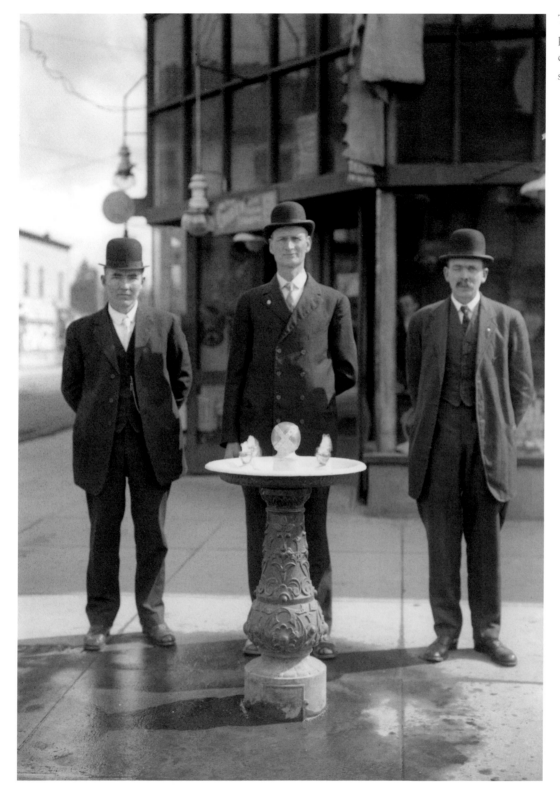

Three men in bowler hats pose behind an ornately crafted water fountain on a sunny day. (ca. 1908)

The Piper Undertaking Co. did business at 5034 South Union Avenue, according to the Tacoma City Directory of 1910. In view here is a Piper hearse.

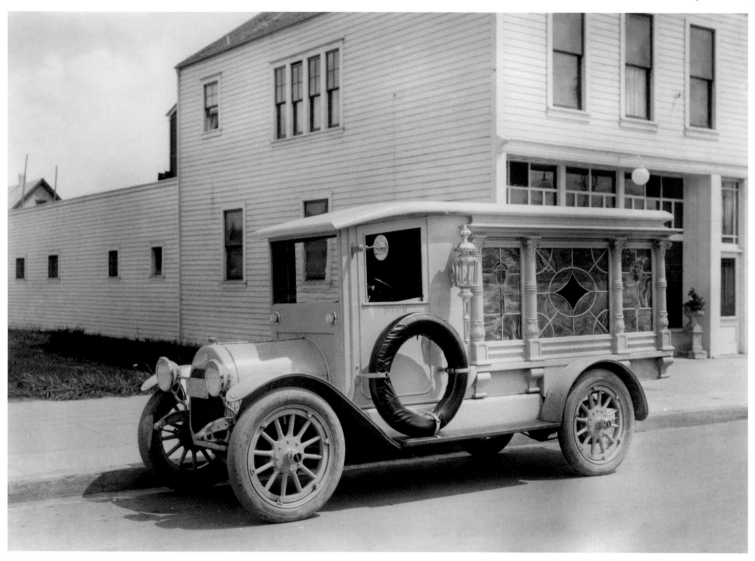

A group of men in suits and hats visit the bear exhibit at the Tacoma Zoo. The bear's face is blurred because it moved as the photographer took the picture.

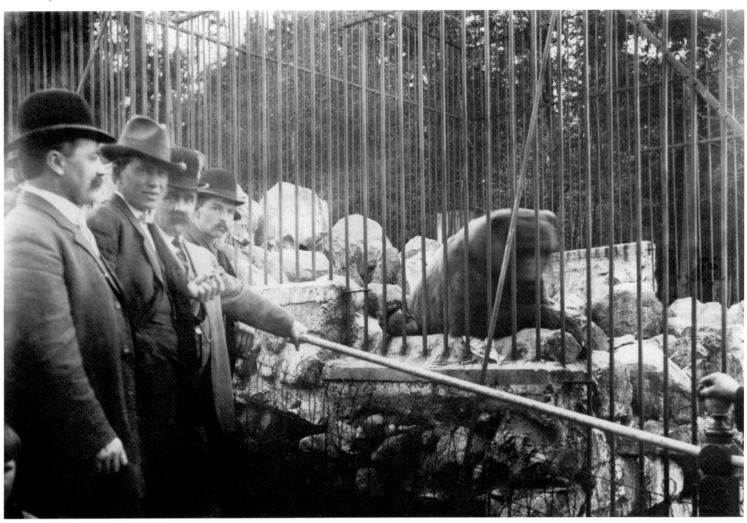

Stadium High School ca. 1909. Designed in the French Chateaux style by architect Frederick Heath, the building was conceived as a tourist hotel, but the hotel failed to open following the onset of a recession. Acquired by the City of Tacoma and converted into Stadium High in 1906, today the building is on the National Historic Register.

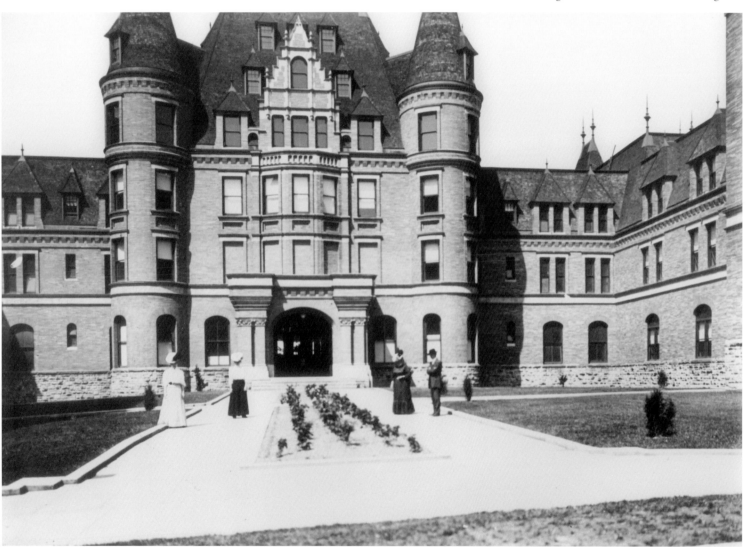

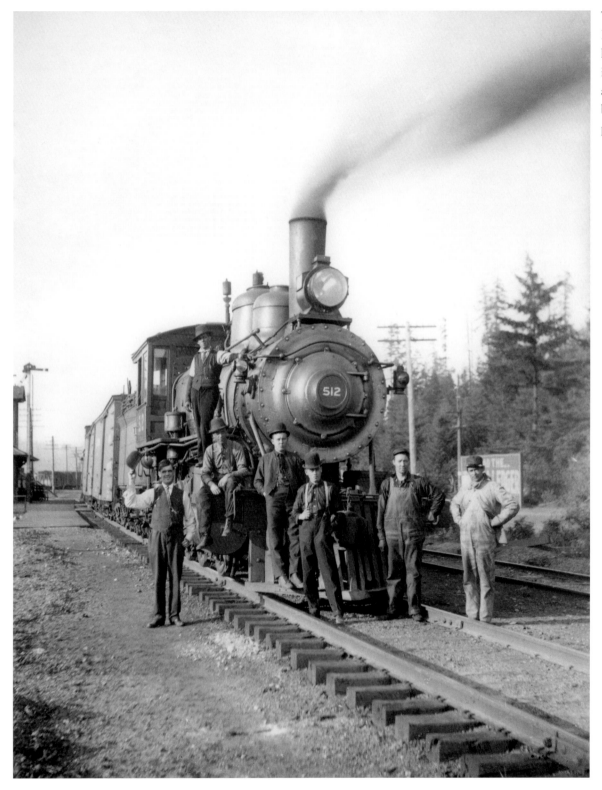

The Union Pacific
Railroad steam
locomotive No. 512
idles, as its crew
and several men in
bowler hats pose for a
photograph ca. 1908.

"You'll like Tacoma" reads the banner at lower-right. Facing south from a steep slope between South Cliff Avenue and Pacific Avenue at about South 4th Street, this image clearly shows the "half moon" railroad yard, the tideflats, and Mount Rainier in the distance. Rising at far-right is the old Tacoma City Hall and the Northern Pacific Headquarters Building on the other side of the street.

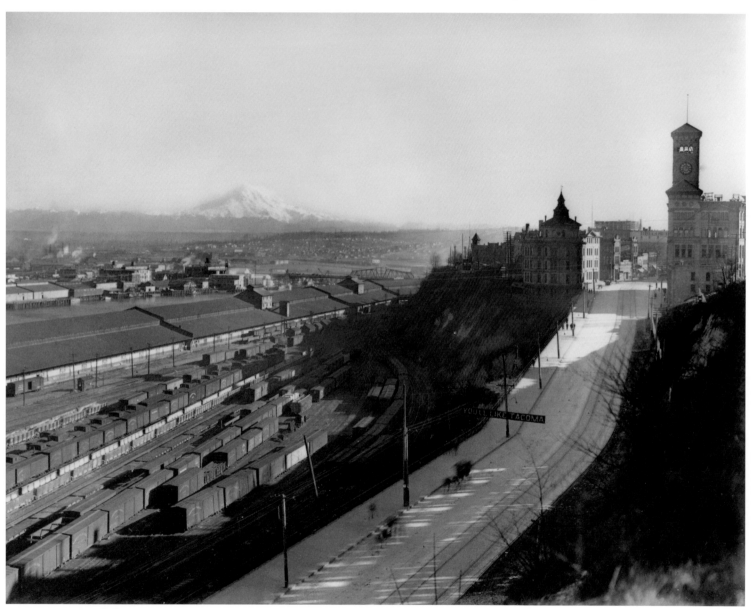

The original Horace Mann School at 5234 South J Street was built in 1901 as a simple two-story, four-room building. It appears here in 1910 with two additions, to accommodate growing numbers of pupils. The school was named for noted American educator Horace Mann, who revolutionized public school instruction and established the first normal school for teacher training.

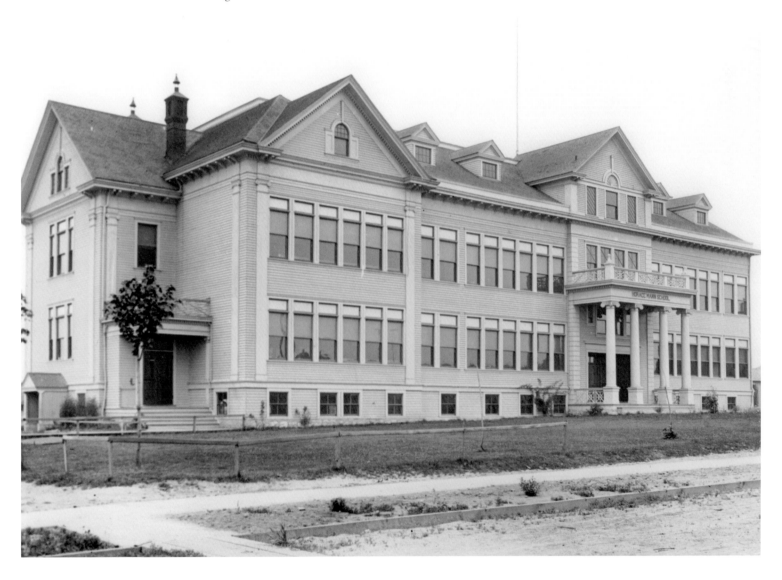

Around 1911, an Al G. Barnes Wild Animal Circus wagon rolls down a South Tacoma street. The wagon hauls a small brass band on top and African lions inside.

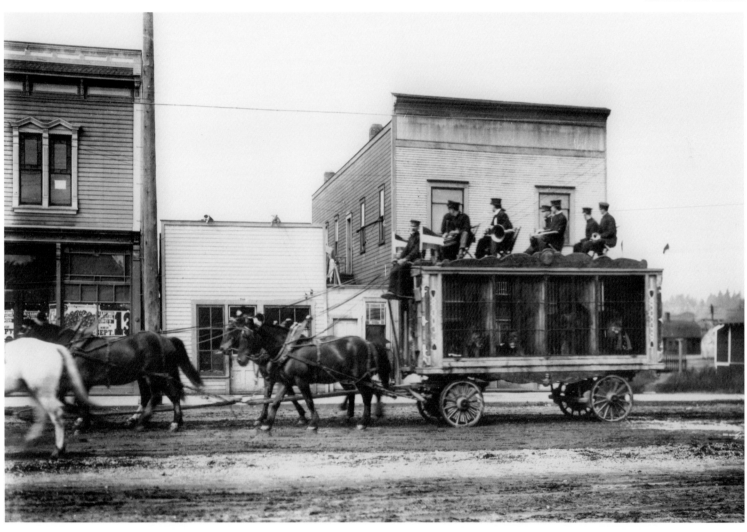

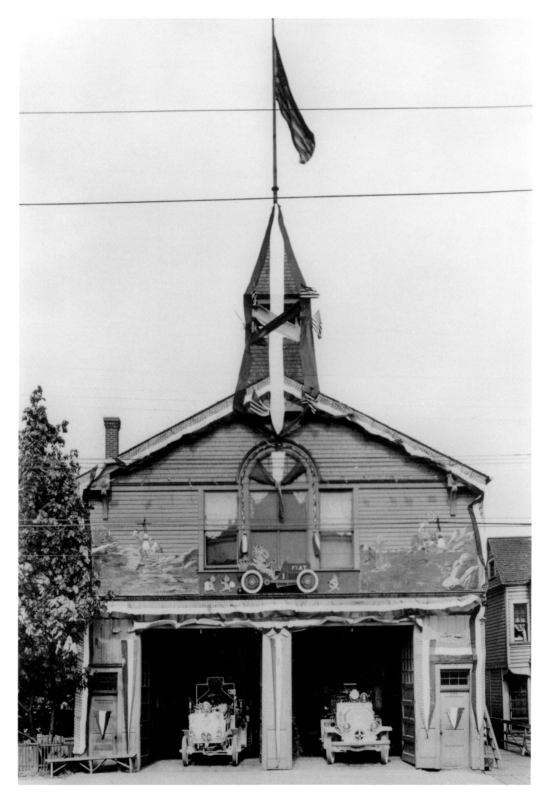

Bunting decorates Engine Company No. 1 Fire Station at 209-211 Saint Helens Avenue, probably for the Montamara Festo, held in Tacoma over the 4th of July holiday every year from 1912 to 1922. On the roof, a model Fiat racing car driven by "Tige," a character created by editorial cartoonist Edward Reynolds of the Tacoma *Daily Ledger,* points to the highlight of the festival: a series of automobile races.

In early July 1917, the Tacoma Rail & Power Company fired seven employees they accused of union organizing. Within days the remaining workers were signed up by the Amalgamated Association of Street & Electric Railway Employees of America, and when the company refused to re-hire the fired workers, the newly organized group sabotaged tracks with boulders.

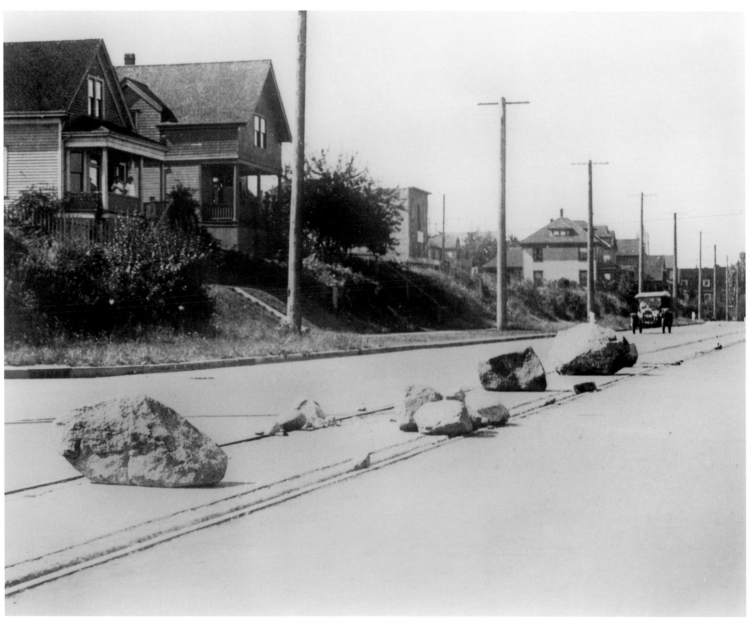

On the brink of entering World War I, the United States was looking for a Northwest location for the Army. To aid the effort, H. B. Blitz devised a publicity stunt to get people to vote for a proposal to sell $2 million in bonds to buy 70,000 acres. The land would be given to Uncle Sam with the understanding that Fort Lewis, to be built on the site, would bring revenues to the area. The proposal carried 6 to 1.

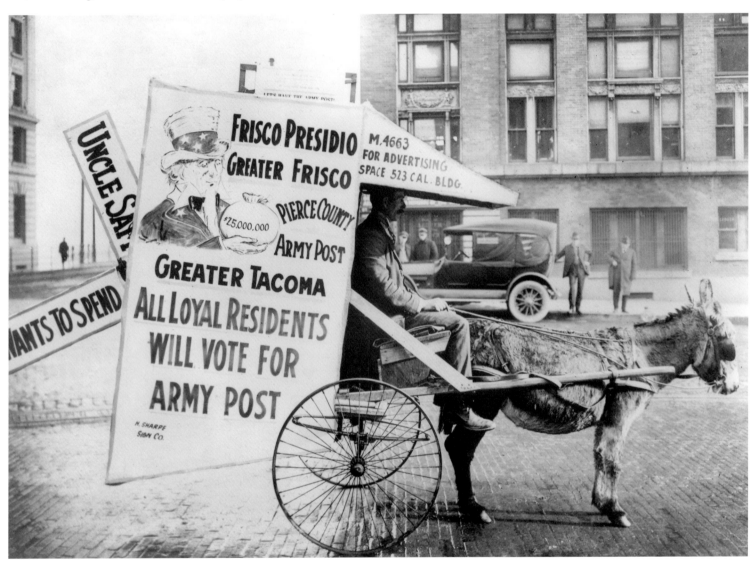

Sarah Bernhardt, world-renowned actress, performs in *Camille* at Tacoma Theatre, 902-14 Broadway, in June 1918. Built in 1890 by the Tacoma Opera House Co., the theater was advertised as having the largest stage on the West Coast. The building succumbed to fire in 1963.

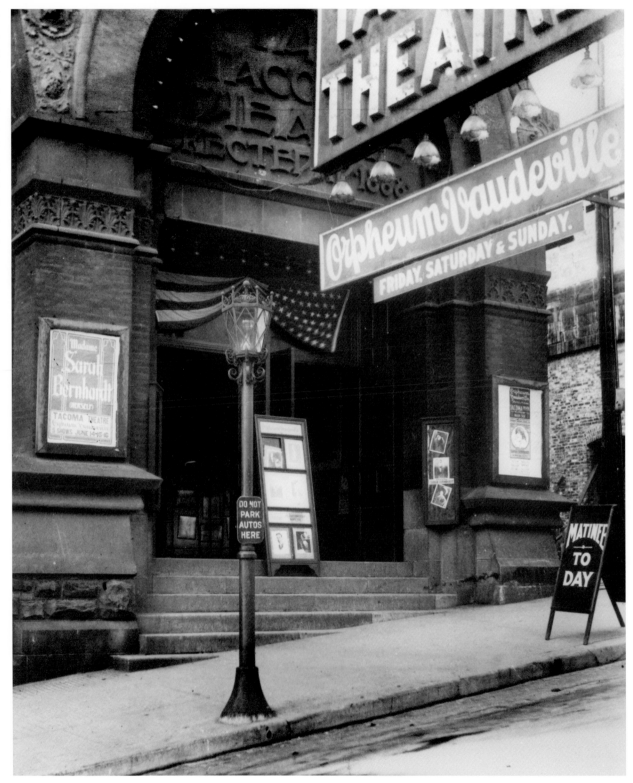

Boy Scouts salute the American flag during Tacoma's Labor Day Parade in 1918. Organized labor flexed its muscles as nearly 20,000 marchers participated, including ironworkers, boilermakers, machinists, and shipyard workers—and among them twelve bands and an occasional float.

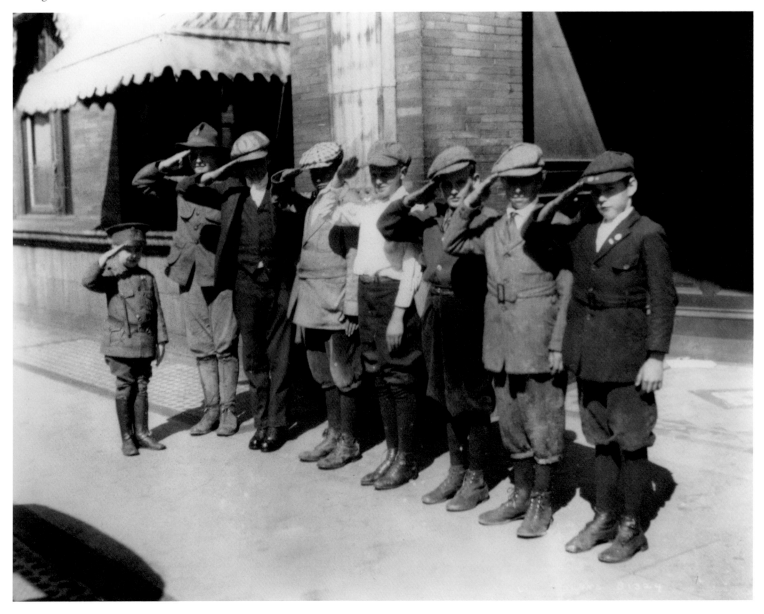

Employees of the Oriole Candy Company bid farewell to H. L. Brown in April 1918. Harry L. Brown, a budding confectioner and experimenter in sweet treats, opened Oriole Chocolates, his own retail candy shop, on Broadway in 1907. By 1909 he had converted it into a wholesale operation. Brown then partnered with Jonathan Clifford Haley, a Schilling Spice salesman, to form Brown & Haley, now one of the oldest companies in Tacoma and the U.S. The company's chocolates were hand-crafted and enjoyed by soldiers stationed at Fort Lewis during World War I.

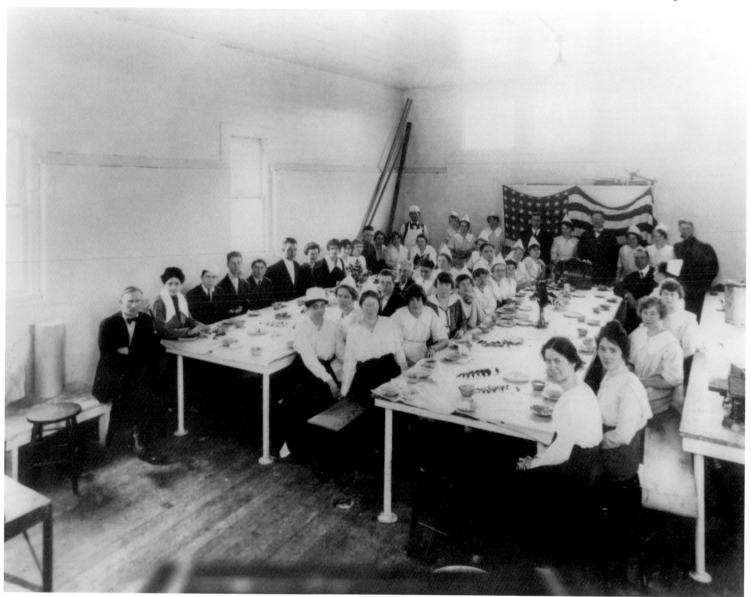

Without benefit of freeway between Tacoma and Seattle in June 1919 and little paved road, Harry Barsamian, shop foreman for Pacific Car Company, managed to drive from the city limits of Tacoma to the city limits of Seattle in 30 minutes, 55 seconds. His feat broke the previous record of 34 minutes, 30 seconds. He swore never to do it again.

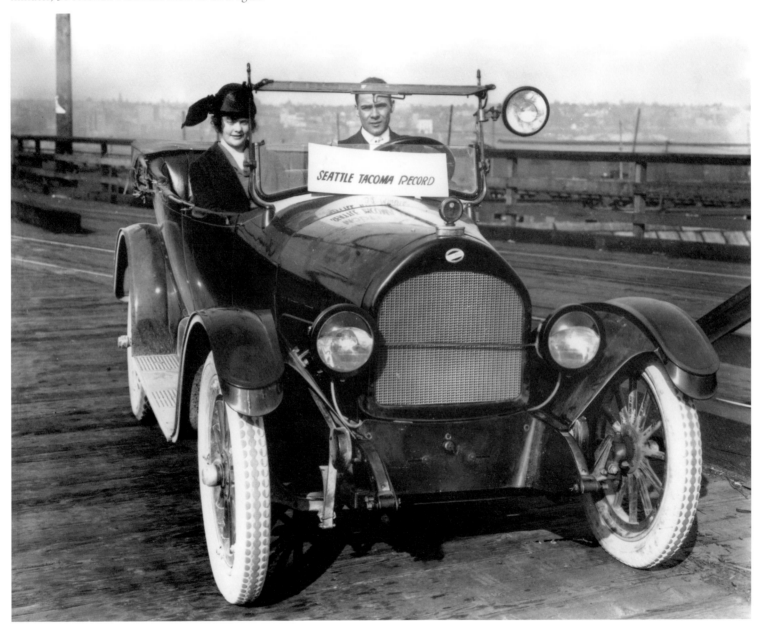

A City Come of Age

(1920–1939)

Tacoma kicked off the Roaring Twenties by building Stadium Way, watching Babe Ruth play baseball in Stadium Bowl, and welcoming President Warren G. Harding for a visit. The sumptuous Hotel Tacoma, now 41 years old, faced its first competition when the dazzlingly modern Winthrop Hotel opened at 9th and Broadway. The city's long-held hope of changing the name of Mount Rainier back to Mount Tacoma was again refused by the House of Representatives' Public Lands Committee—after the Senate endorsed a resolution to change the name and raised the hopes of citizens.

In 1927 the Crystal Palace Market, one of the largest in the nation, opened at 11th and Market Street. The following year the cornerstone for Bellarmine Preparatory, a Jesuit school, was laid. And in 1929 the aircraft carrier *Lexington* docked in the tideflats and fed power to the troubled city.

Franklin Delano Roosevelt was elected president of the United States in 1932. Prohibition was repealed in 1933, and in 1934 Tacoma's first Daffodil Parade was held. George Weyerhaeuser, 9, was kidnapped in 1935 on his way to meet his sister at Annie Wright Seminary. His kidnappers received $200,000 in marked bills, which led to his release and soon led to their capture. Less fortunate was Charles Mattson, 10, who was murdered by kidnappers in the woods near Everett despite a ransom of $28,000 paid by his parents.

The city's beloved Tacoma Hotel was tragically destroyed by fire.

Will Rogers, fabled comedian and Hollywood star, visited Tacoma a few days before his fatal flight in Alaska. Anna Louise Strong, communist American journalist and daughter of a Social Gospel minister, was refused permission to speak at Jason Lee on the subject "Soviet Russia and World Peace" following strong public pressure.

Northwest banker and industrialist Norton Clapp envisioned suburbia and built colonial Lakewood Center in 1937. And in 1938 the last cable car was taken out of service.

Washington celebrated its 50th anniversary of statehood with a week of Grand Jubilee events that included "Saga of the West" in Stadium Bowl with a cast of 2,000.

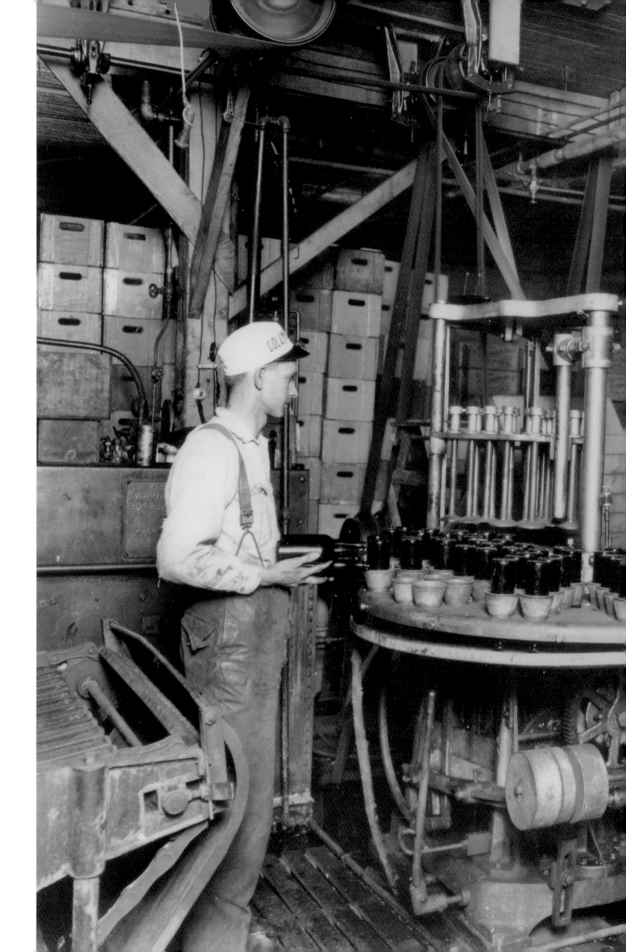

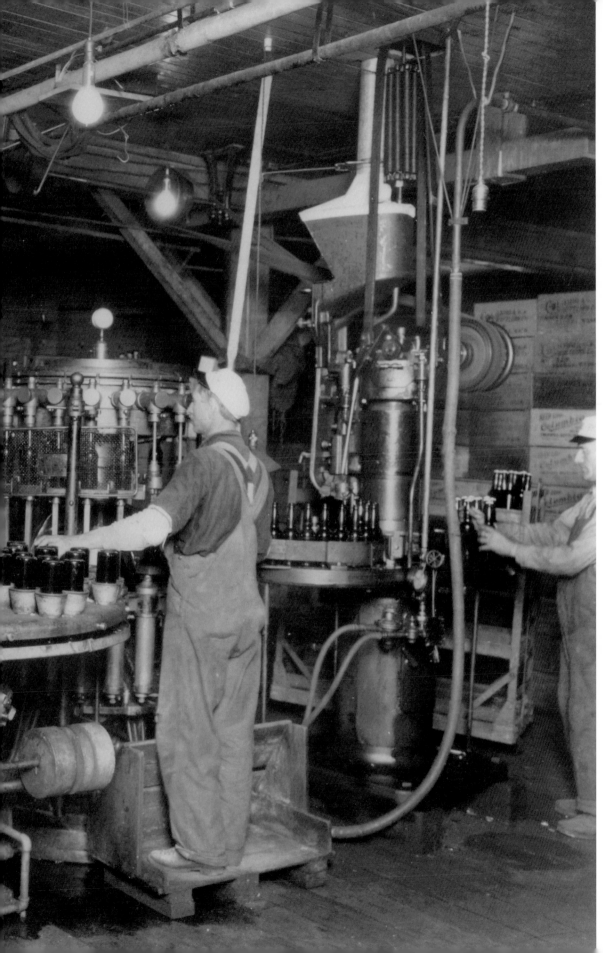

A day on the job at Columbia Breweries. Early day bottling was tedious, relying on hand-operated machines. Producing 500,000 bottles a year was an achievement mildly monumental.

A man exits Tacoma Transit Co. bus #105 near the 700 block of Pacific
Avenue. The bus was used on the Tacoma-Puyallup route. At left is a
cigar and tobacco store, at right-rear the Eau-Claire Apartments and
Auto Parts Supply Co.

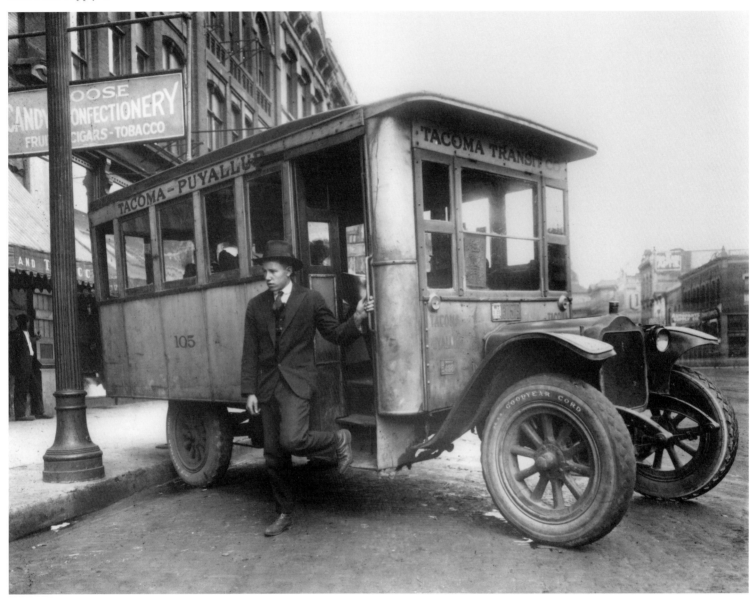

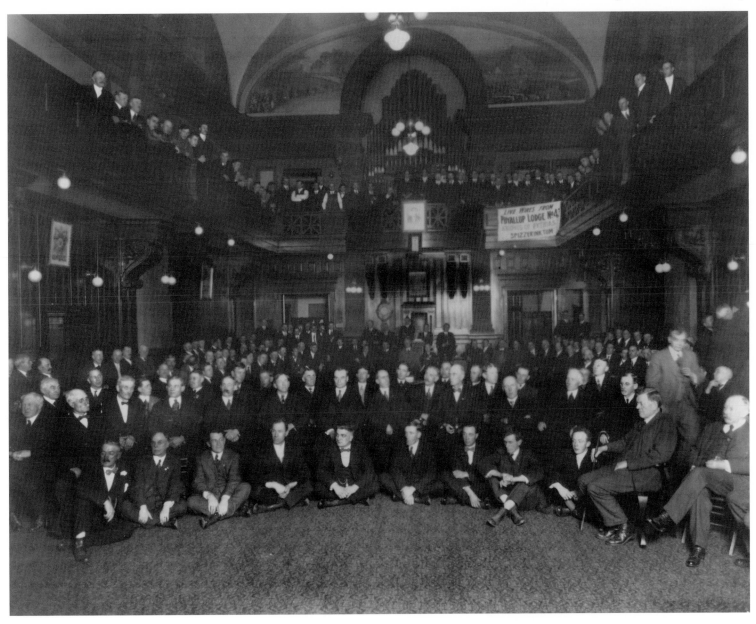

Upstairs balconies ringed with men, a homecoming celebration is under way in the Castle Hall of the Knights of Pythias Commencement Lodge #7 at 924-26 Broadway.

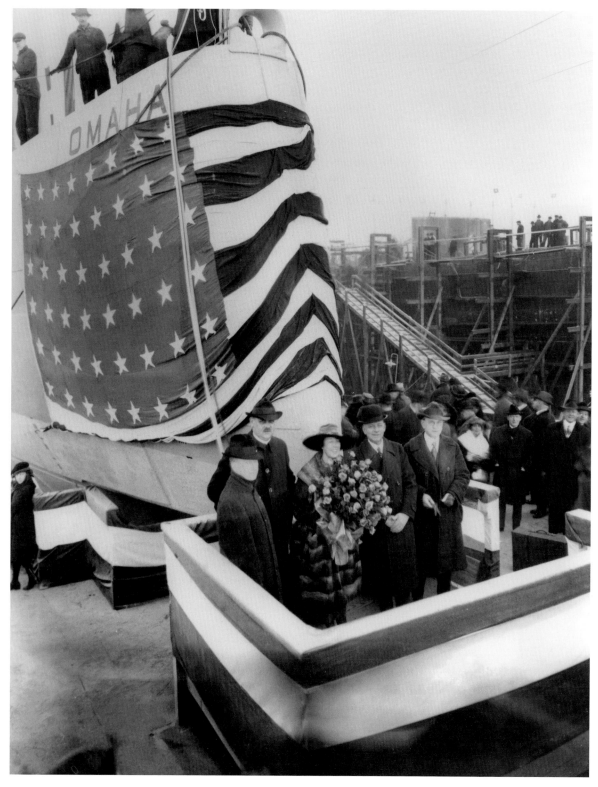

Miss Louise Bushnell White of Omaha stands on the landing platform on December 14, 1920, after smashing a customary bottle of champagne on the U.S.S. *Omaha* at Todd Shipyards. She was chosen for the honors as a descendant of David Bushnell, inventor of the one-man submarine during the Revolutionary War. Posing with her is C. W. Willey of Seattle, president of Todd Drydocks, and other dignitaries. This was the 27th launching at Todd yard.

McEldowney Garage in 1920 was located at 731 St. Helens and 712 Broadway. According to a newspaper article, this garage was second to none, performing all facets of automobile restoration under one roof. Pictured here is thought to be the painting department.

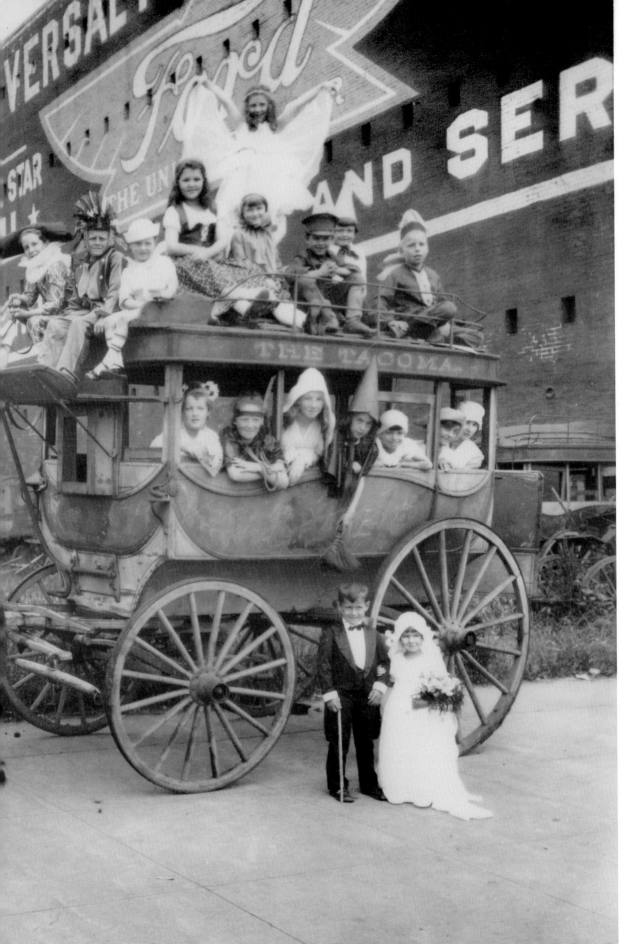

In view here is the "Cinderella Coach" as it looked on July 25, 1920, when it rolled with its load of costumed children through the streets of Tacoma on the way to a story-telling festival in Wright Park.

Residents of Trafton Street between 6th Avenue and South 8th Street were treated to Tacoma's first block party. The Community Service Club hosted the party in an effort to end the isolation of city life. More than 600 people turned out for the successful event, which ended around midnight as children grew weary and parents carried them home.

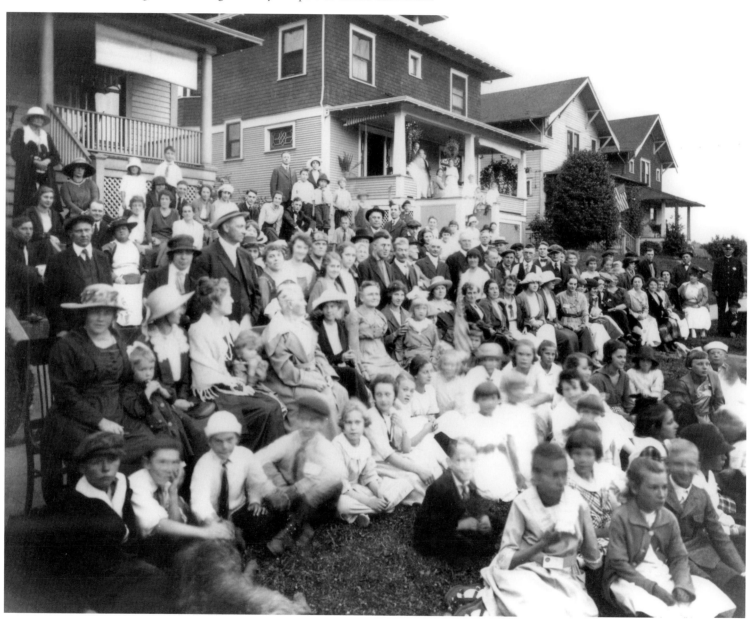

The foreman and construction crew of the new Scandinavian American Bank, 1019 Pacific Avenue, in 1920. The crew, or "erectors," was responsible for raising the 32-ton beams and 60-foot steel columns into position.

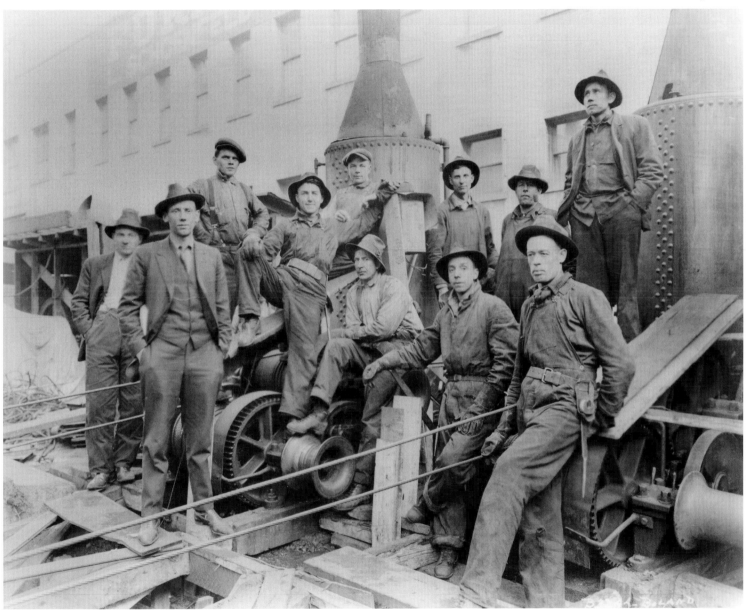

A horse-drawn sleigh is the preferred means of travel in downtown Tacoma near 10th and Pacific Avenue in February 1923. Tacoma would see days of snow in mid February with accumulations of 15-18 inches, and up to 24 inches in outlying areas. Schools were closed and streetcar service was suspended.

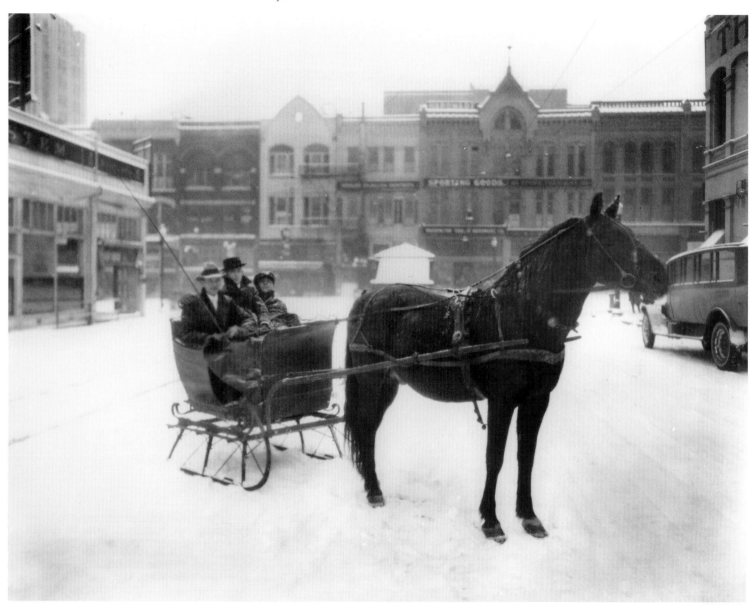

Crowds fill Lincoln Bowl to watch a City League baseball game on May 29, 1924. The match pitted Fern Hill against the 23rd Street Boosters. Fern Hill won. Lincoln High School is visible in background.

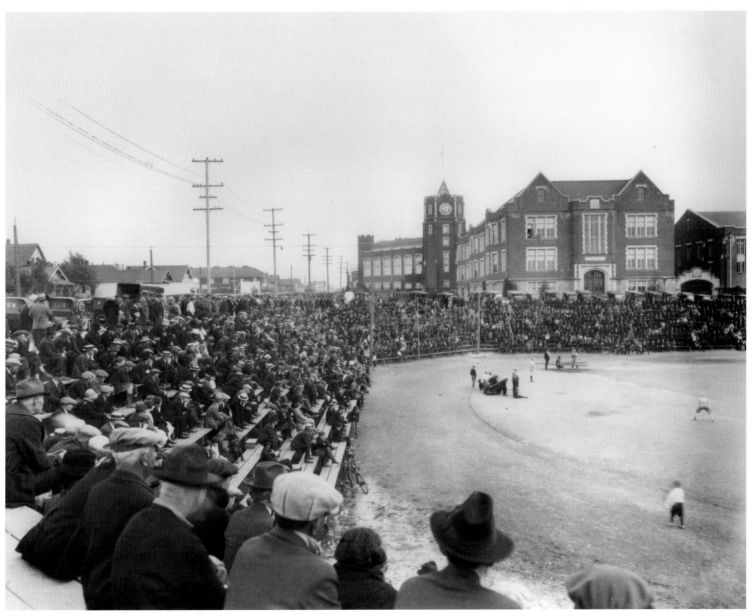

The Tacoma Civic orchestra, posing here for a group portrait outside the Scottish Rite Temple at 5th and South G streets, performed their first concert of the winter season November 22, 1925. Every seat in the house was filled. P. D. Nason, director of music at Lincoln High School, served as conductor and director.

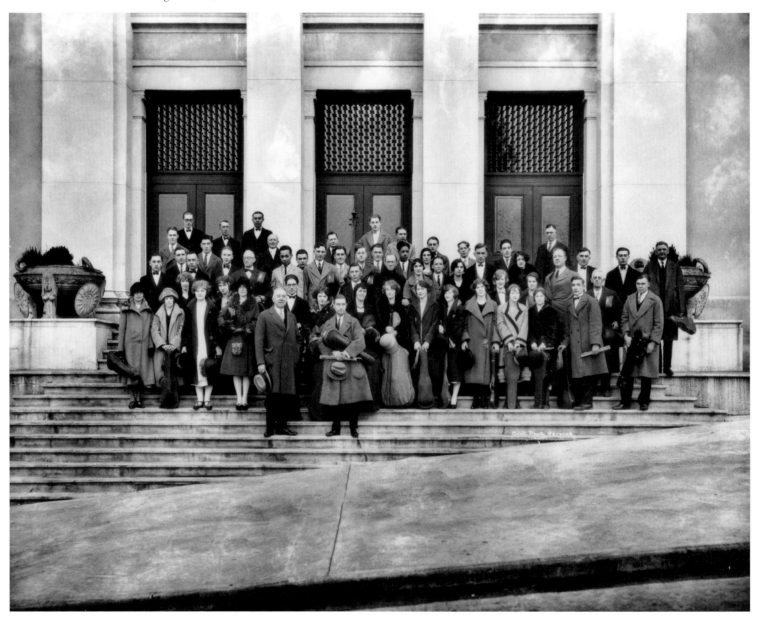

Walter R. "Pat" Patterson prepares to demonstrate a new 1925 Harley-Davidson—missing its handlebars. With his hands cuffed to the saddle of the cycle, Patterson rode to Portland in high gear. Demonstrations like this one proved how easy it was to handle the new model.

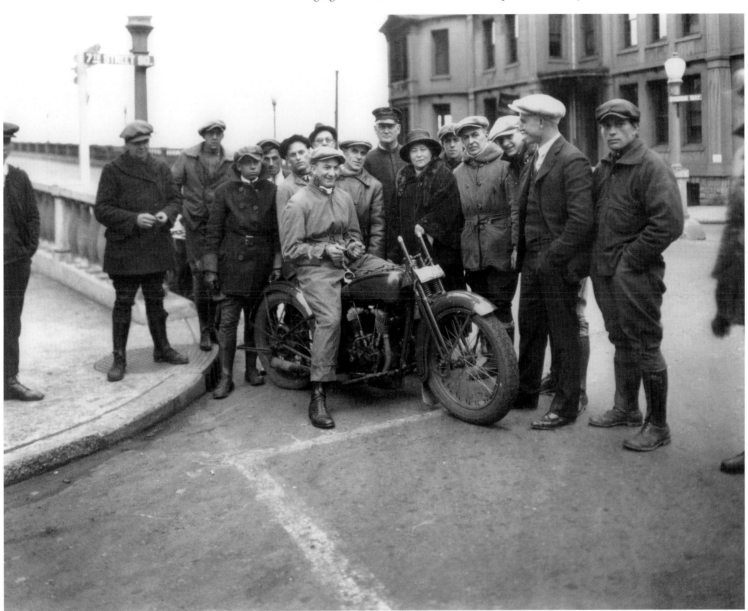

The Park Theater was purchased by Hans Torkelson in 1922 and overhauled to become a small movie house for the McKinley Hill neighborhood.

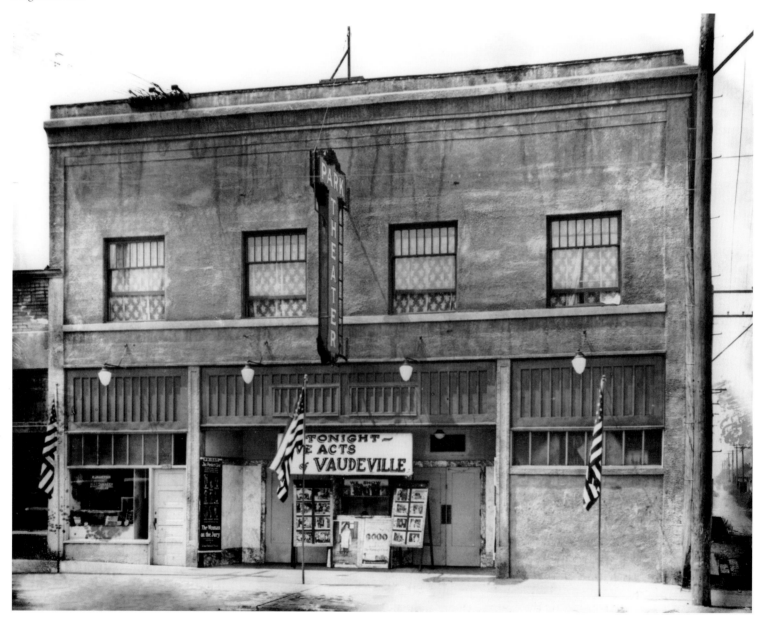

The Tacoma City Hall clock tower gives the time as commuters wait to board buses and the Interurban at the Interurban Depot at 8th and A streets. Operated by the Puget Sound Electric Railway, the Tacoma-Seattle Interurban traveled 36.5 miles between the two cities.

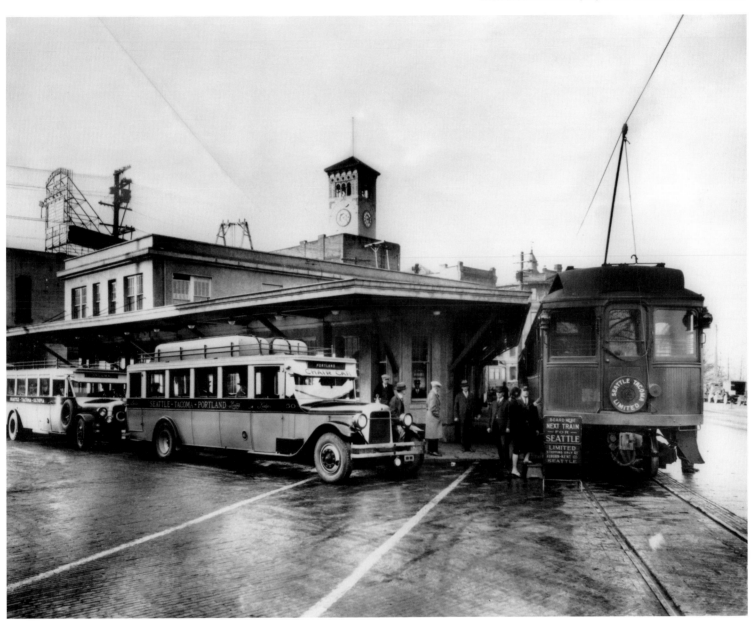

A float carrying a Dixieland band cruises in front of the Elks Club at 565 Broadway in 1925. The musicians are promoting *A Kiss in the Dark,* a silent movie playing at the Colonial Theater and starring Adolphe Menjou, Lillian Rich, and Aileen Pringle. The float may have been intended for Straw Hat Day, the day in spring when Tacoma gentlemen doffed their winter hats and put on their summer straw.

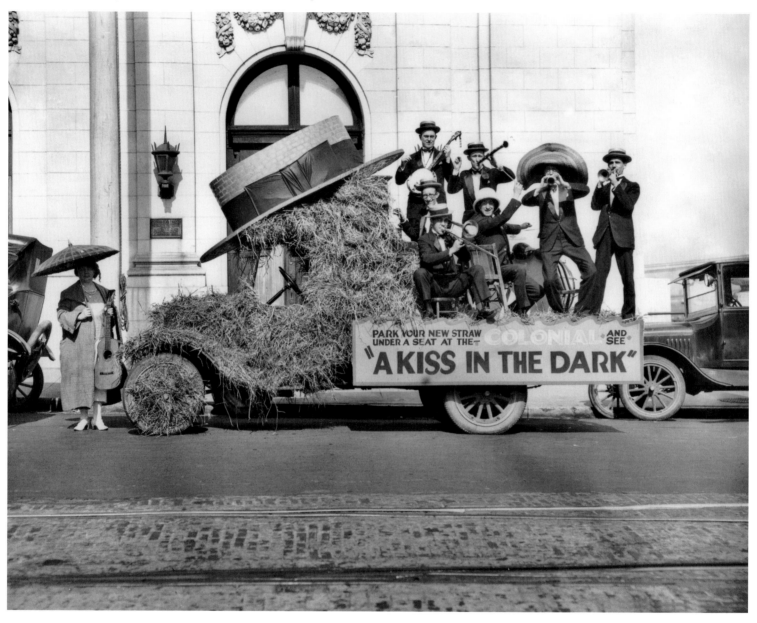

PARK YOUR NEW STRAW UNDER A SEAT AT THE COLONIAL AND SEE "A KISS IN THE DARK"

Woolworth management treats patrons to a free bottle of Orange Kist on September 4, 1925. With Prohibition in full force, Columbia Brewery was producing sodas instead of beer, introducing Orange Kist to Tacoma citizens the preceding month.

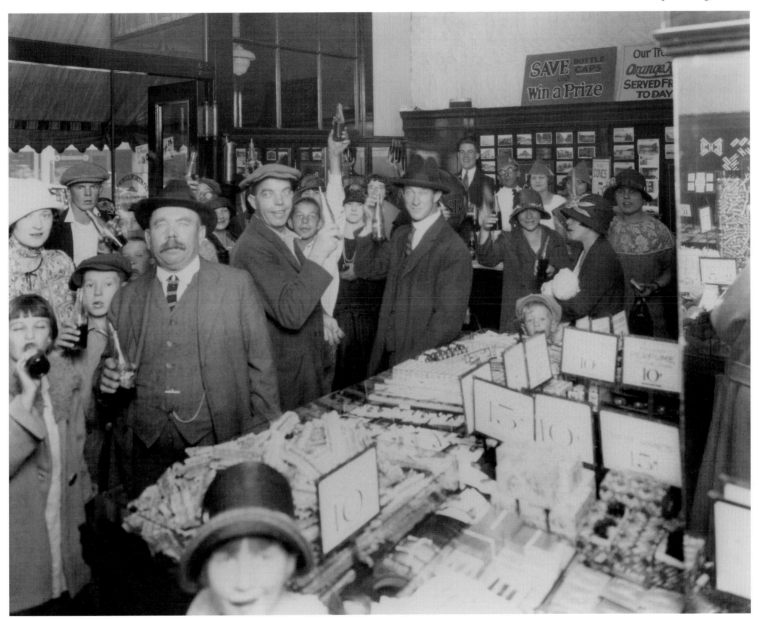

Men unload lumber from a ship at the Defiance Lumber Co. dock. Some of the lumber appears to be around two feet by two feet, showing why Tacoma was known as "the lumber capital of the world." The Defiance Lumber Co. closed in December 1951.

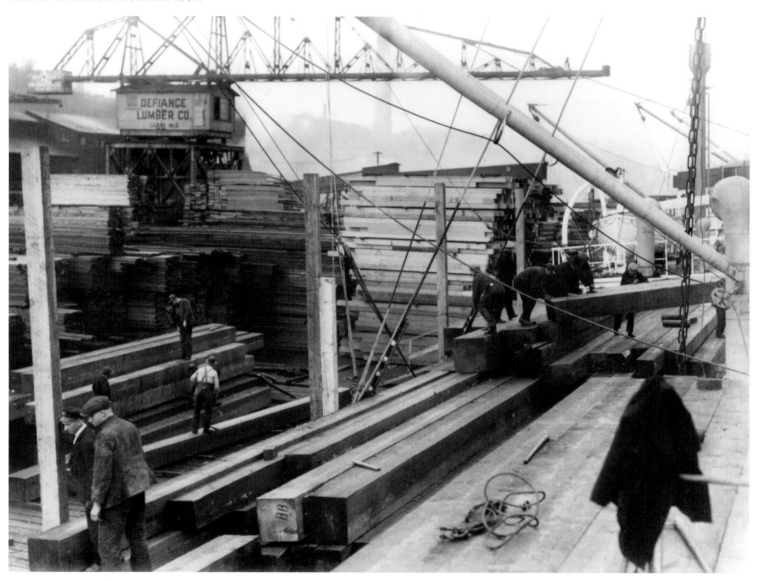

Men cheer on a 1926 Moon Jubilee 6-60 as it goes up South K Street Hill, near Center Street. Made in St. Louis, the automobile sold for under $1,000 and featured, according to ads, European styling adapted to American needs.

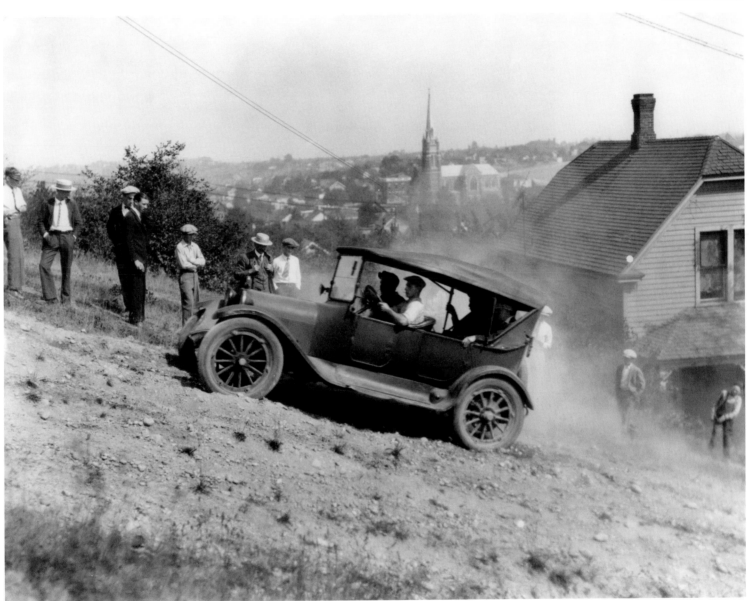

The March 1926 election brought defeat to all City Council incumbents up for re-election. The new council is seated at the table; the defeated council stands behind them. At the head of the table is newly elected mayor Melvin G. Tennent.

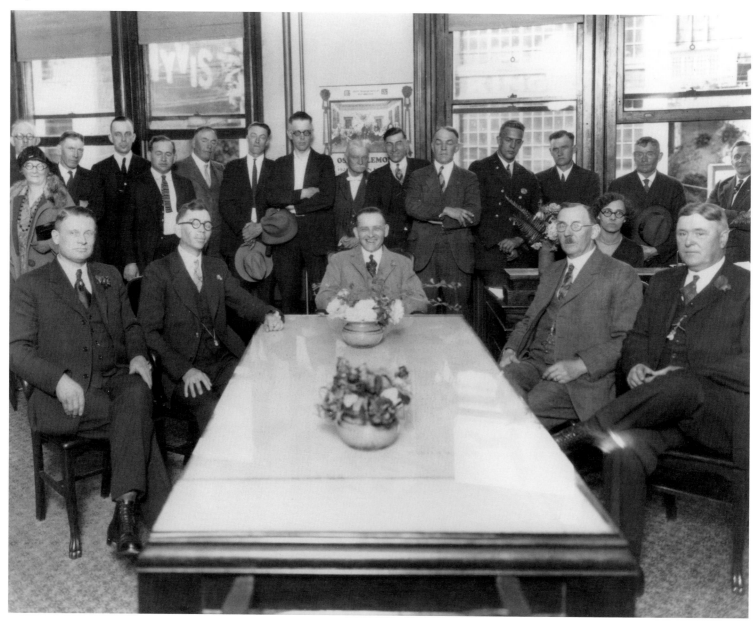

The 800-ton lift span on the Hylebos Bridge is open in January 1926. Costing $80,000 by the time it was completed in 1925, it formed a link between Tacoma and the Browns Point and Dash Point communities in Northeast Tacoma.

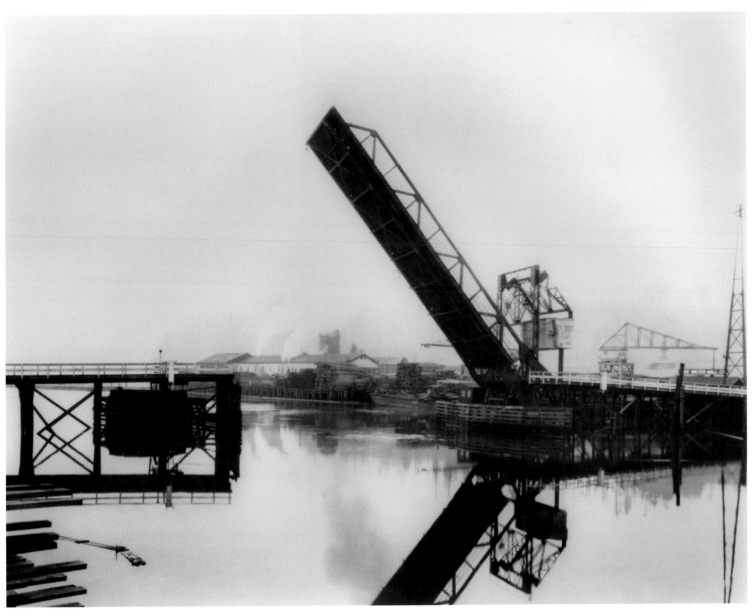

At McKinley School ca. 1926, the pupils of Miss Sawyer's First Grade
Class B display their alphabet cards.

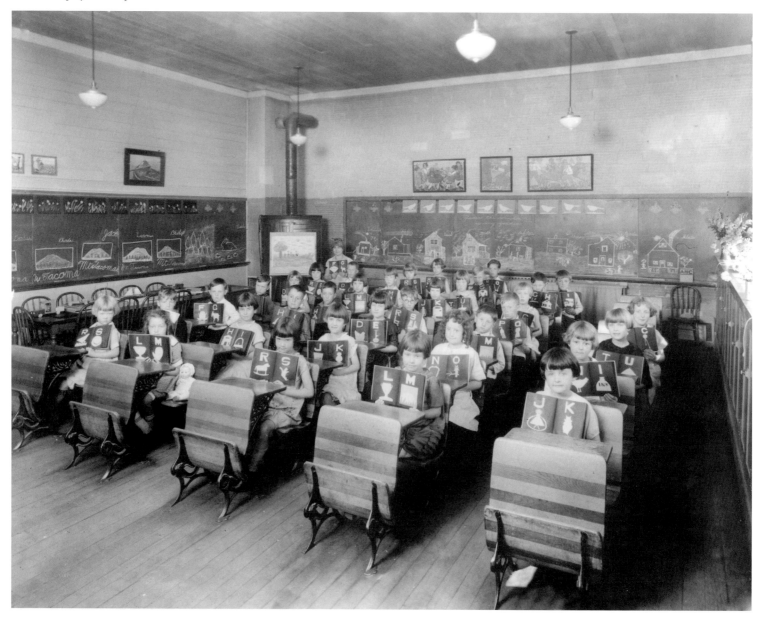

Seven usherettes in bat capes and bat ears line up outside the Rialto Theatre where the silent film *The Bat* was showing in 1926. Left to right are Rose Travaglio, Mary Marko, Lillian Hansen, Ann Brower, Irene Carnahan, Helen Morley (chief usherette), and Florence Lloyd. Theater patrons commented favorably on the costumes.

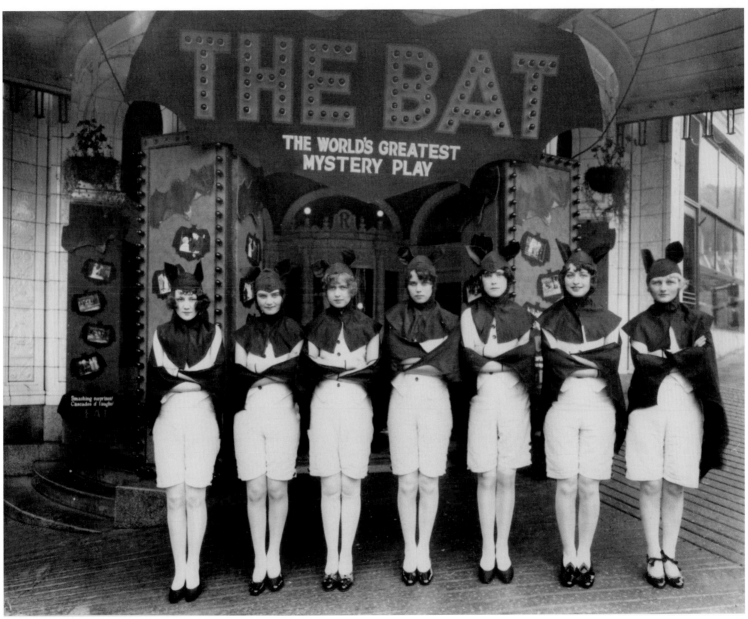

The *Pacific Spruce* was the first vessel to unload cargo at the new dock of the Washington Cooperative Egg & Poultry Association. On April 26, 1927, the ship discharged 360-370 tons of oyster shells.

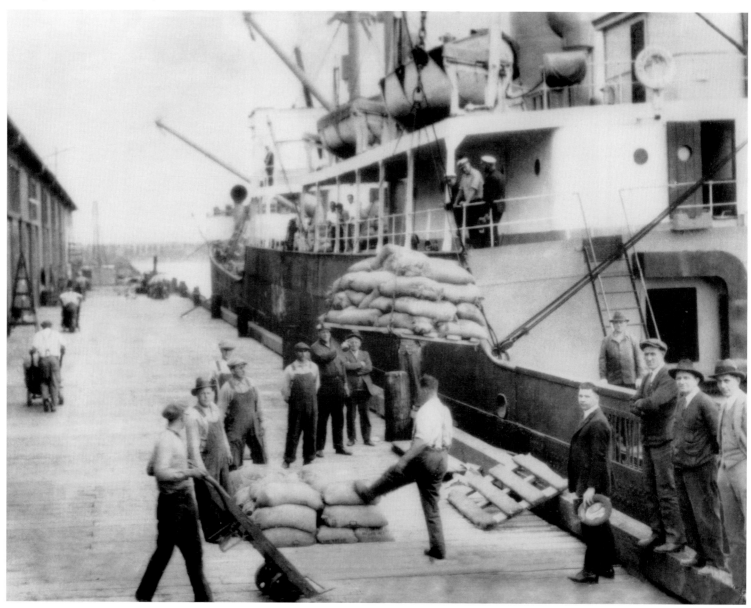

Owned and operated by the Victor brothers, George, Steve, and William, the Pacific Oyster & Fish Co. is open for business in the Crystal Palace Market, at 11th & Market streets, ca. 1927. The Crystal Palace Market opened in June 1927. It was three stories tall and housed 189 stalls and 50 farmers' tables.

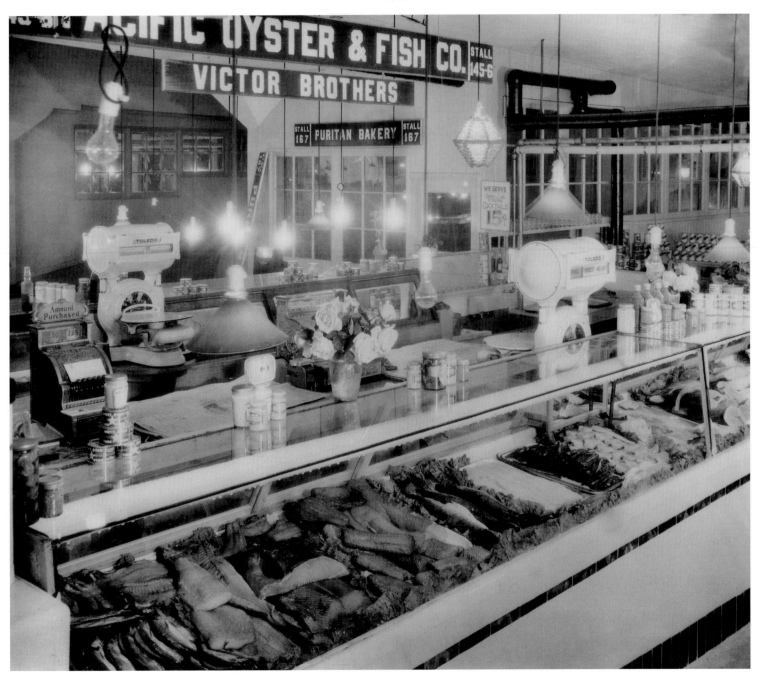

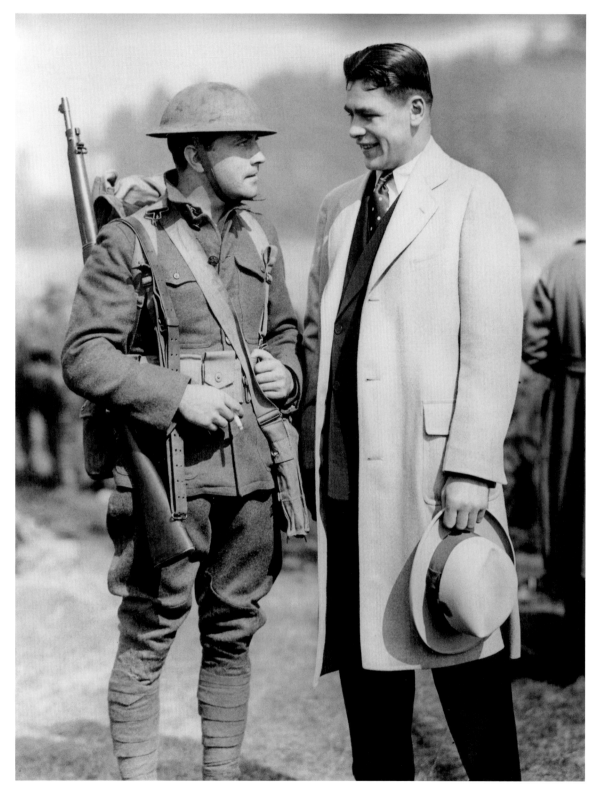

Actor Richard Barthelmess and boxer Harry Dillon take a break during the filming of *The Patent Leather Kid* at Camp (Fort) Lewis on March 29, 1927. Still in his doughboy uniform, Barthelmess shares a moment of conversation with Dillon.

A bird's-eye view of the Wheeler Osgood plant, ca. 1927. Opened in 1889 by George R. Osgood and W. C. Wheeler as a mill, in 1927, the 37-year-old company was the largest door factory in the world. The plant covered 14 acres and employed 1,500 people. The factory closed in 1952 and was demolished in the late 1950s.

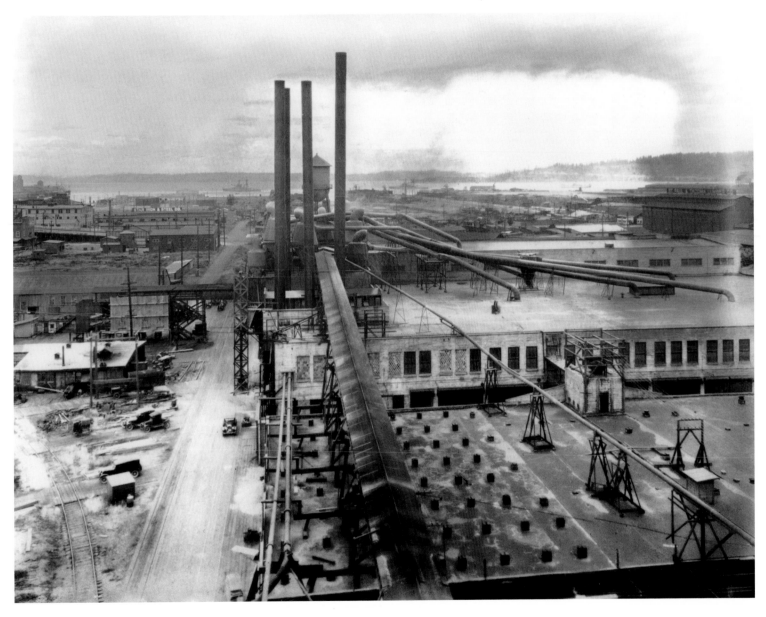

The College of Puget Sound Track Team, ca. 1927. The small team scored well in competition. In the top row are Van Patter, Wallace, Norton, Wilson, Darrow, Pugh, and Smith. Kneeling are Fassett, Carruthers, Gamero, Captain Gordon Tatum, and Hendel.

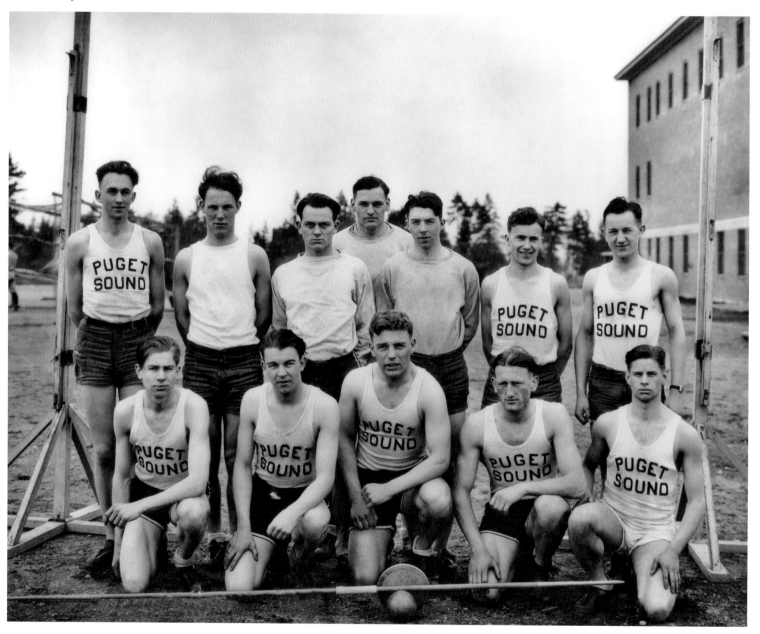

On February 2, 1927, Mayor Melvin G. Tennent and several commissioners joined throngs of Tacomans coming to see the giant Great Northern electric locomotive #5007 on display at Union Depot. The latest and greatest "Iron Horse" had an overall length of 94'4" and a total weight of 715,000 pounds. A banner on its side proclaimed it to be "the most powerful motor-generator electric locomotive ever built."

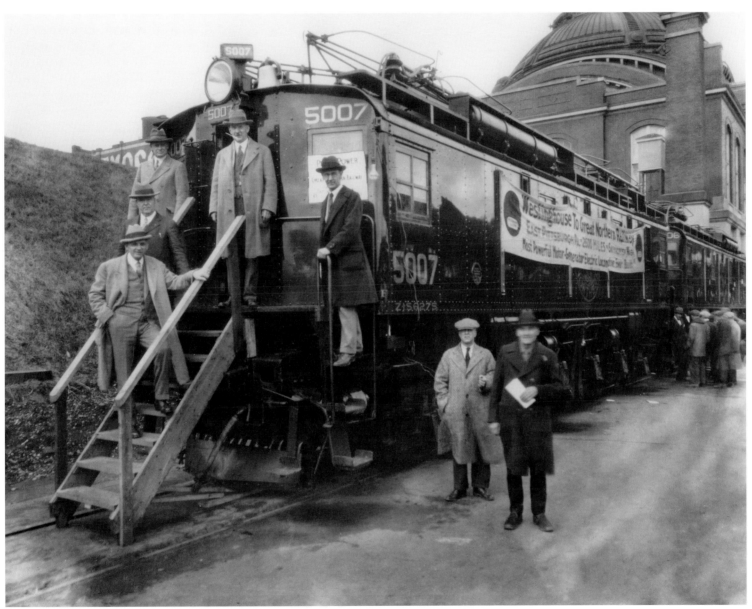

On July 17, 1928, Summer E. Orr and E. J. Gauthier, proprietors of Gauthier & Orr all-night garage, receive a lease for six Union Oil stations from company official, E. C. Wilson, and N. W. Watson, special agent.

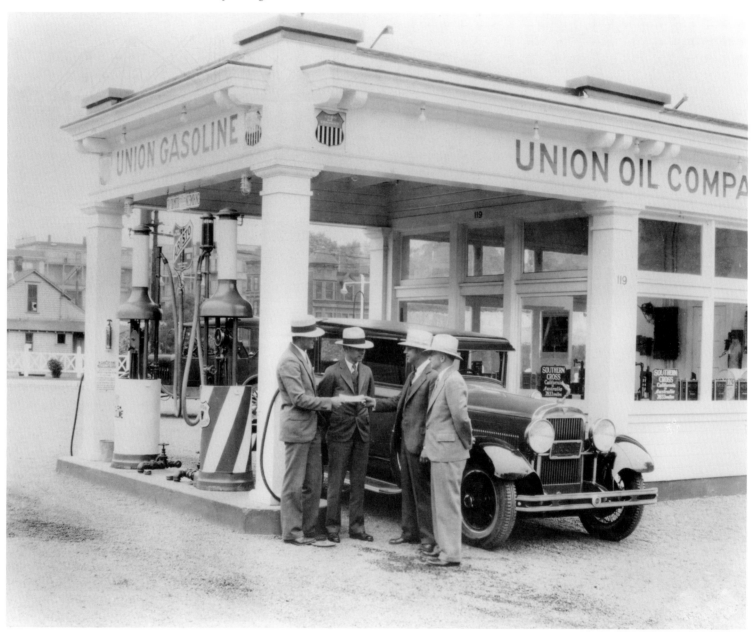

Pilot Harold Bromley and a second man, probably his benefactor, industrialist John Buffelen, stand next to Bromley's Lockheed Vega monoplane, *City of Tacoma*. They hold a map charting Bromley's proposed 4,700-mile non-stop flight from Tacoma to Tokyo. The plane would never leave the ground, crashing on take-off.

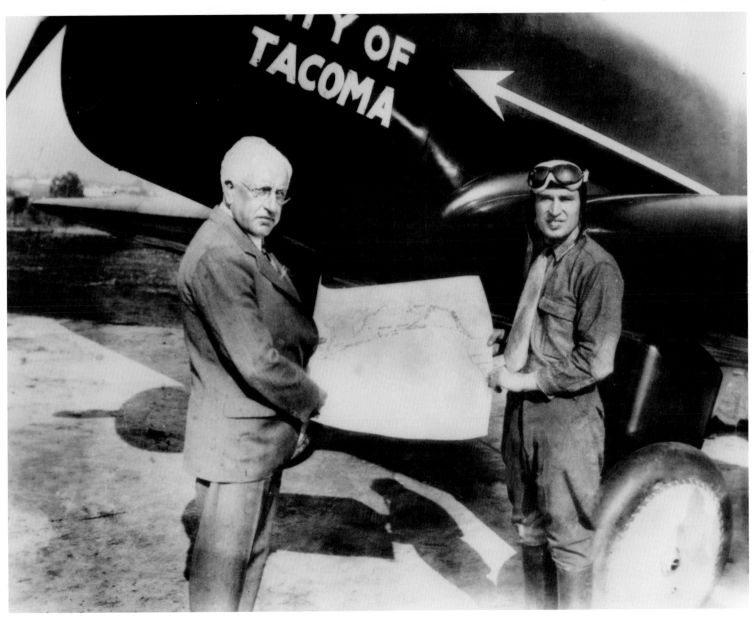

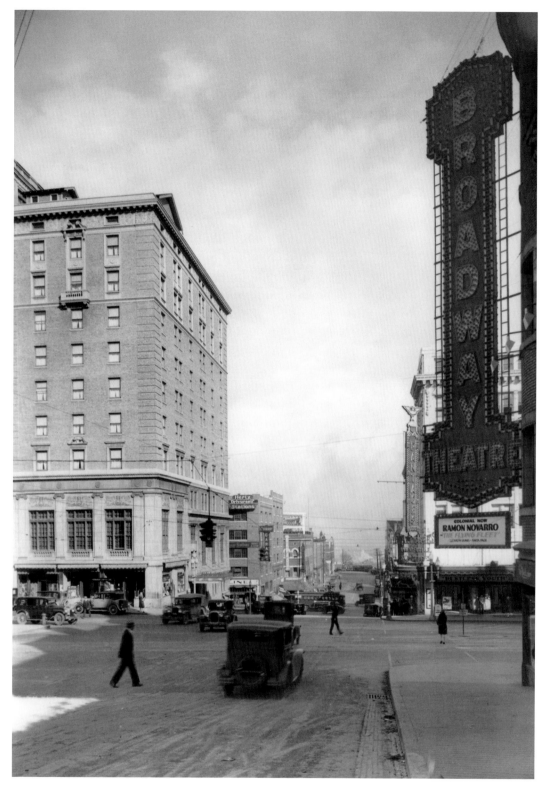

Facing east on 9th Street. The marquee of the Broadway Theatre is visible at right; the Winthrop Hotel at left.

Olga Johnson drops a donation in the kettle of Salvation Army member Nicholas Rody on December 18, 1929, at the corner of 11th and Commerce. The aptly named Nicholas, sprouting his Santa Claus beard, jingled a Salvation Army bell for four years.

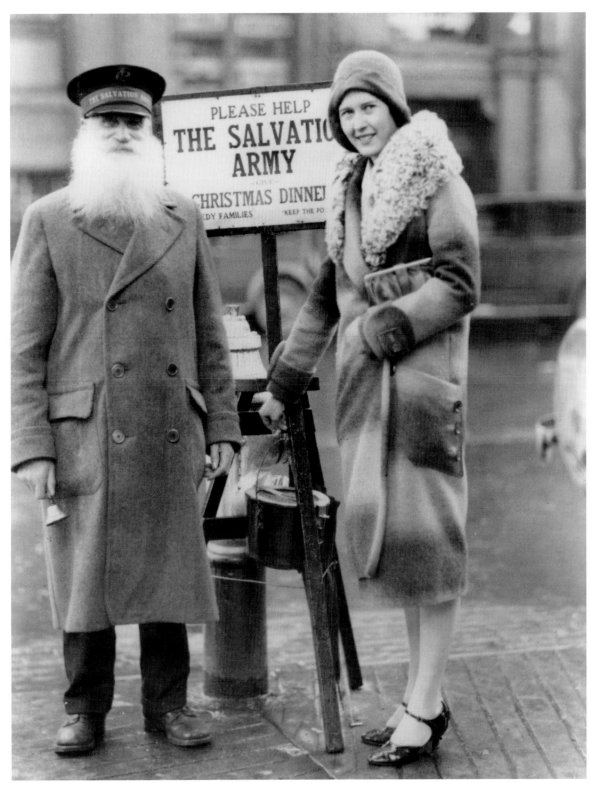

Passenger plane service, 1930s-style.

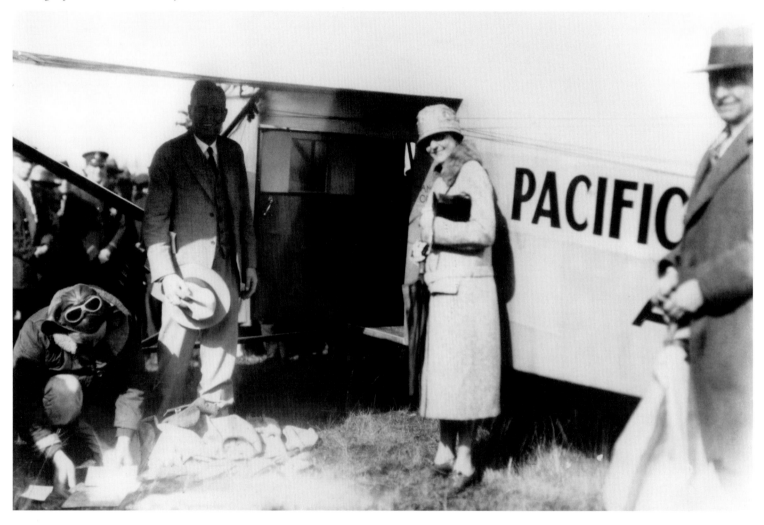

Inside the "Happy Days Here Again" Beer Parlor, only men are admitted to the "Gentlemen's Service" area, where they are free to drink, smoke, and tell off-color jokes. Located at 1302 Broadway, the bar proffered beverages to both sexes.

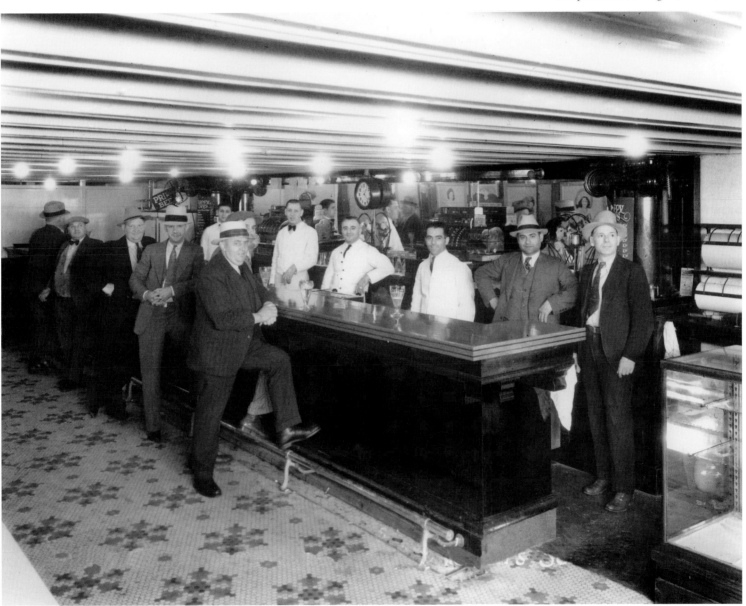

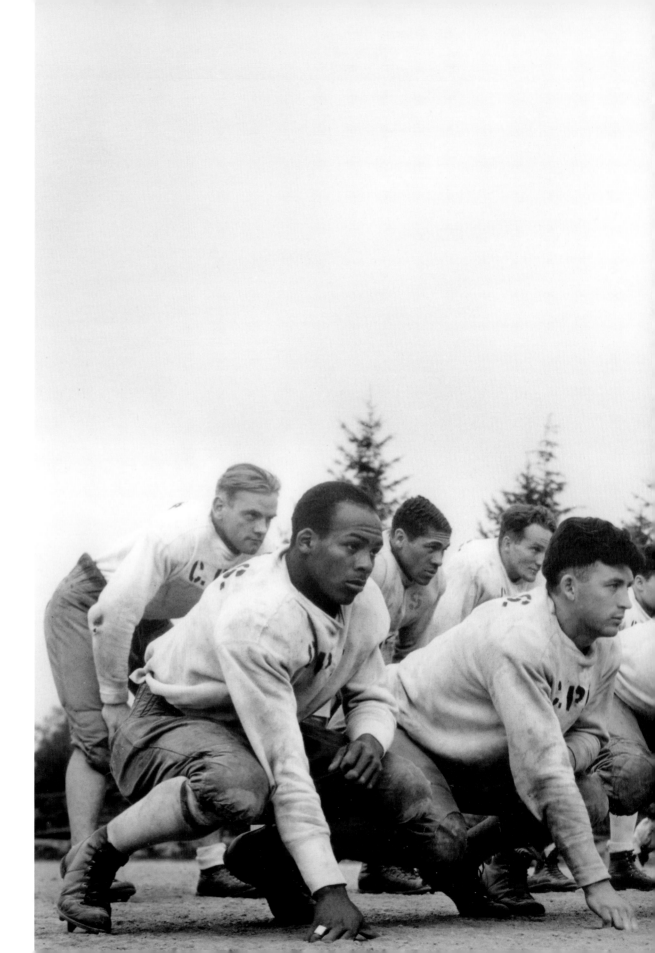

The College of Puget Sound football team lines up for the 1934-35 season. The team included two African American players, Brennen King and Jess Brooks. Brooks was a 1932 graduate of Lincoln High School, where he was the first black student to win the coveted Richard Graff award for high scholastic achievement and athletic prowess.

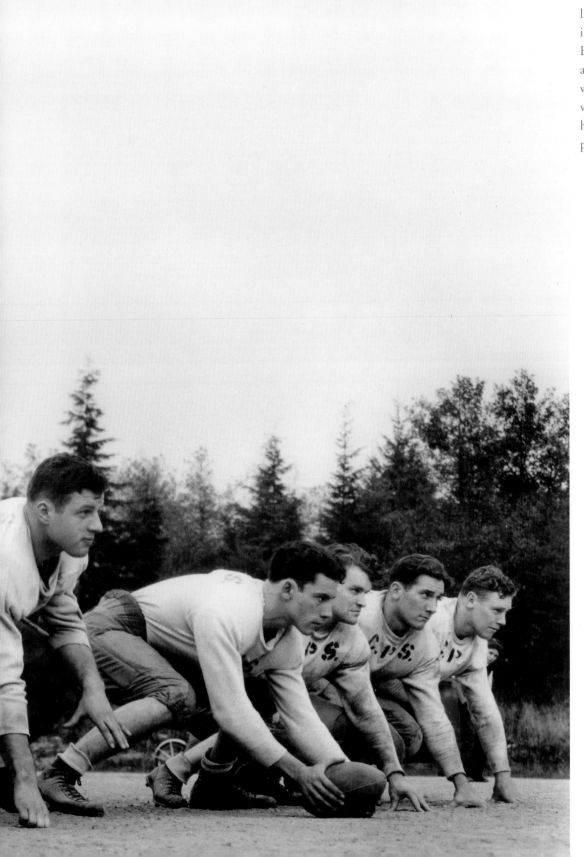

Three members of Tacoma's Junior League examine merchandise in the jewelry and cosmetics department of Fisher's Department Store at 1102 Broadway. Their goal is to prepare for the League's fund-raiser at the store on September 8, 1935, when about 50 League members will work alongside the store's regular employees for a day. A percentage of the day's proceeds are to be donated to Junior League charities.

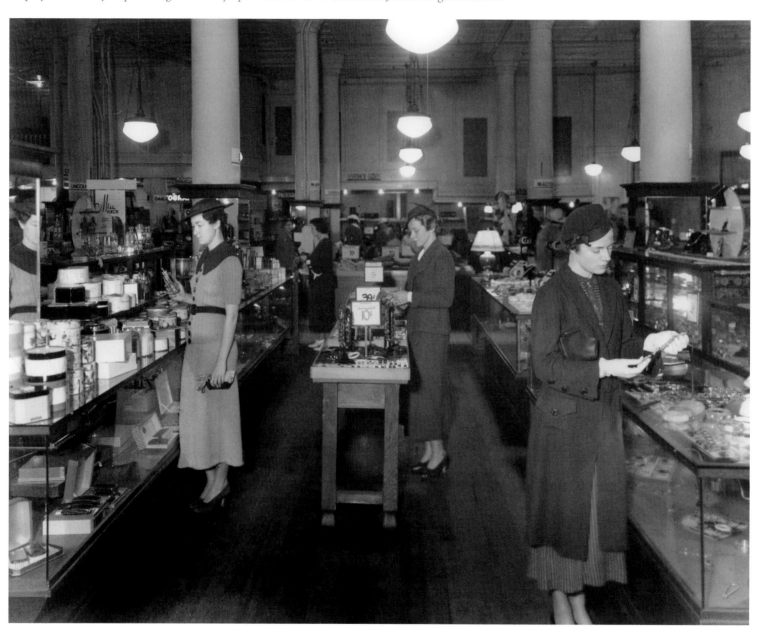

The kidnapping of nine-year-old George Weyerhaeuser on May 24, 1935, becomes a national story as reporters converge on the Weyerhaeuser home at 420 North 4th Street. A $200,000 ransom secured his release on June 1. The kidnappers were apprehended shortly thereafter.

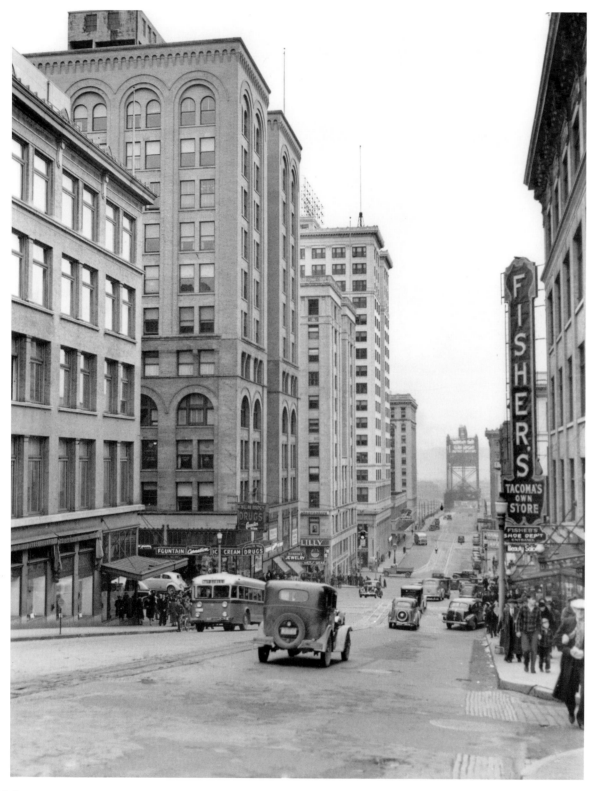

A view of Tacoma from Court C facing 11th Street toward the Murray Morgan (11th Street) Bridge in February 1939. Fisher's Department Store is on the right. On the left descending the hill are Rhodes Department Store, the Fidelity Building (demolished in 1949 to make way for the F. W. Woolworth Building), the Rust Building, the Washington Building, Kegel's, and the Tacoma Building. Bus service has replaced the 11th Street cable car, which ended service in 1938.

Tacoma postmaster George Fishburne presents the Eastern Airlines silver trophy to three postal carriers, (left to right) Rollin Ogilvie, Jesse Webster, and Everett J. McAllister. The trophy was awarded for airmailing an arrangement of flowers the longest distance to the National Airmail Flower Show in Milwaukee, Wisconsin.

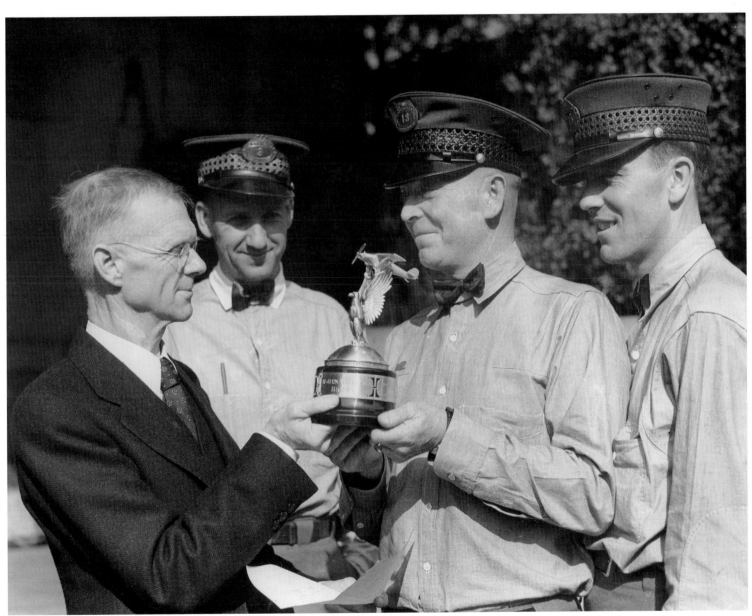

The Washington National Guard uses tear gas and fixed bayonets to halt striking
lumber mill workers at the corner of South 11th and A streets on July 12, 1935. The
Guard had been called out by Governor Clarence Martin to protect replacement
workers hired to help break the strike.

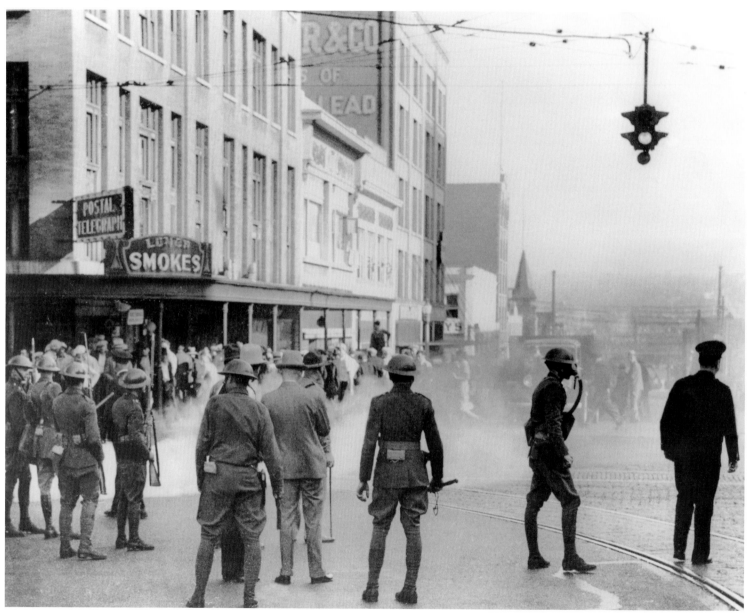

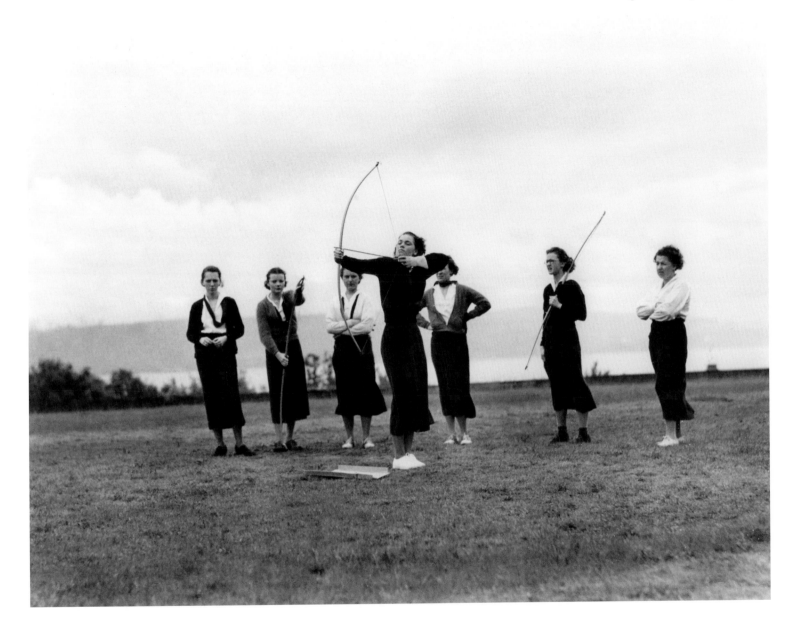

Students practice their archery skills on Field Day at Annie Wright Seminary in May 1936.

A shore patrol unit from the U.S.S. *San Francisco* greets visitors as they
board a military motorboat, used for ferrying visitors from the Municipal
Dock to the battleship for tours.

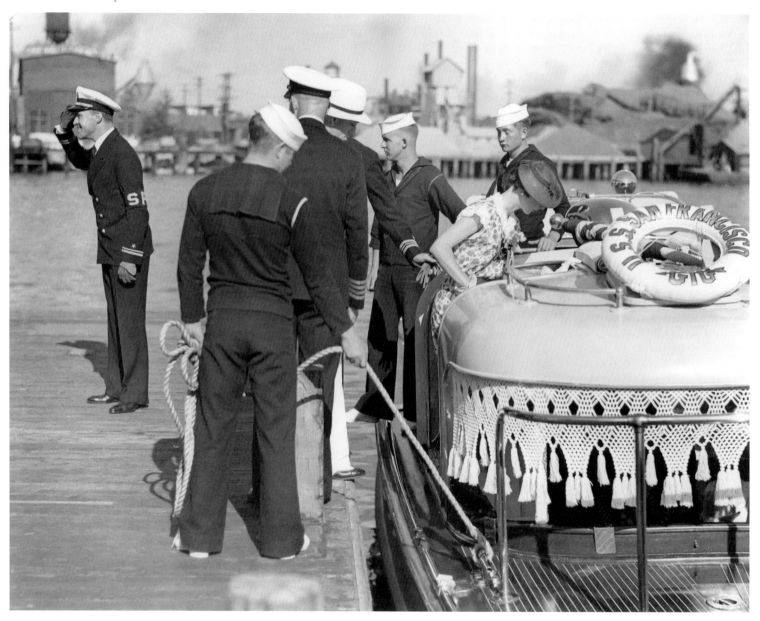

Employees of a new restaurant pose for the photographer. The eatery features elaborate wood and leaded glass cabinetry, a sculptured-tin ceiling, and arcaded windows with Corinthian columns.

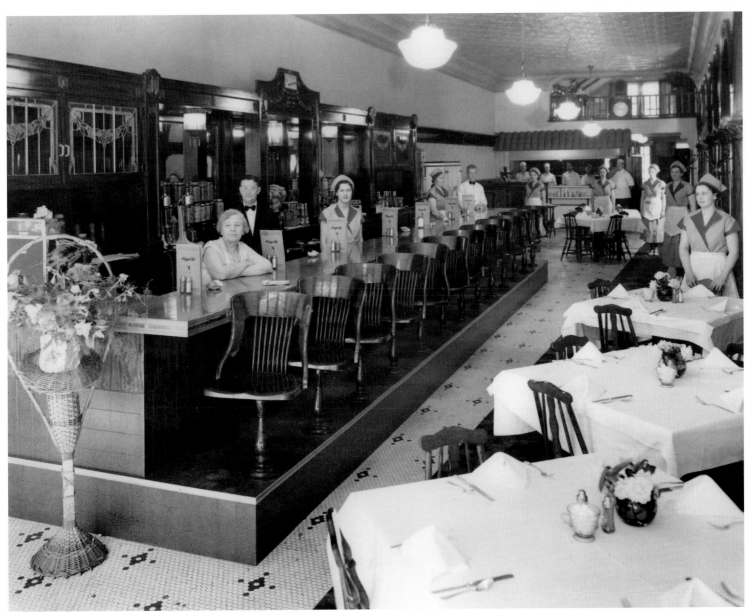

The *Diamond B,* a Foss Tug and Barge tugboat, tows a barge loaded with a
large crane. Another tug pushes the barge from behind.

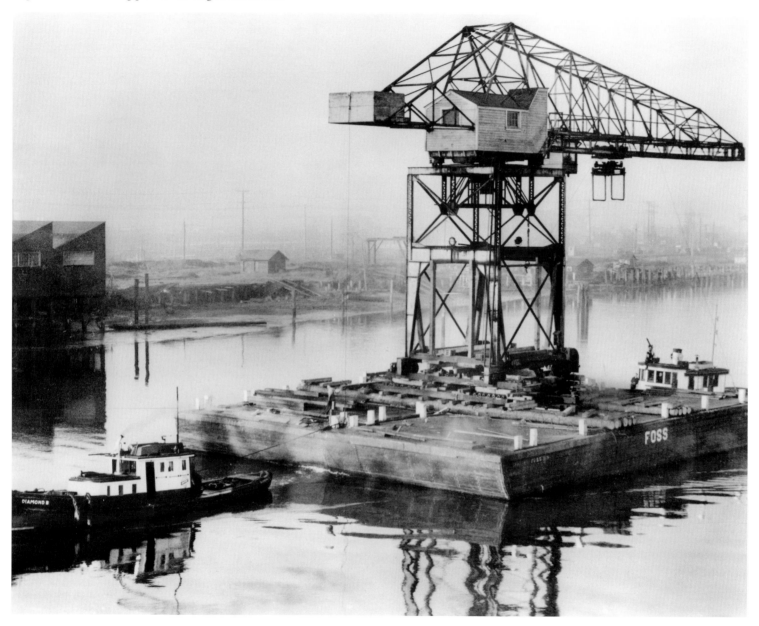

Doctors and nurses prepare the operating room for the arrival of their patient at Tacoma General Hospital in 1936.

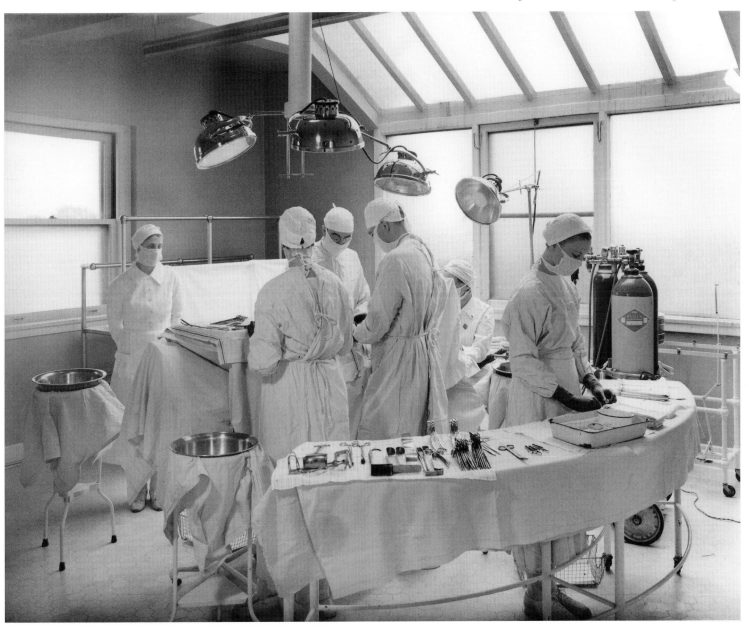

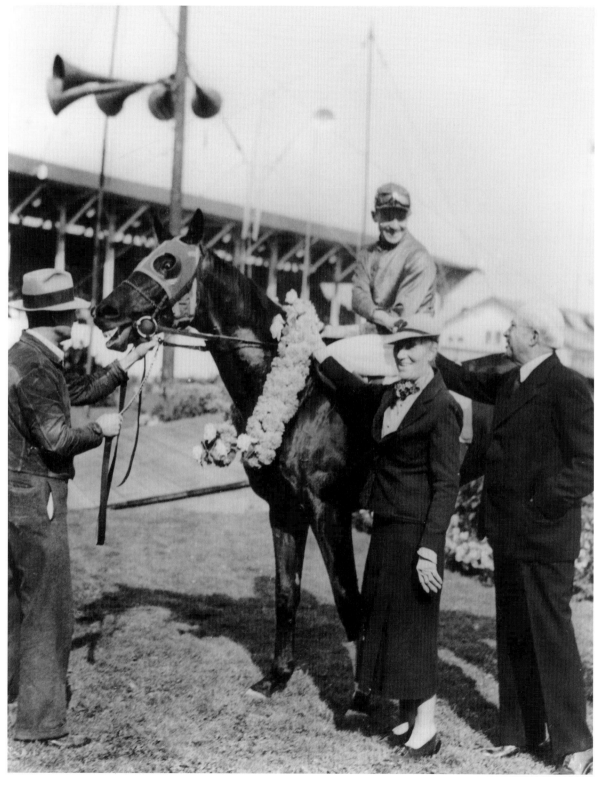

Mayor George Smitley and Mrs. Smitley congratulate the jockey after a horse race on Tacoma Day at the Western Washington Fair in Puyallup on September 22, 1937. The winner of the feature event, a one-mile race, was Premium Jim, taking home a $200 purse.

126

A view of Tacoma's busy commercial center on Pacific Avenue at 11th Street, February 2, 1937. Shoppers queue up to board one of the city's 95 buses operated by Tacoma Railway & Power.

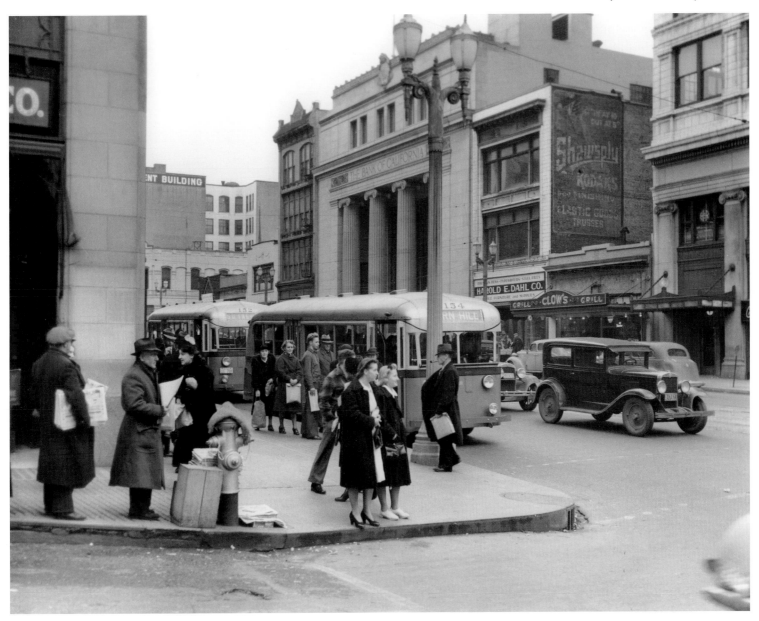

After Tacoma's streetcar lines ended service in April 1938, many of the rails were removed from the streets. Here workers use a special lever to pry up rails along Pacific Avenue. A group of "sidewalk superintendents" gathers to watch the activity.

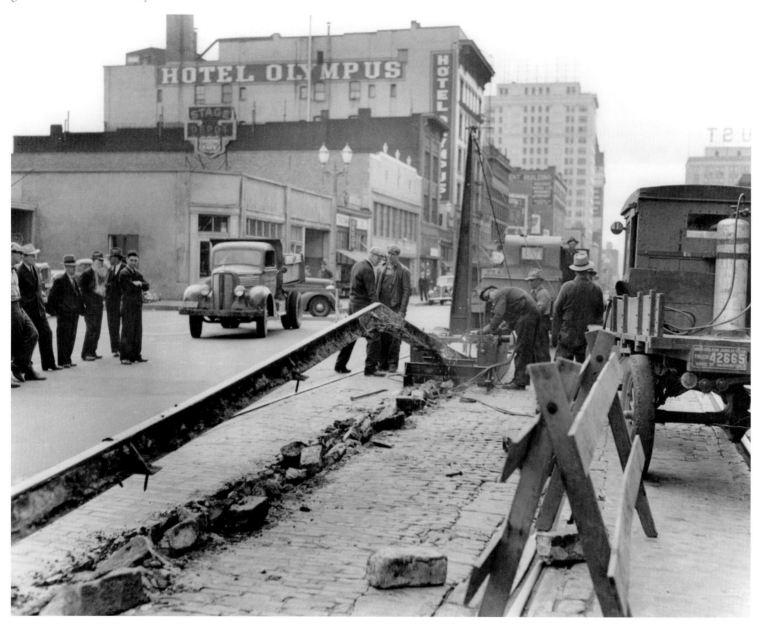

In this view facing north from South 13th Street, a newly paved Pacific Avenue holds a grand opening. Banners overhanging the street herald the upcoming Golden Jubilee parade.

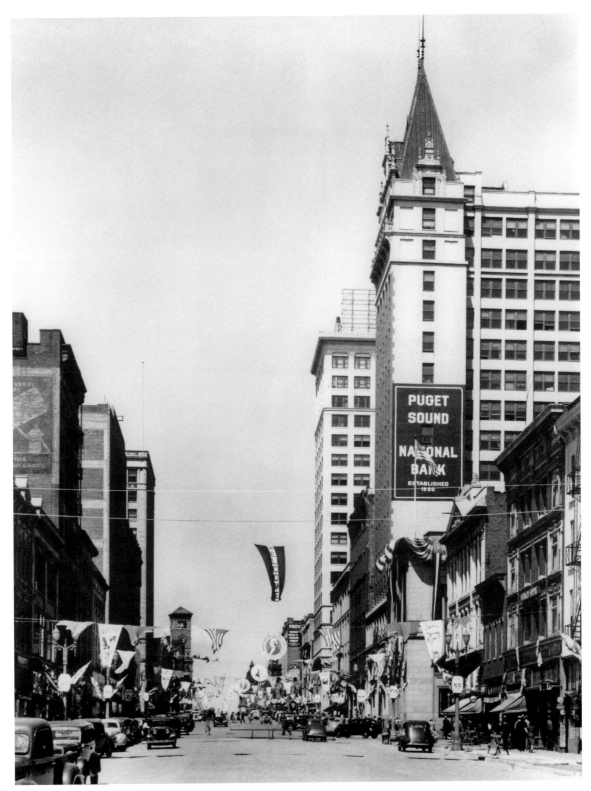

Bystanders inspect the damage following a mishap at the Goodrich Silvertown Stores on August 29, 1939. A 6-ton truck carrying 3 tons of groceries lost its drive shaft and brakes descending 32nd Street. The truck hit a fire hydrant, demolished a shed, uprooted a gas pump, and flung debris through a plate-glass window. Two persons were injured, but not seriously. Union Station rises in the distance.

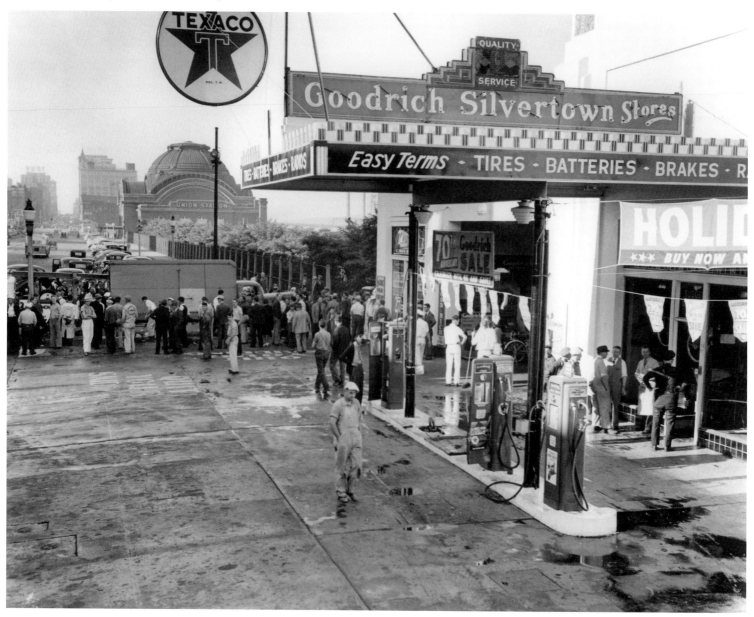

Nearly 1,200 Rainbow Girls from around the state met in Tacoma from July 12 through July 15, 1938. Representatives are seen here marching down St. Helens and Broadway, past the Bostwick Building at 755-71 St. Helens, which housed the Kress Malted Milk Shop. A picnic in Point Defiance Park concluded the event.

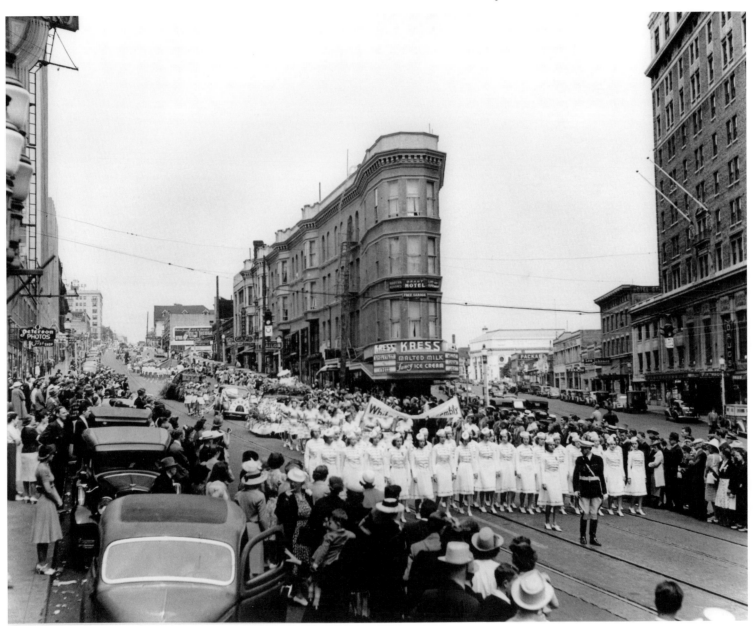

At the College of Puget Sound, students of Professor McMillin's mineralogy night school class listen attentively while examining rock samples.

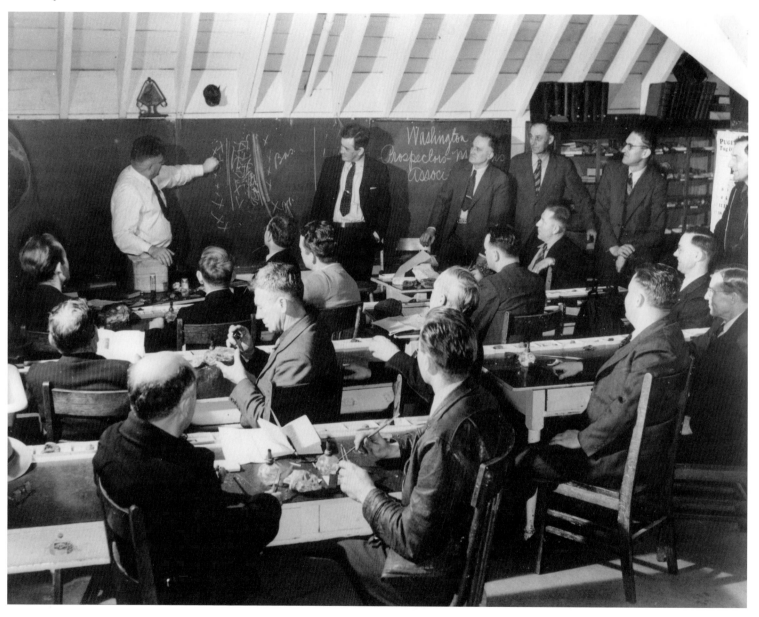

Downtown Tacoma is decorated for Christmas 1938 at 13th and Broadway in this view facing north. The neon signs of Sears, Roebuck & Co. and other stores reflect off the wet pavement and a pair of streetcar tracks.

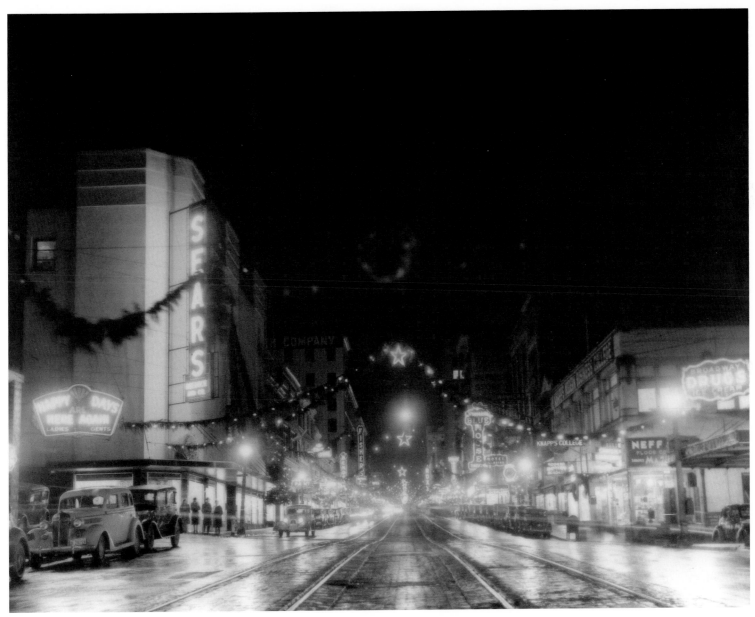

News photographer Howard Clifford escapes the Tacoma Narrows Bridge just before it collapses and plunges into Puget Sound in 1940. A cocker spaniel was the only fatality.

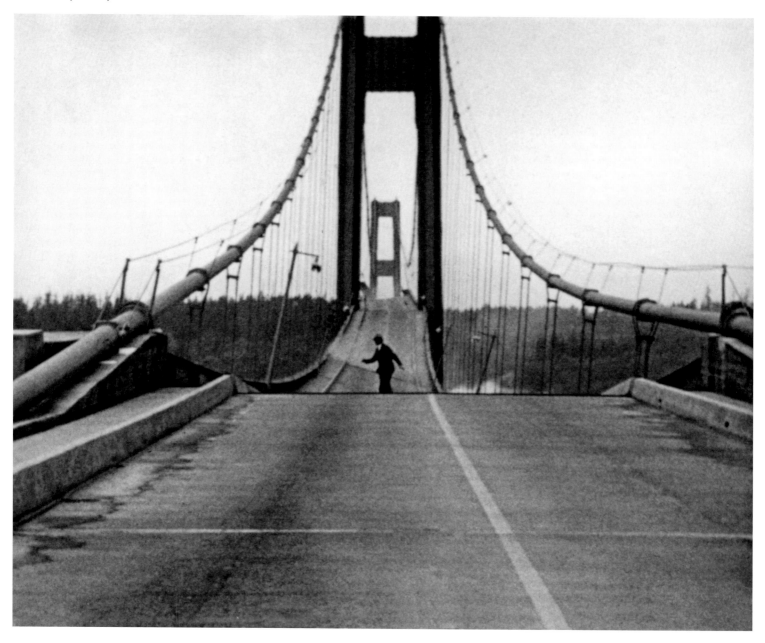

THE WAR ERA TO RECENT TIMES

(1940–1969)

The decade got off to an ominous start with the collapse of the Tacoma Narrows Bridge, nicknamed "Galloping Gertie," on November 7, 1940. While the city came to grips with the war raging in Europe, the Japanese attacked Pearl Harbor on December 7, 1941, a day President Roosevelt correctly identified as one that would live in infamy. Soon America was deeply involved in World War II.

Always a boat-building city, Tacoma became a dynamic producer of warships and minesweepers during the early 40s. When the war was over the city's beloved Top of the Ocean, a restaurant that resembled a ship and was the last word in swank, opened on Ruston Way featuring a live dance band.

In 1945 Betty McDonald's novel *The Egg and I* became a best-seller, and then a Hollywood movie starring Claudette Colbert and Fred McMurray. Gretchen Frazer, in 1948, became Tacoma's first Gold Medal winner at the Olympics in St. Moritz, Switzerland. And the new Narrows Bridge, "Sturdy Gertie," opened in 1950.

KTNT-11, Tacoma's first TV station, became operational in 1953. In 1956 Tacoma was honored as an "All American City" by the national Municipal League and Look magazine. Also that year Bert Thomas became the first man to swim from Seattle to Tacoma. The former Marine frogman swam 18.5 miles in 15 hours and 20 minutes. He was too exhausted and cold to speak when he arrived on the shores of Commencement Bay.

In 1966 Weyerhaeuser announced that their new $10 million headquarters, designed by Skidmore Merrill and Owens's San Francisco office, would be built in Federal Way, thoroughly devastating Tacoma's hopes that the dynamic corporation would remain in the city, where they had risen to international prominence.

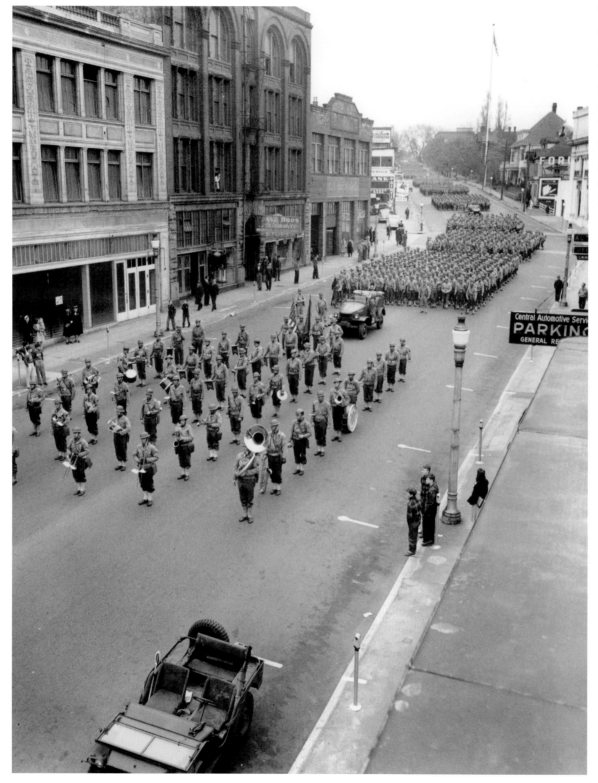

Tacoma was host to the first wartime parade through downtown Tacoma on April 6, 1942, the 25th anniversary of the U.S. entry into World War I. A full regiment of infantry in steel helmets, packs, and gas masks marched behind a military band.

One of the main attractions of the Fourth Annual Young Men's Business Club Water Carnival of 1941 was a "battle" staged by troops from Fort Lewis and McChord fields. Landing boats hit the shore in Point Defiance Park as a trio of bombers roared in and "strafed" the beach. Wading to shore were 312 fully equipped soldiers, who had to fight a second force of soldiers defending the park. Noisy, but harmless ammunition was used.

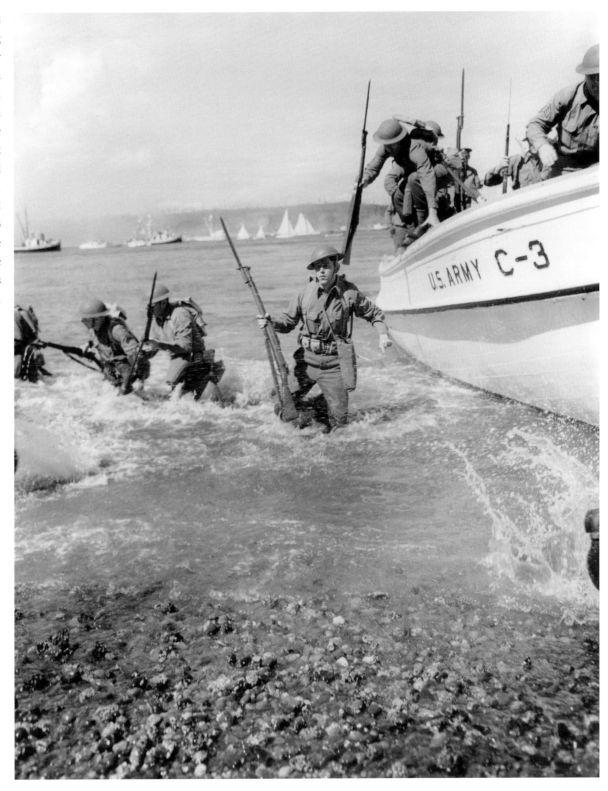

One of the three Army B-25 Mitchell medium bombers that participated in the "strafing" and "invasion" of Point Defiance Park on June 15, 1941, during the Fourth Annual Young Men's Business Club Water Carnival.

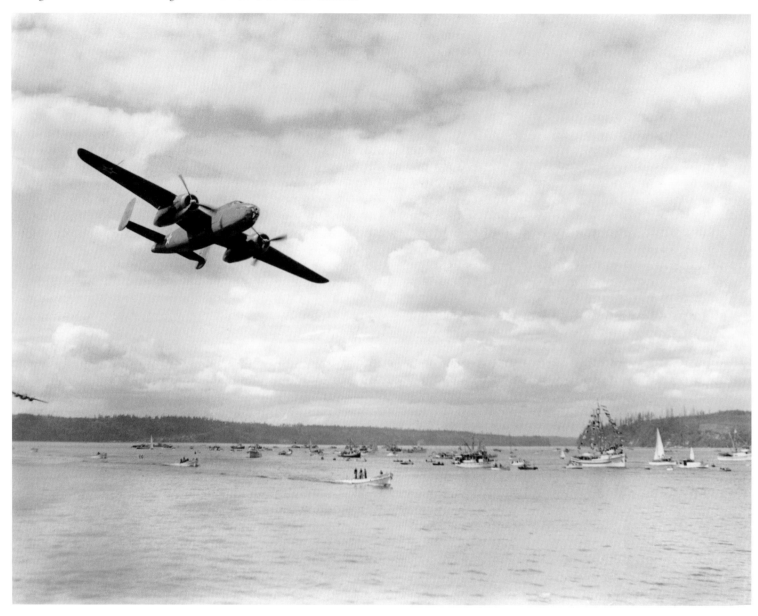

Johnny Sheffield, who starred as "Boy" in the Tarzan films of the era, serves the war effort as a bond salesman for Uncle Sam. Citizens purchasing war bonds would be permitted to board the Army tank. During Sheffield's visit, cub scouts presented him with a scrapbook of Tacoma.

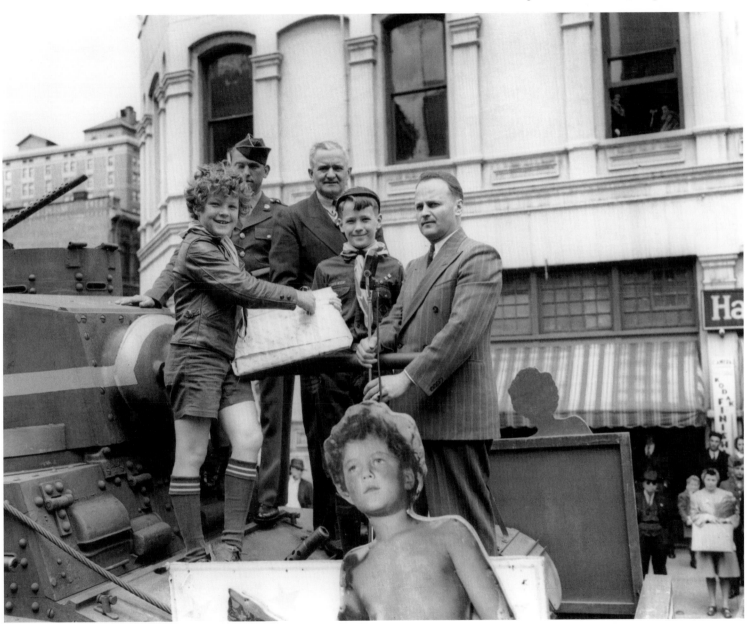

Hollywood's Lana Turner, right, appears with Mayor Harry Cain and her mother in a 1924 Lincoln Touring car during the actress's visit to Tacoma for a War Bond rally. Turner sold more than $120,000 in war bonds in 24 hours.

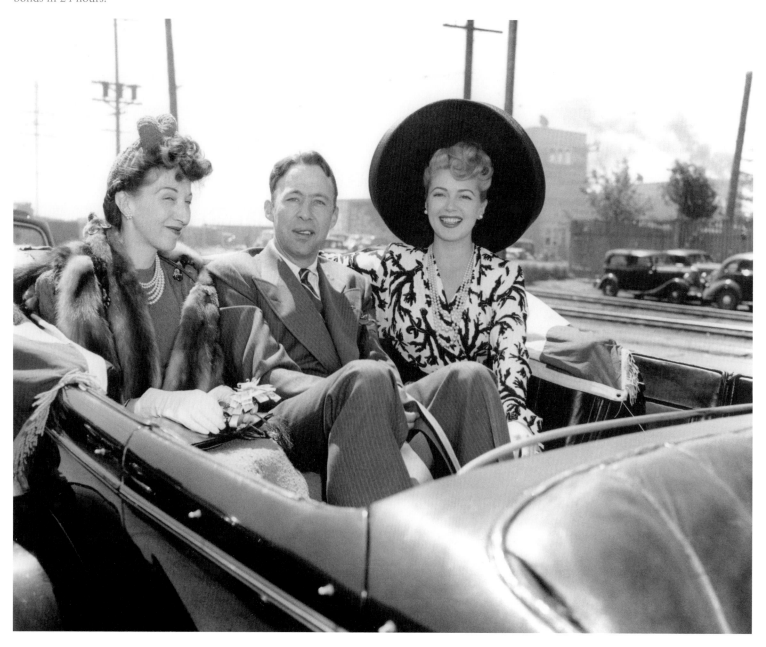

A Surrender Day Parade is held August 15, 1945, on Pacific Avenue, the day after the Japanese surrendered, ending World War II. Four platoons from Fort Lewis highlighted the event. People yelled, horns honked, and bits of paper poured down from business buildings.

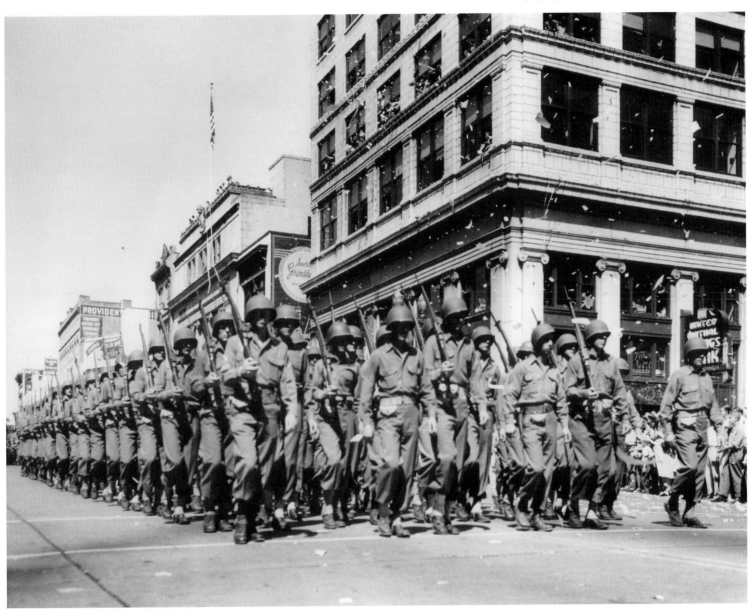

Three newsboys for the Tacoma *Times* receive a late-afternoon edition from District Manager Ken Hagen. In 1944 the Times printed five editions daily to keep up with breaking news from the war. The boys (left to right) are Jim Olson, Melvin Merchant, and Bill Hergert.

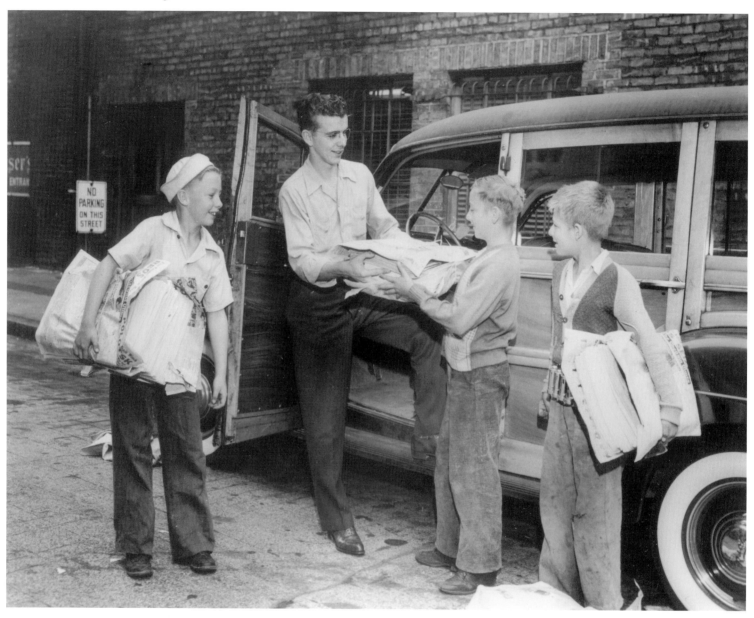

J.C. Penney Christmas party at the Olympus Hotel in downtown Tacoma in 1945. Santa also attended the party.

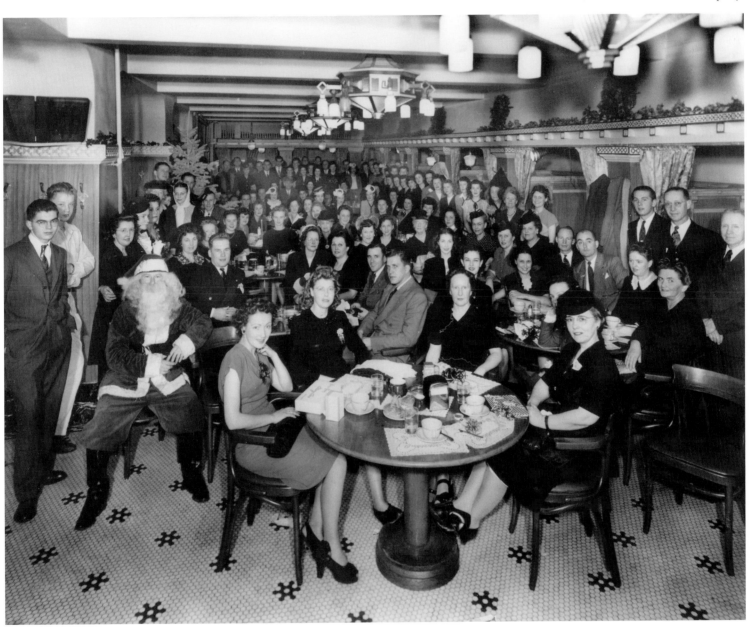

The neon marquee for Murphy's Cigars, Cafe, and Tavern at 938 Pacific Avenue sweeps out over the sidewalk in 1946. The facade is built of glass blocks, popular at the time.

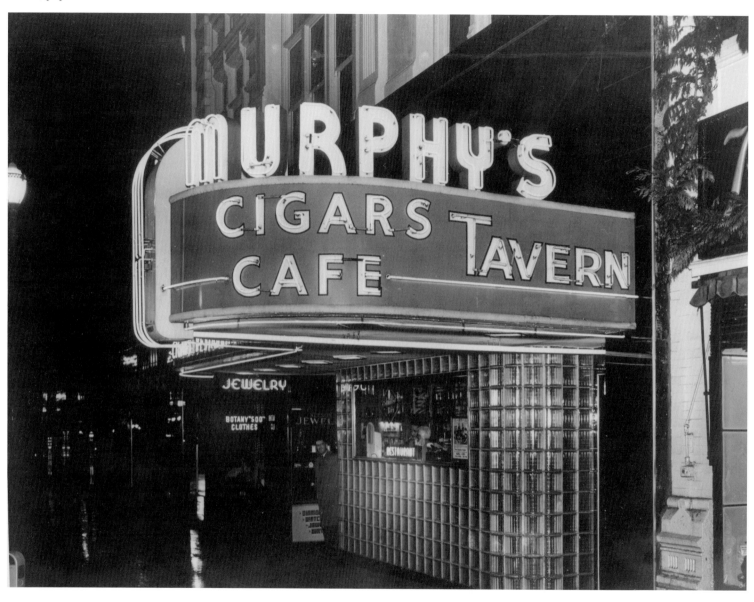

Vincent Hansen's funeral service was held at the C. C. Mellinger funeral home,
November 27, 1946. Hansen, a 35-year-old patrolman, died of kidney ailments
attributed to yellow fever contracted overseas during his service in World War II. Nearly
the entire Tacoma police department turned out for the funeral.

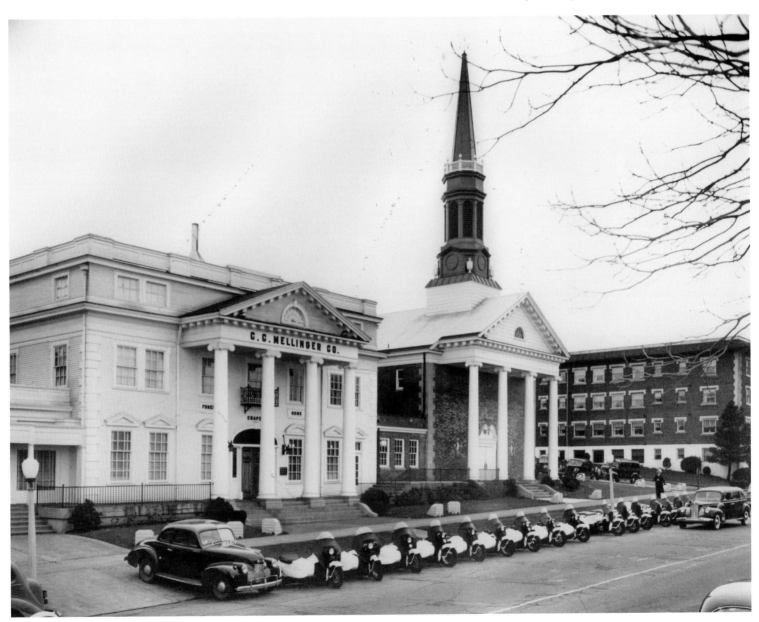

Popular daytime announcer Arnold Benum sits behind the microphone in KMO's broadcast booth in November 1946. To his right are three large transcription turntables that could play discs up to 16 inches in diameter. The studios were downtown, near the corner of 9th and Broadway.

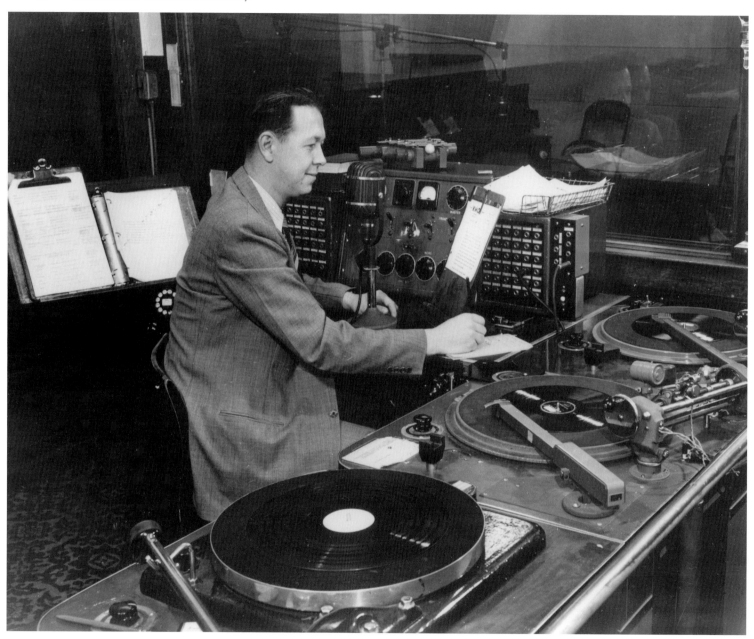

In view here is the east side of Broadway from the Blue Mouse Theater to South 11th Street. John Hamrick's Blue Mouse, at 1131-33 Broadway, was the first movie theater in Tacoma to show "talkies." It was demolished in 1960 during urban renewal to make way for Tacoma's experiment with "moving sidewalk" escalators. At the theater, Claude Rains and Vivien Leigh star in *Caesar and Cleopatra*.

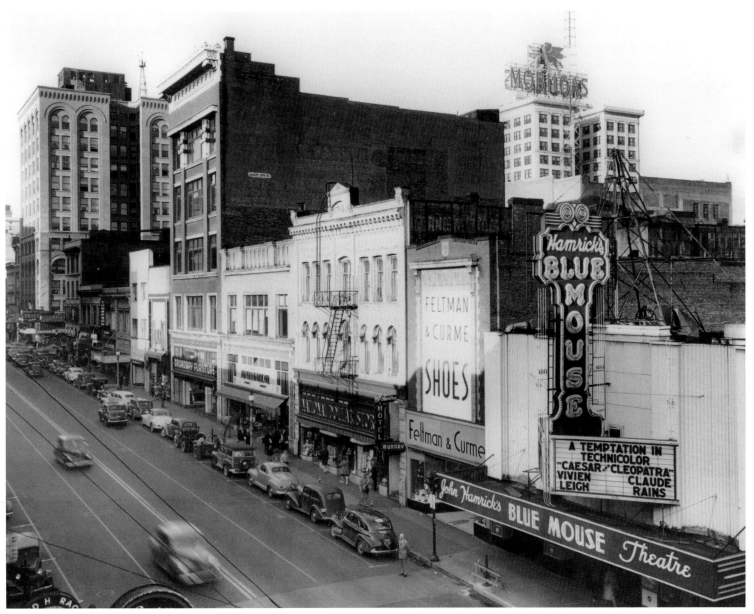

The annual Shipmates' Tea and Style Show was held at the Tacoma Yacht Club. Shipmates wear a variety of clothing to show how swimwear has changed over the years. The *Santa Rosa* belonged to Jewell and Edna Lerum, a member of Shipmates.

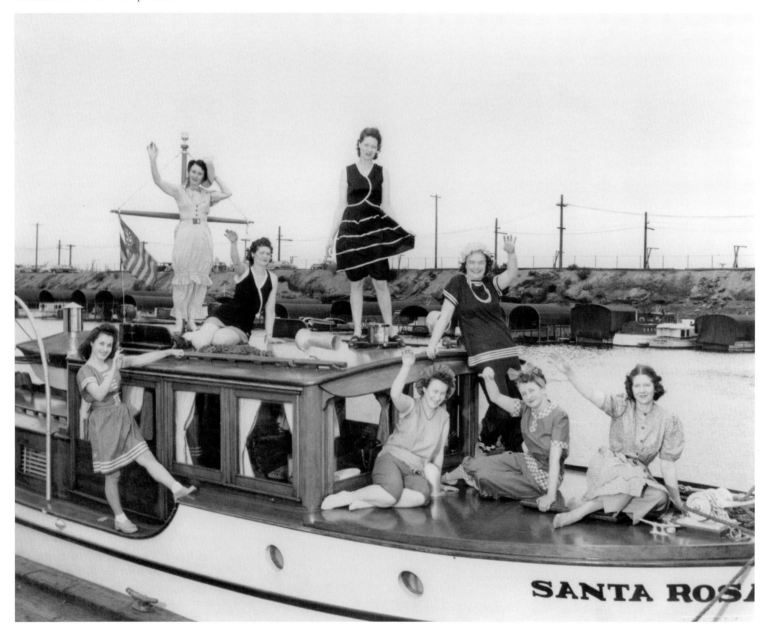

Bicycles are awarded to five boys in front of the Tacoma Times building at
919 Market Street on September 6, 1947.

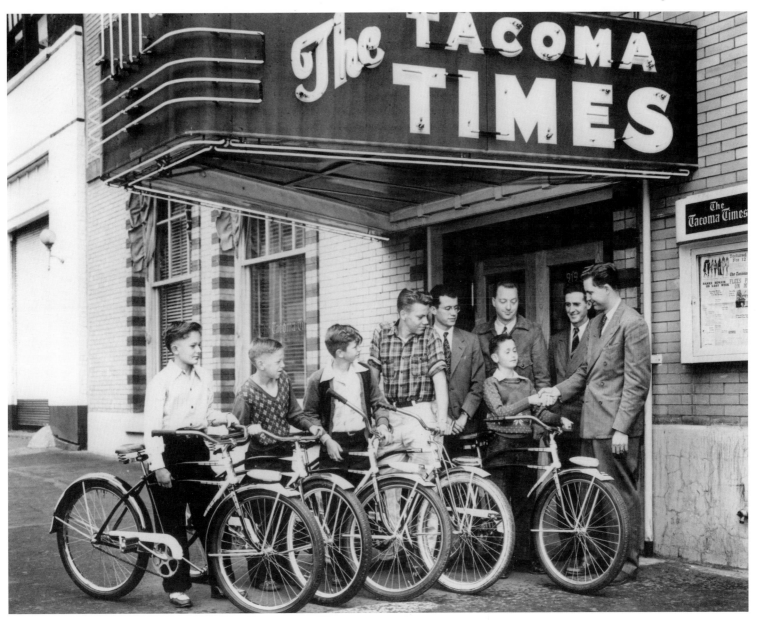

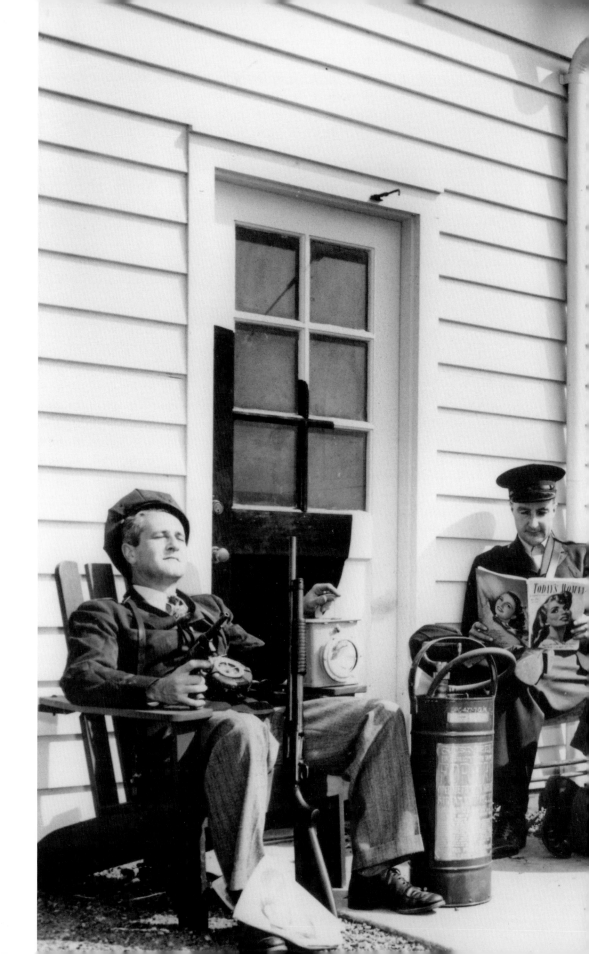

150

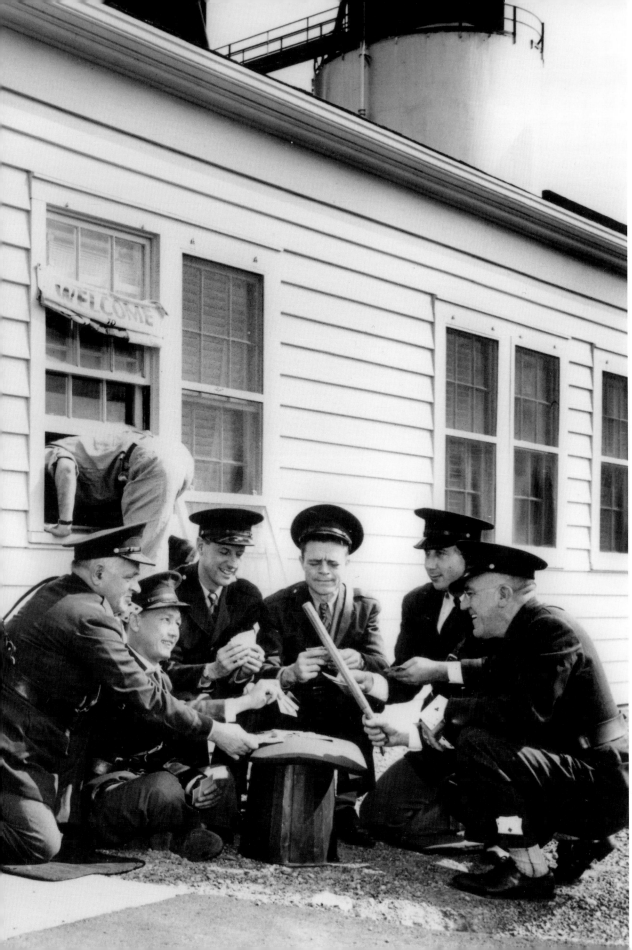

Security guards at Kaiser aluminum plant ham it up for the photographer during a break in September 1947. It appears that an uninvited guest is taking advantage of a "Welcome" sign, unbeknownst to the guards, who are preoccupied with off-duty "diversions."

A delegation of 22 business leaders from Honolulu visits the Pacific Northwest in August 1947 to help foster trade and support for Hawaii statehood. A full schedule of activities was organized for the visitors, including a trip to Mount Rainier, Olympia, and Carstens Packing Company on the tideflats. At Carstens, the delegation enjoys a ride in a horse-drawn wagon as several staff members look on from rooftop.

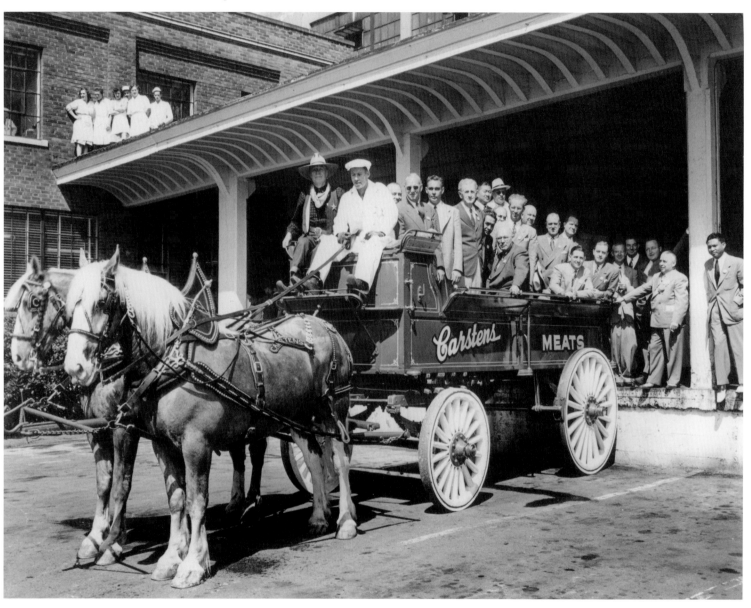

In 1947, new traffic signals are installed on Pacific Avenue in front of Union Depot.

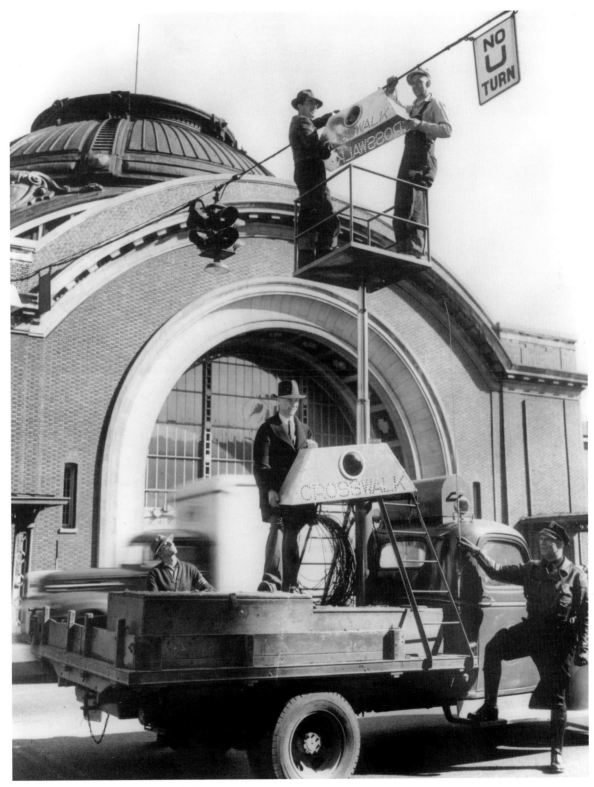

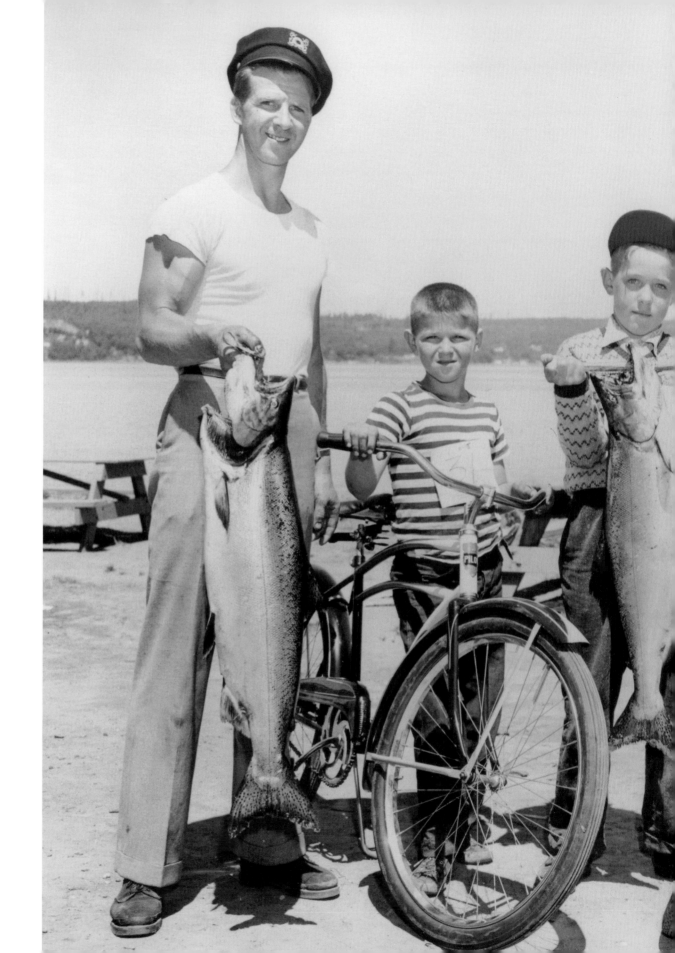

154

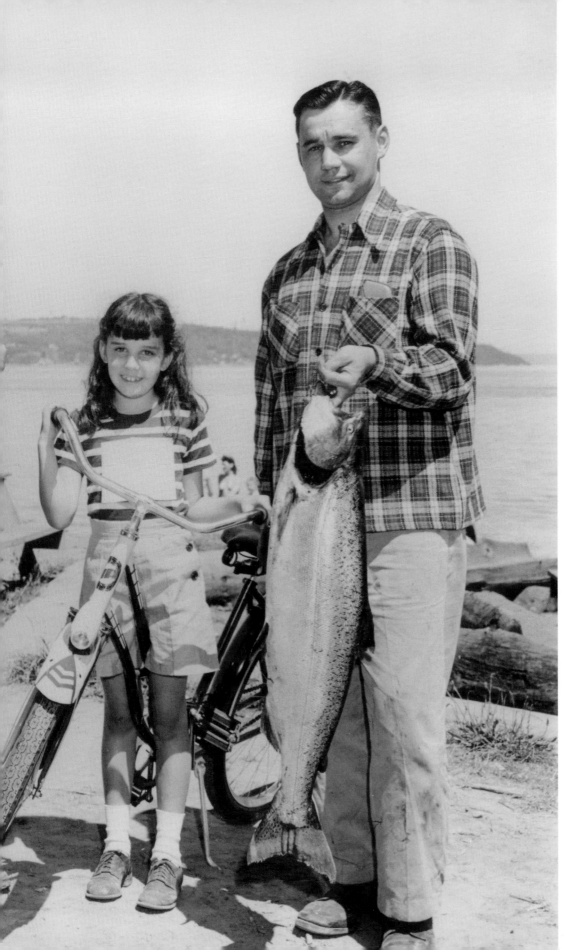

Posing for their picture are the big winners of the 1947 Poggie Club Father-Son-Daughter Salmon Derby at Point Defiance. At left, Richard Sheriff shows off his top-prize bicycle, while his dad, Johnny Sheriff, holds their 18-lb.,13-oz. salmon. At right are Judy Weller and her father, C. J. Weller. Judy's king salmon weighed 2 ounces less than Richard's, but she also won a new bike. At center, Ted Lowe proudly holds his second-place catch.

The freighter *Tahsis* is being loaded with lumber and logs while docked at the Port of Tacoma. In the foreground a laborer moves logs with a spiked pole as they are unloaded from a log truck.

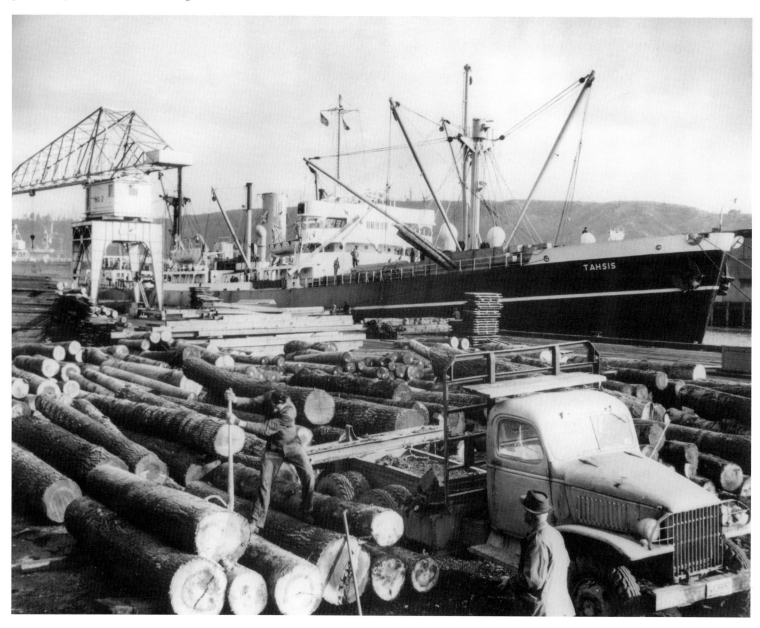

Experiencing traffic congestion in 1948, some people thought municipal parking lots or garages should be built. The Roxy Theater is visible at right; at left, Burnett's Jewelry and Telenews Theater; at left-center, the Bostwick Building.

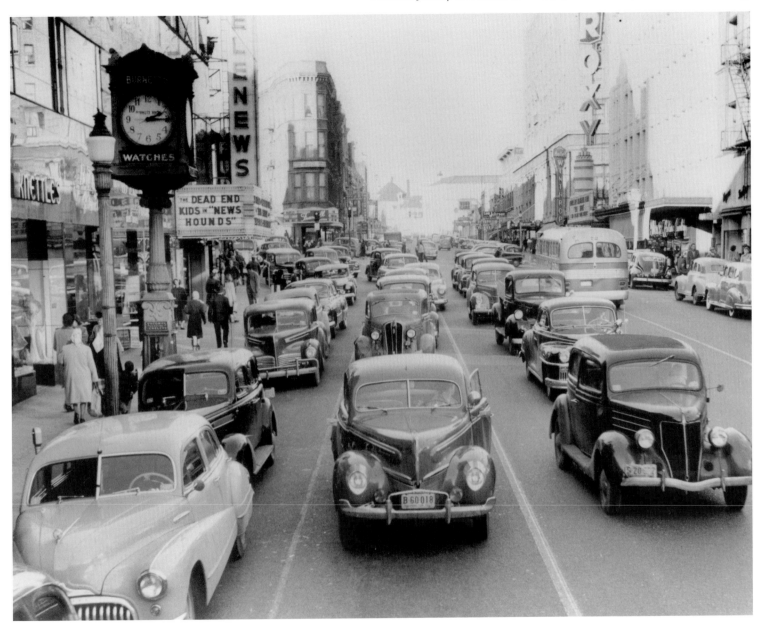

An explosion aboard *Los Angeles,* docked at the Port of Tacoma, was followed by a flash fire that swept the engine room of the Swedish motorship. Rescuers found one worker dead in the engine room and police are putting the body into an ambulance parked dockside.

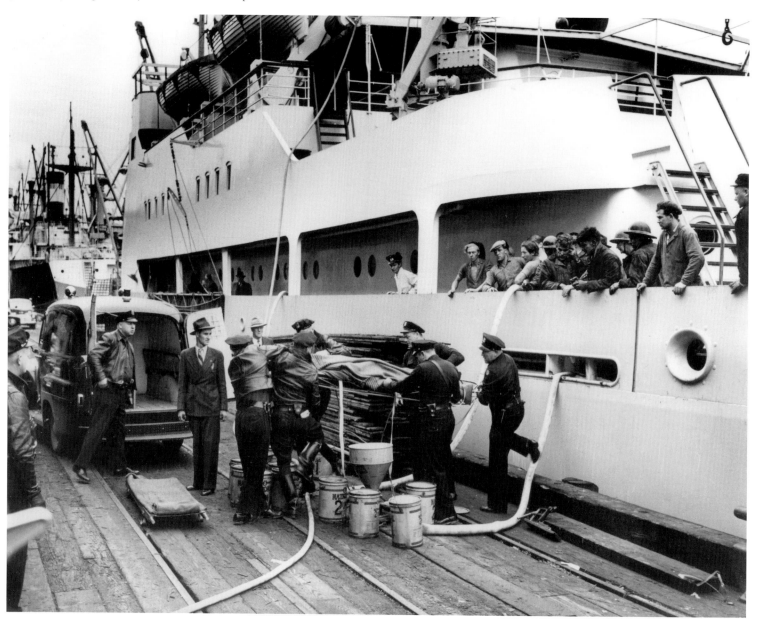

At Shortt Saw and Knife Company, this saw filer sets a band saw blade used in saw milling in an automatic sharpening machine. Men skilled at saw filing were important to the operation of the mills.

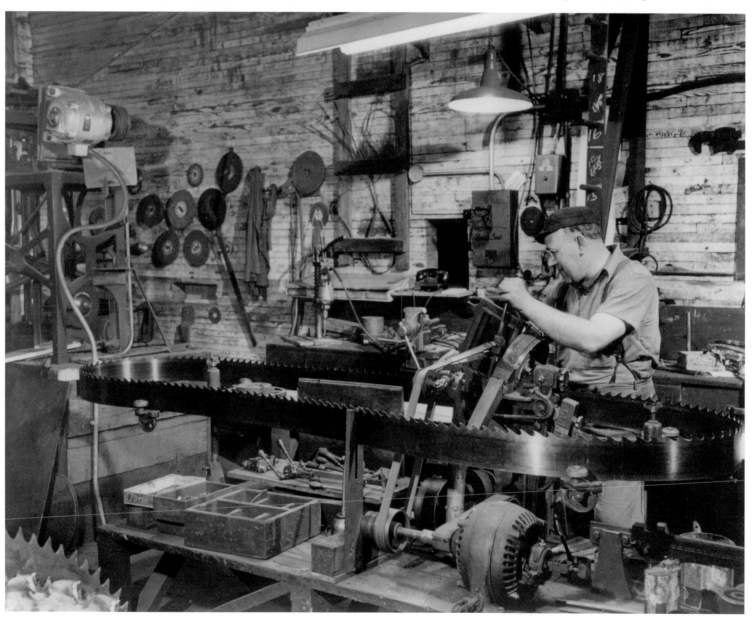

A group of children watch the 15th Annual Puyallup Valley Daffodil Parade on April 3, 1948, along with thousands of Tacomans and visitors lined up at Broadway and Pacific Avenue. It was estimated that a million daffodils were used to decorate the floats. Festival queen Doreen Moody and Gretchen Fraser, winner of a gold medal at the 1948 Olympics, shared the limelight.

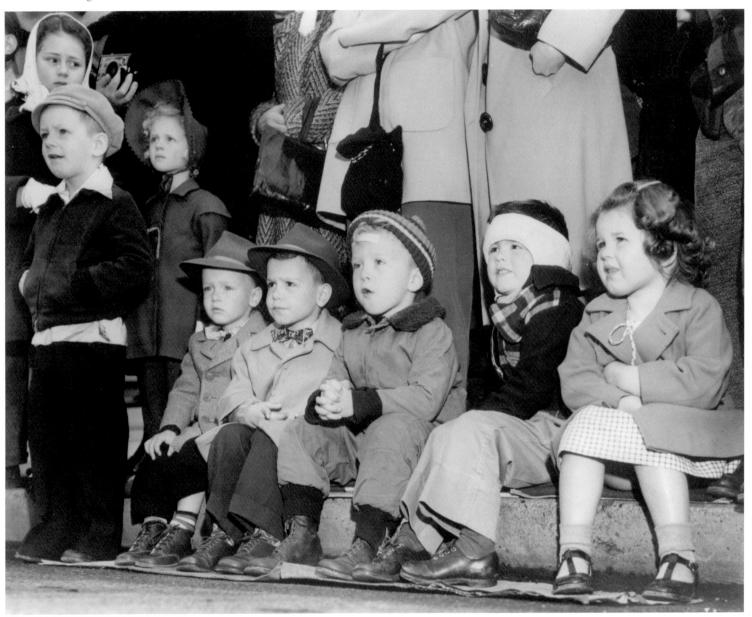

During a labor dispute that has kept ten Tacoma stores closed for more than five weeks, 20 Sears Roebuck & Company trucks line up in a Sears parking lot on September 15, 1948. Merchandise from the local Sears store was to be trucked to Seattle.

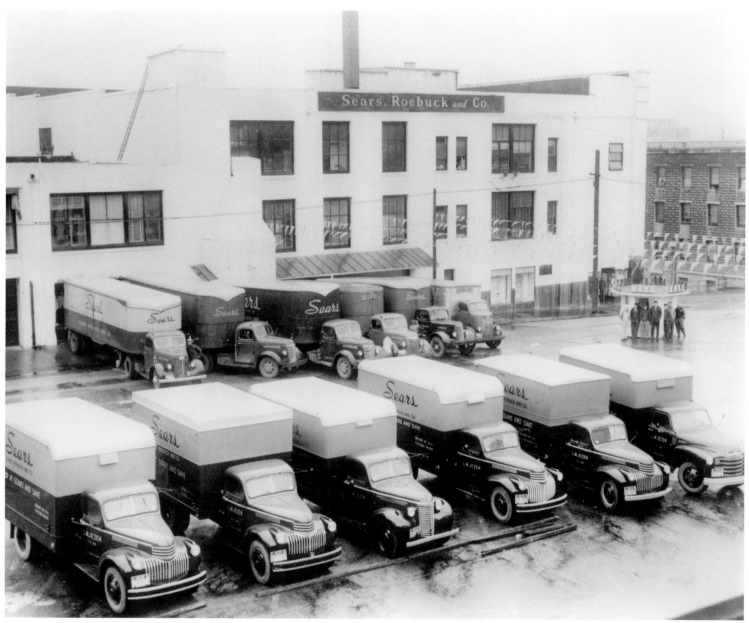

The Paul Bunyan entry in the American Legion's Goof Parade included
Bunyan astride the Blue Ox. Bunyan and a group of axe-wielding loggers
stop to pose in front of Northwest Airlines Ticket Offices on the corner of
9th and Broadway.

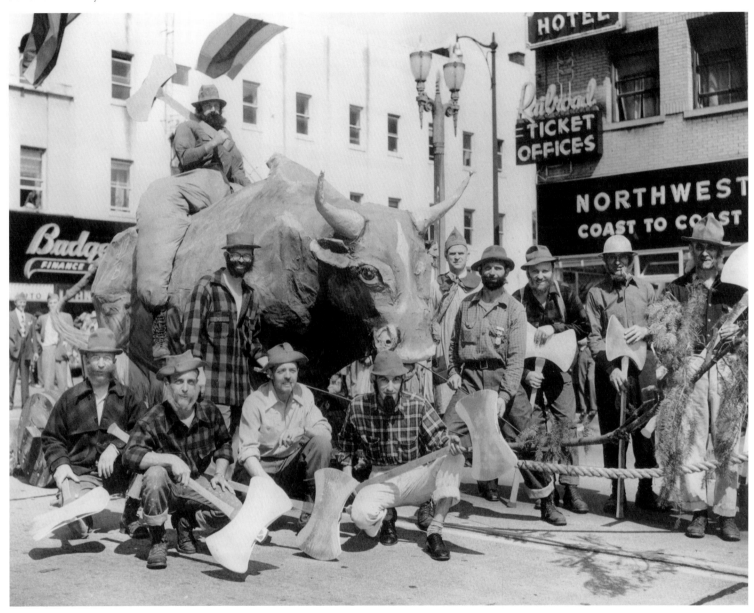

Nalley's potato chip and popcorn employees operate the assembly line used in cooling, bagging, and preparing potato chips for shipment. The potato chips were manufactured at a separate plant on South Tacoma Way.

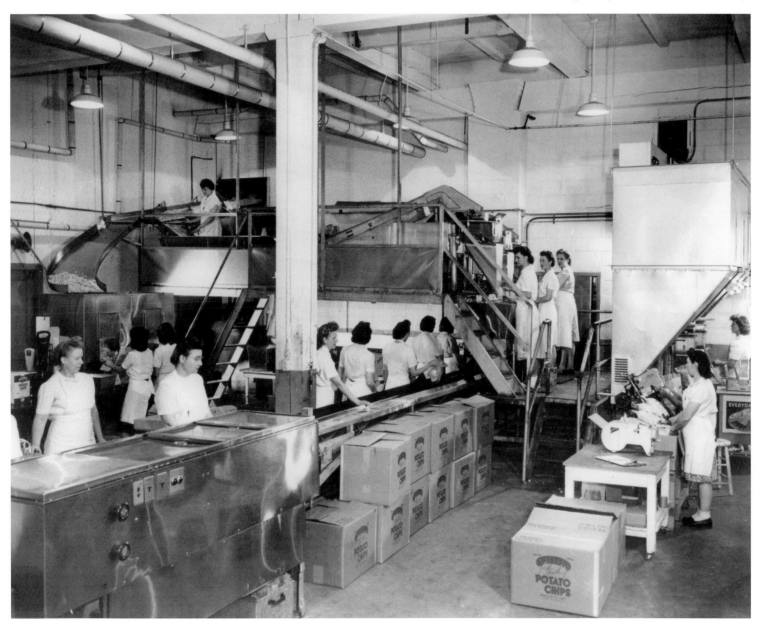

New York governor Thomas E. Dewey, Mrs. Dewey, and former governor Arthur Langlie address
Tacomans from the "Victory Special" on June 6, 1948, during a 15-minute stop at Tacoma Union
Station. Dewey, the 1948 Republican Presidential candidate, was favored to win but unexpectedly
defeated by the incumbent president, Harry S Truman.

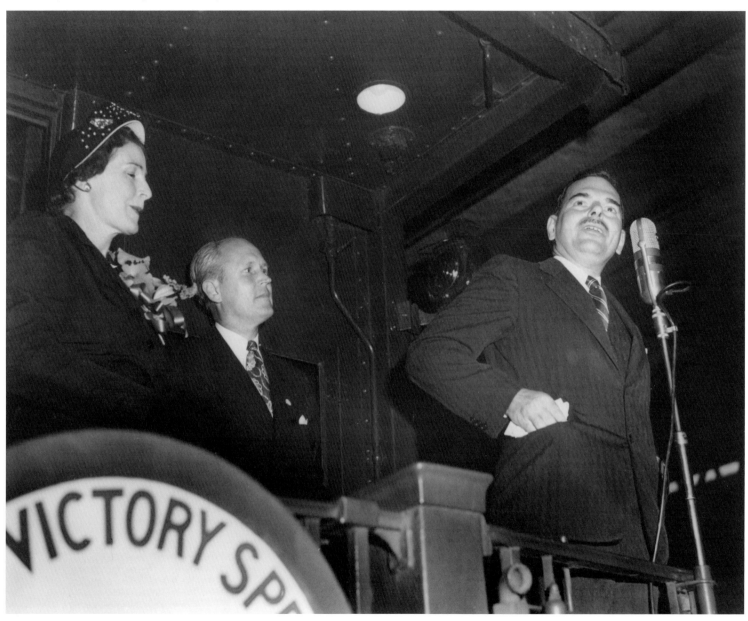

Leo Dobry, owner of *City of Tacoma,* sits in the maroon-and-cream race car, ready to roll after six months of hard work and approximately $20,000. Dobry, a racing enthusiast, had the car built at the Kurtis-Kraft plant in South Gate, California. The car was to run in the Indianapolis Race on Memorial Day, 1949, reportedly placing 6th in the event.

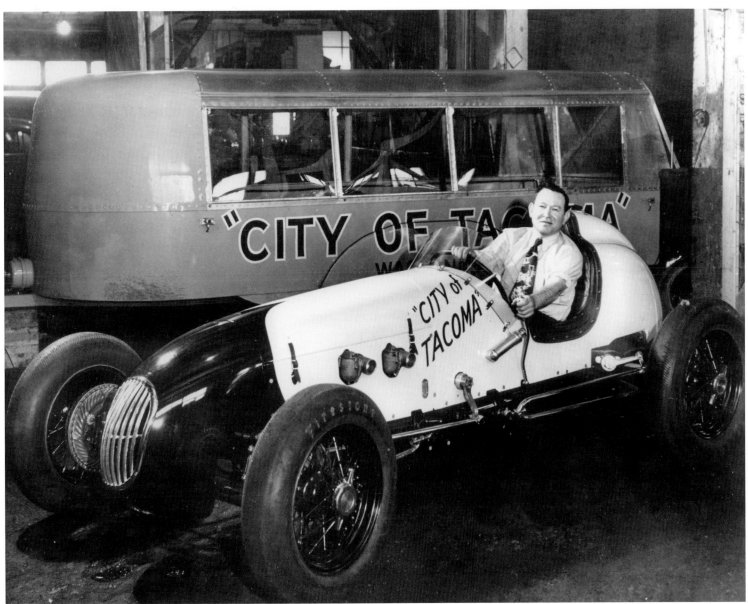

165

The Norwegian Rogalands Laget Convention held at Messiah Lutheran Church on August 14 and 15, 1948, attracted Scandinavian immigrants from far and wide. Built in 1891 the church housed several different denominations over the years, becoming a Lutheran church in 1959, and a Baptist church in 1965.

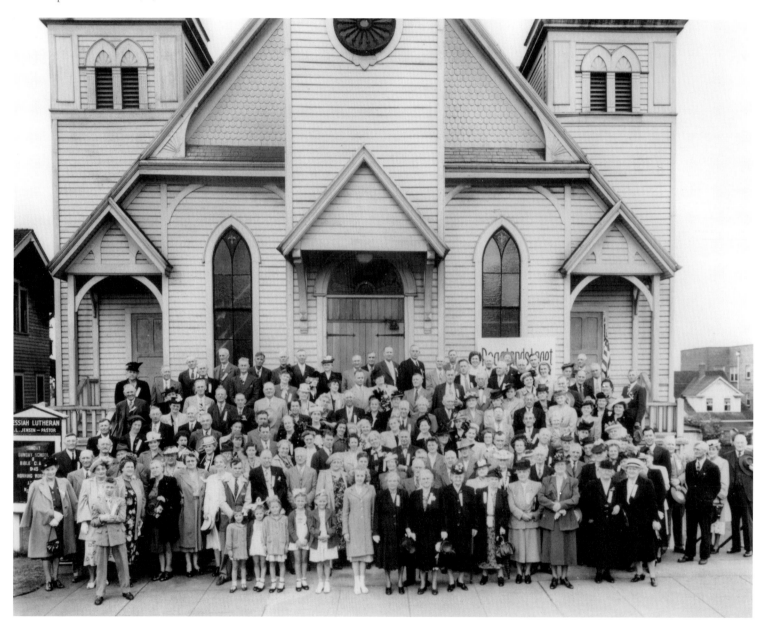

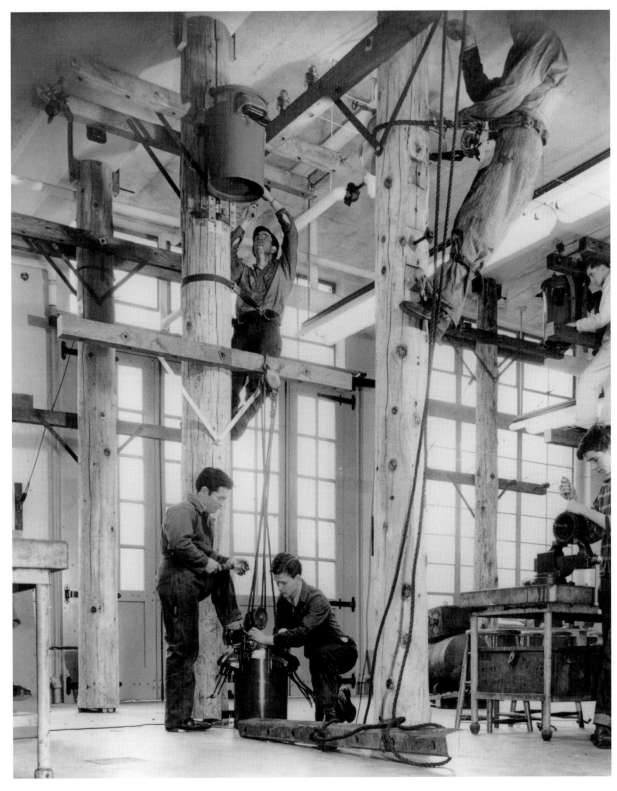

Students at Tacoma Vocational School learn to work on utility lines by practicing on shortened poles in February 1949.

Marcus Nalley, founder and chairman of the board of Nalley's, maker of potato chips and popcorn, along with other Nalley's officers, greets guests at the 31st anniversary celebration of the company.

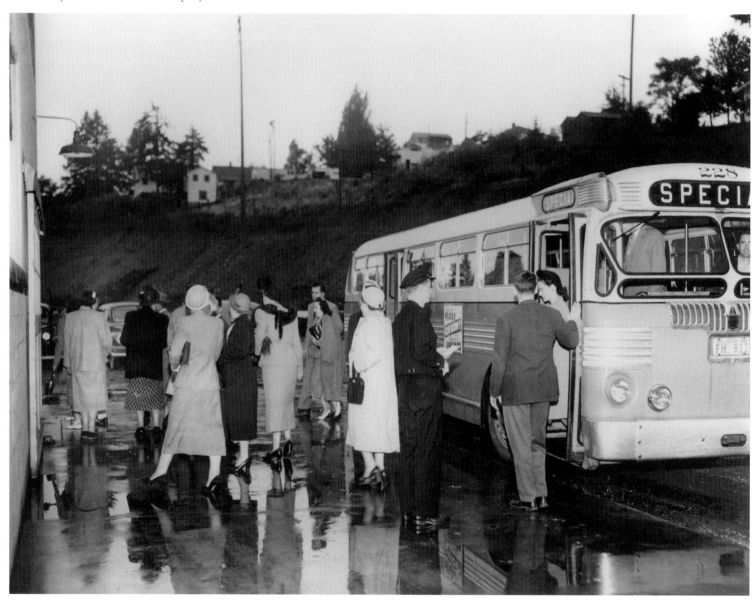

A blaze of fire engulfs 400 feet of the Port of Tacoma open storage Pier 1. Men from the nearby U.S. Naval Station and Tacoma firemen and sailors work together to salvage finished lumber, ties, and logs at risk from the fire.

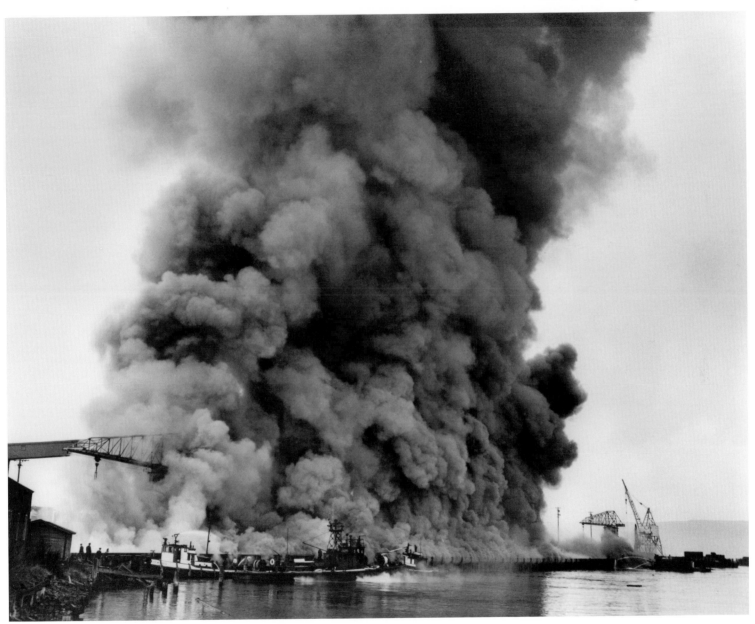

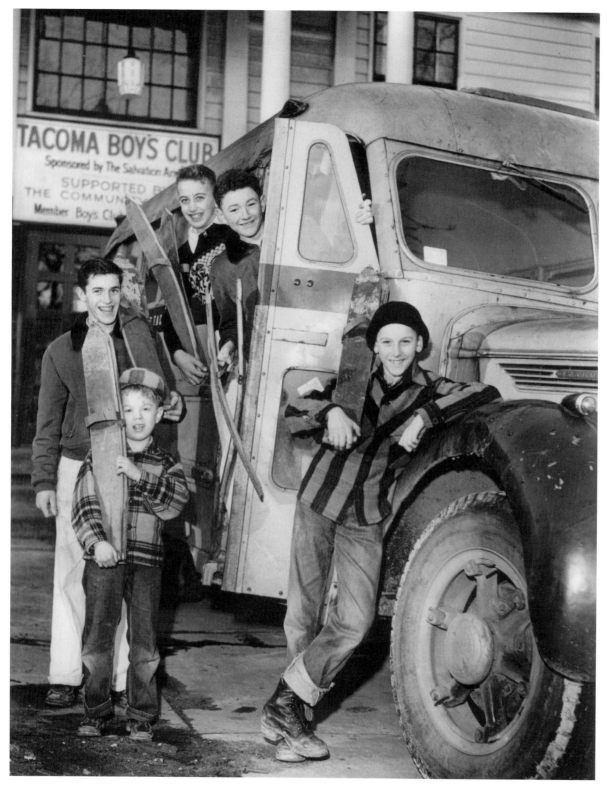

Waiting to board a bus to Mount Rainier, these boys are holding skis made out of old barrel staves. In the winter months of 1949, the Tacoma Boy's Club took boys up to Mt. Rainier every weekend. Trouble was, neither the club nor the boys owned any real skis.

Kaiser Aluminum's Tacoma plant on the tideflats was expanded in 1952 at a cost of $2.8 million, increasing the plant's production by one-third.

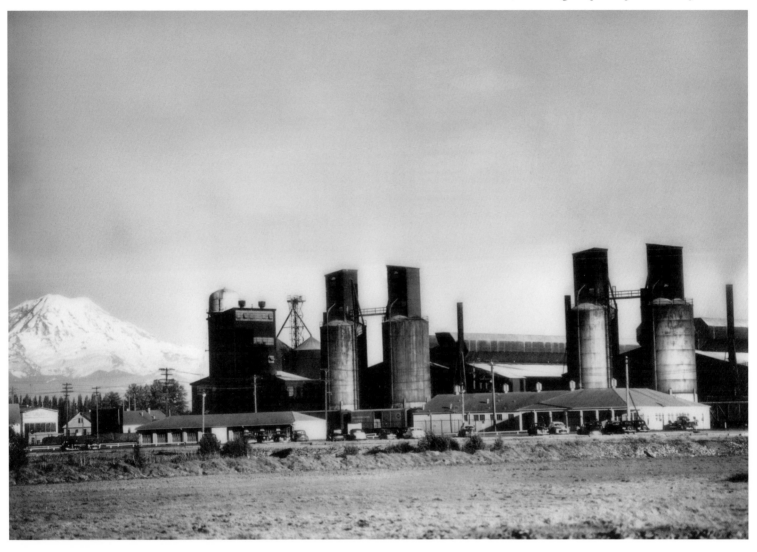

Vaughn Monroe signs autographs for five excited fans during his visit to Tacoma in May 1950. The popular bandleader and singer was widely acclaimed for "Racing with the Moon" and other favorite tunes.

Pacific Avenue facing south from the 900 block. Visible in this image are the Riviera Theater, Ghilarducci's Florists, and the Provident Building, among others. The Pegasus logo of Mobilgas, first adopted by Standard Oil Company in the 1800s, "flies" overhead.

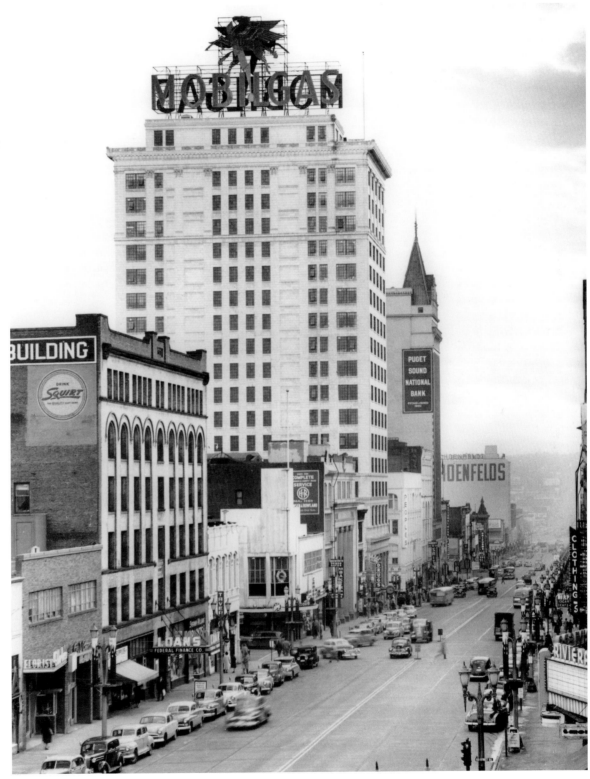

A damaging snowstorm hit Tacoma on January 13, 1950, dropping almost nine inches of snow that winds, reaching 25 miles an hour, piled into drifts up to five feet tall. Twenty-foot waves washed away part of Ruston Way and sank ten boats in the yacht club basin. Two watchmen survey a snowdrift from the Olympus Hotel at 815-17 Pacific Avenue.

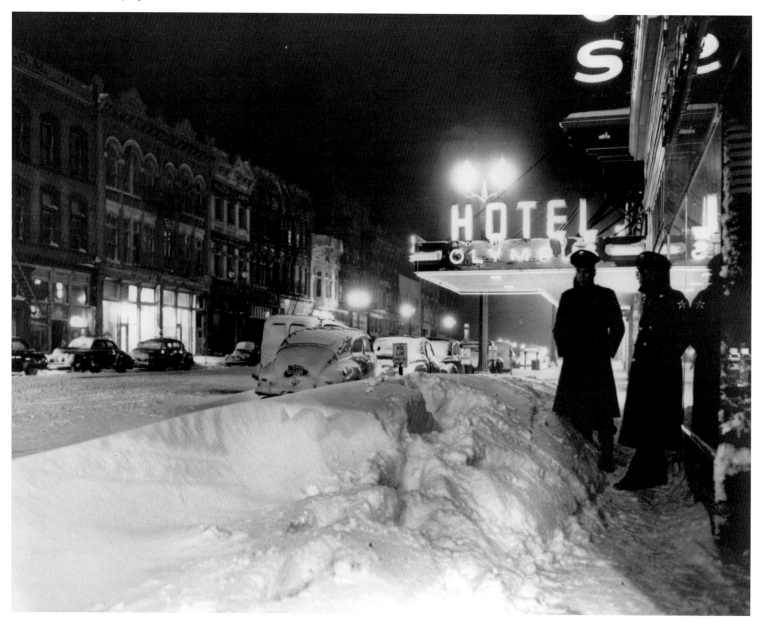

Company K, 38th Infantry, made up of approximately 90 soldiers, poses for their group portrait outdoors at Fort Lewis. Mess soldiers are uniformed in white.

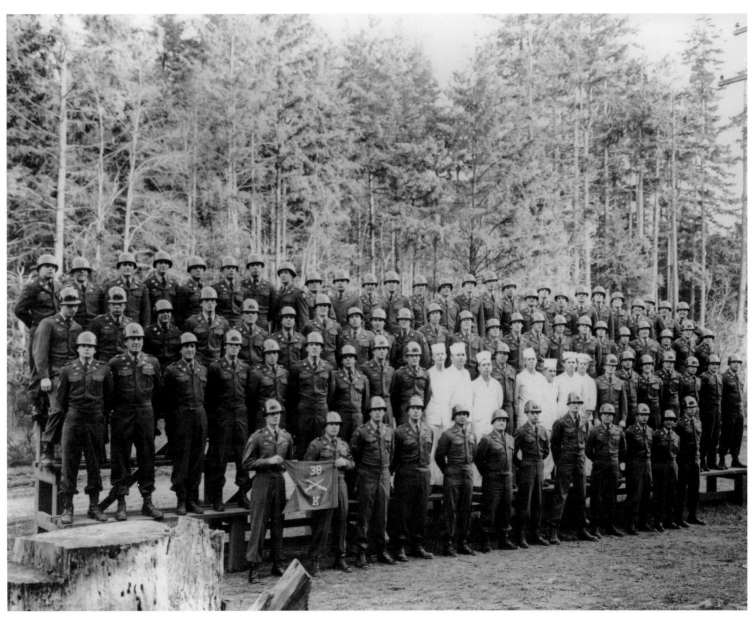

A jubilant bride tosses her bouquet to her waiting attendants on the steps of
Holy Rosary Church in September 1951.

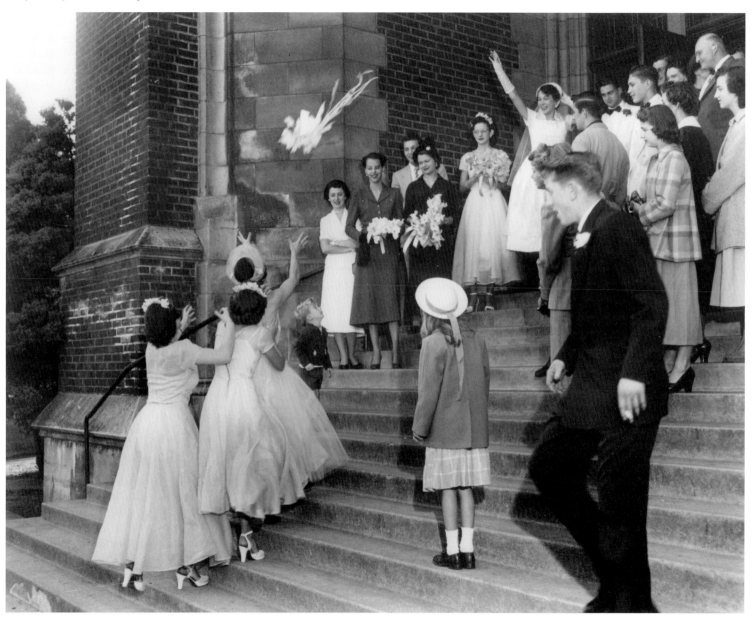

In October 1952, eleven sailors from the U.S. Naval Station in Tacoma volunteer their services to help complete the Living War Memorial, dedicated to the war dead of Pierce County. The dedication took place on Armistice Day 1952. The park was leveled in February 2003 to make way for the new Narrows Bridge, and a new, larger War Memorial Park was dedicated on May 13, 2006.

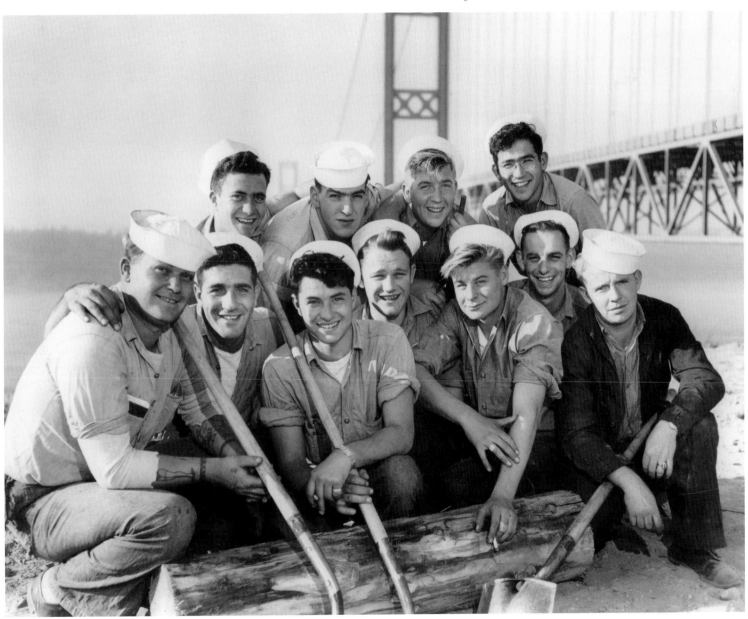

Customers admire new 1952 Chevrolets at South Tacoma Motor Company.
Advertising promotes new suspension and automatic transmission concepts. In
1952, buyers could choose from among eleven body styles.

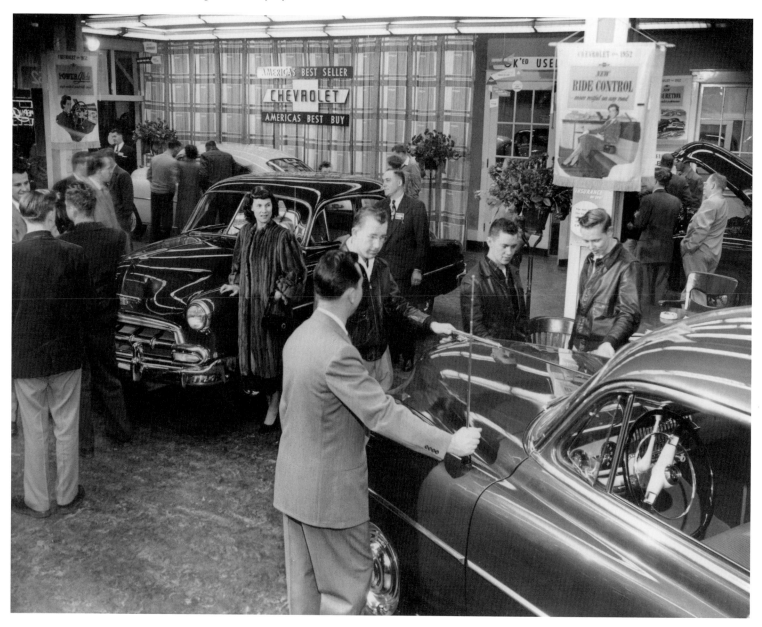

In 1952, the Washington Cooperative Farmers Association operated a grain elevator, feed mill, and warehouse complex at 1801 Taylor Way on the Hylebos Waterway. Built in 1949, the mill was 163 feet tall, incorporated the latest innovations in mill construction, and included a dock that could accommodate ocean-going ships.

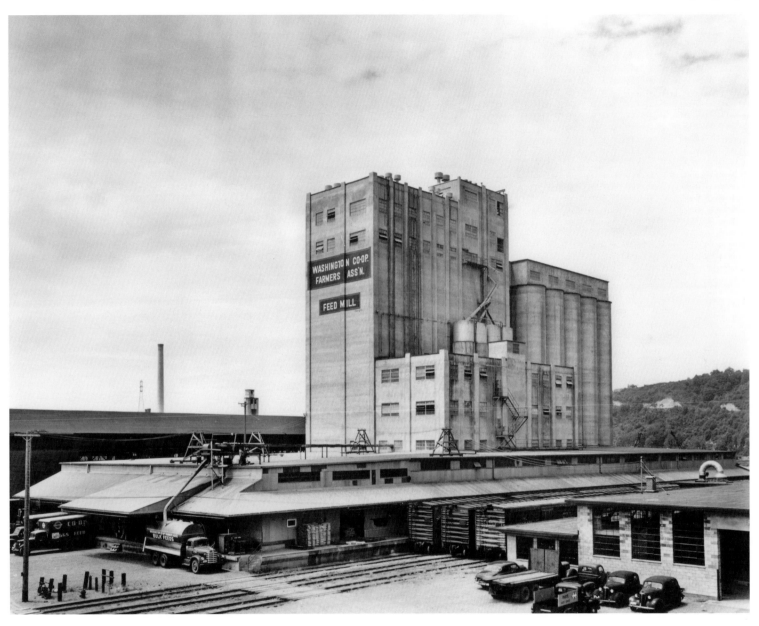

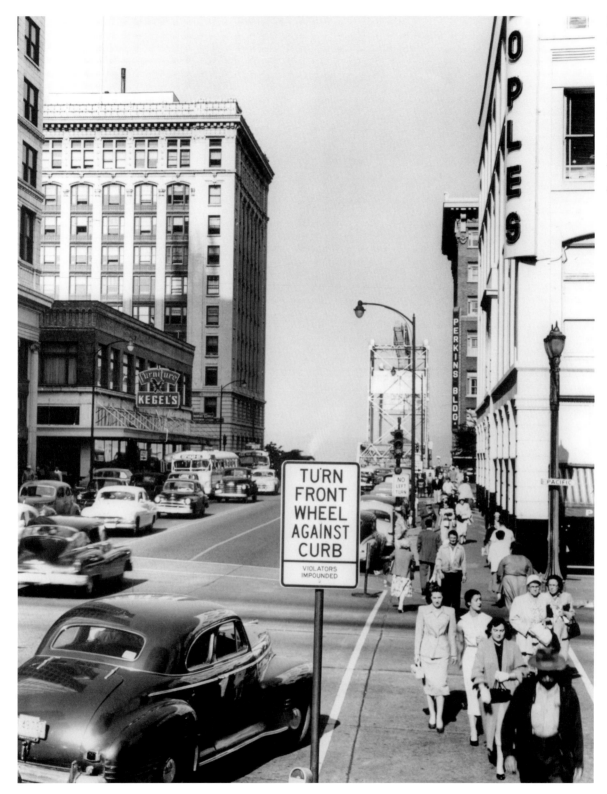

In 1953, a traffic sign at 11th and Pacific reminds drivers to park their vehicles so that they cannot roll down the hill. Peoples Department Store stands at right, Weyerhaeuser at center-left.

The Pierce County Restaurant owner's Association offered free dinners to servicemen at Tacoma's USO club. This dinner is out of hand, as two servicemen wielding straws face off in a milk-drinking duel.

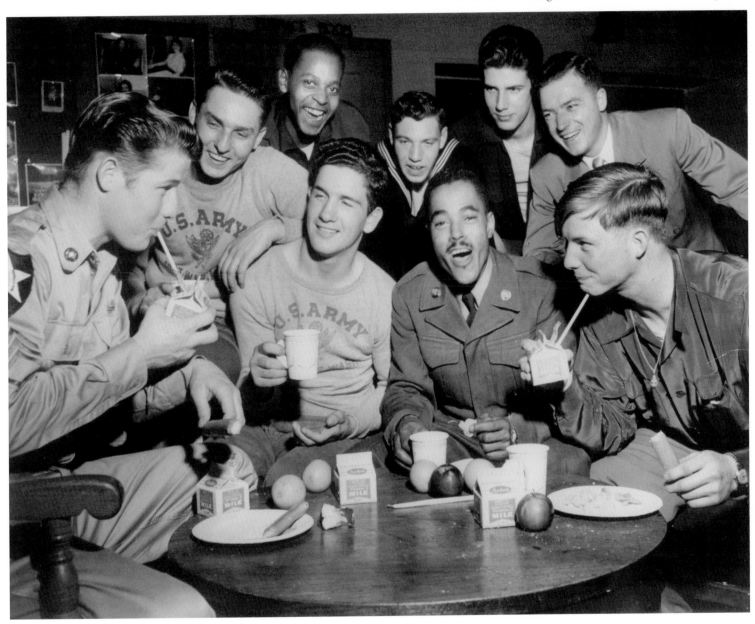

Two 57-foot minesweepers float side-by-side after being launched in May 1953. Built by Tacoma Boat under a Navy contract, the pair are escorted by Foss tugboats.

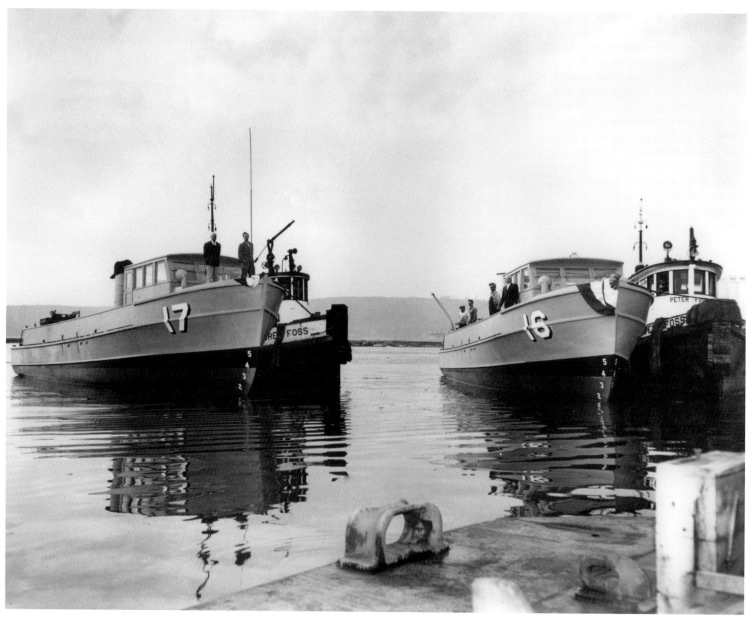

With members of the children's and adult choirs seated up front, the congregation of Sixth Avenue Baptist Church listens attentively to its minister in January 1953.

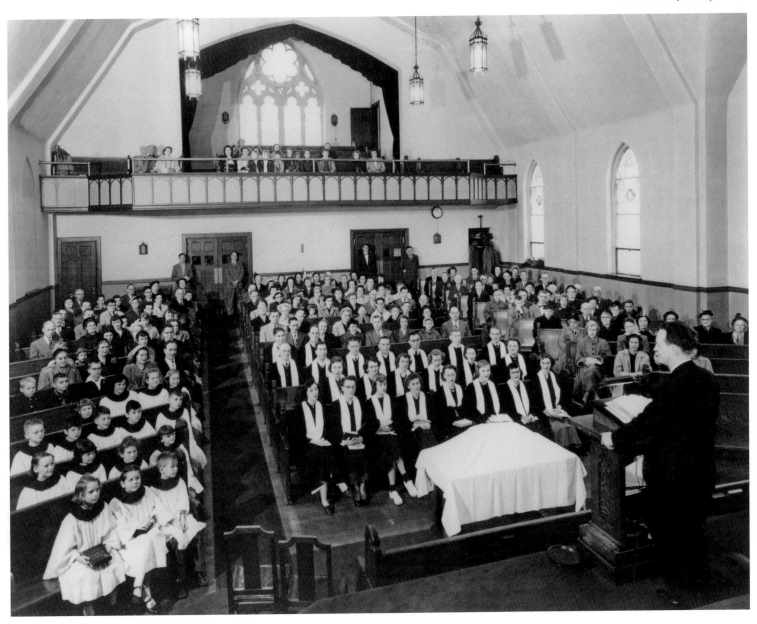

In August 1953, the "stubble patrol" round up a clean-shaven businessman. As part of the festivities surrounding the 100-year anniversary celebration of the Northwest Territory, Tacoma men were forbidden to shave from early August to the late evening of August 29. To regain their freedom, those "arrested" had to buy a "stubble pass" to help fund the celebration.

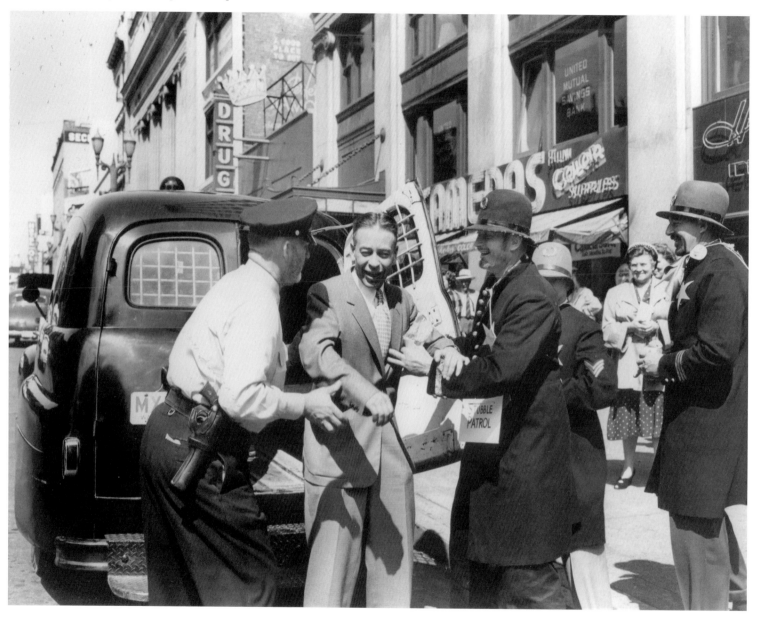

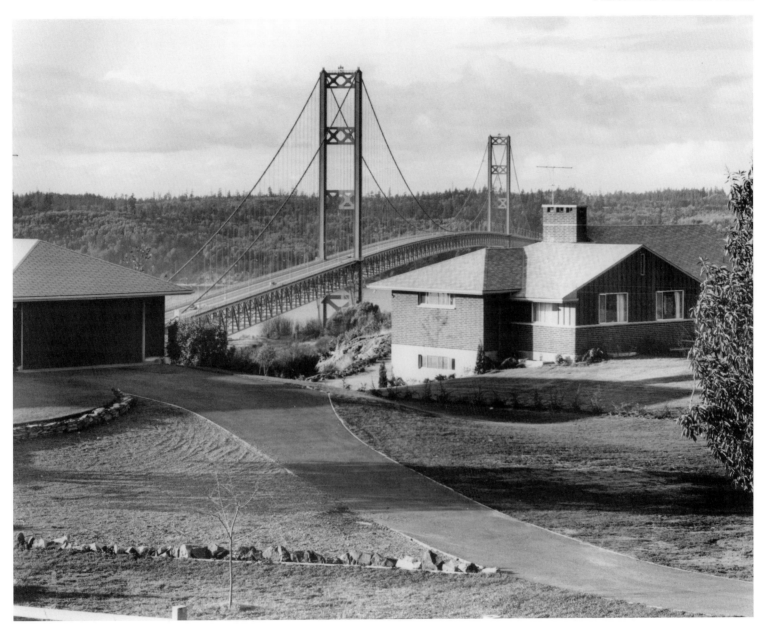

A view of the new Tacoma Narrows Bridge from a home in the Narrowmoor residential district.

Attended by 100,000 citizens, the April 1954 Daffodil Parade may have been the largest ever. Solemn salutes given by a Tacoma police officer and several Scouts suggest that the Color Guard is passing by.

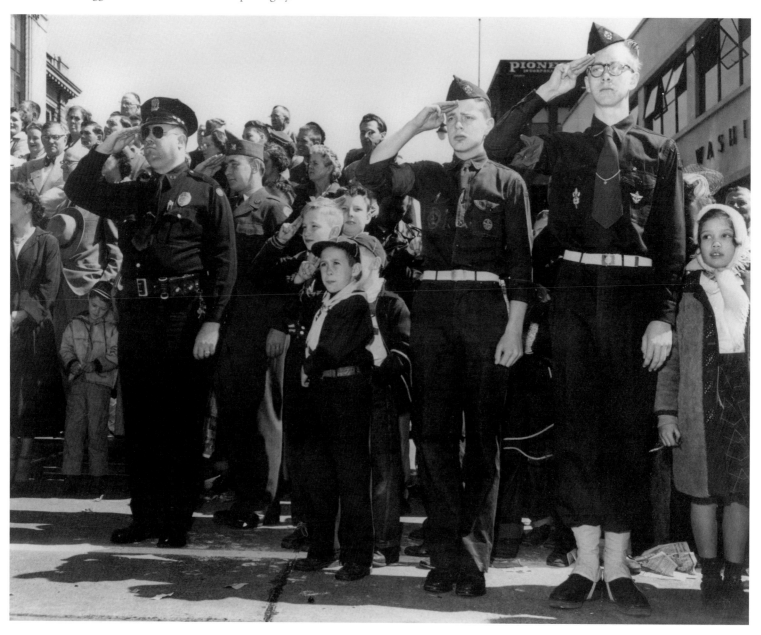

Police headquarters occupies the Italianate Public Safety Building on Pacific Avenue in May 1958. Built in 1887 to house the headquarters of the Northern Pacific Railroad, the structure escaped total demolition in the 1960s and was placed on historic registries.

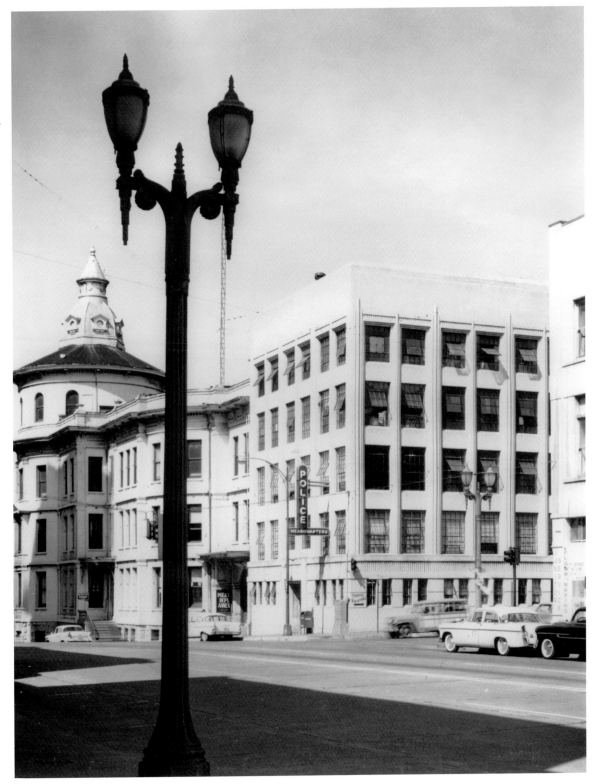

The grand opening of Tacoma's second Piggly Wiggly supermarket is just days away as owner Chester A. Hogan, left, and three supervisors stand for their photograph. The trend toward supermarkets and the lower prices they could offer would signal the decline of mom-and-pop markets.

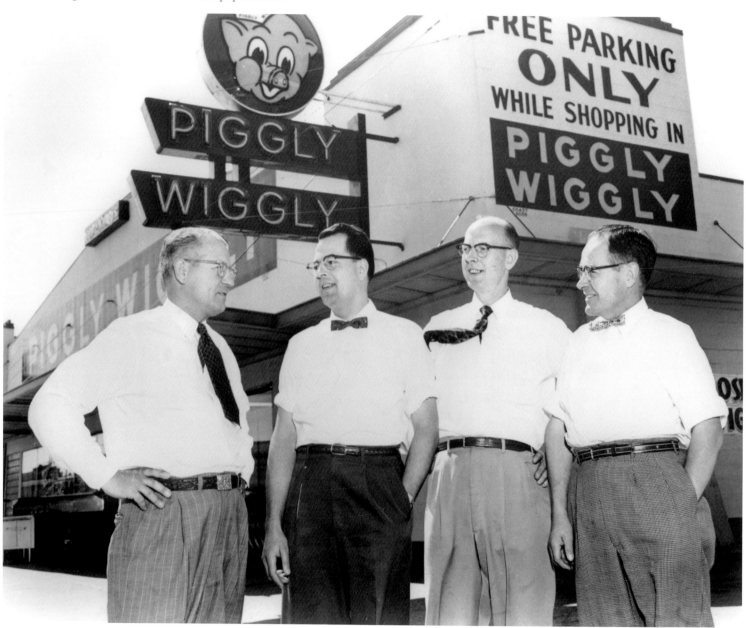

The Salvation Army distributes toys at Christmas time in 1955. Children and adults gaze at wrapped and unwrapped presents in Army headquarters as members assist two small girls.

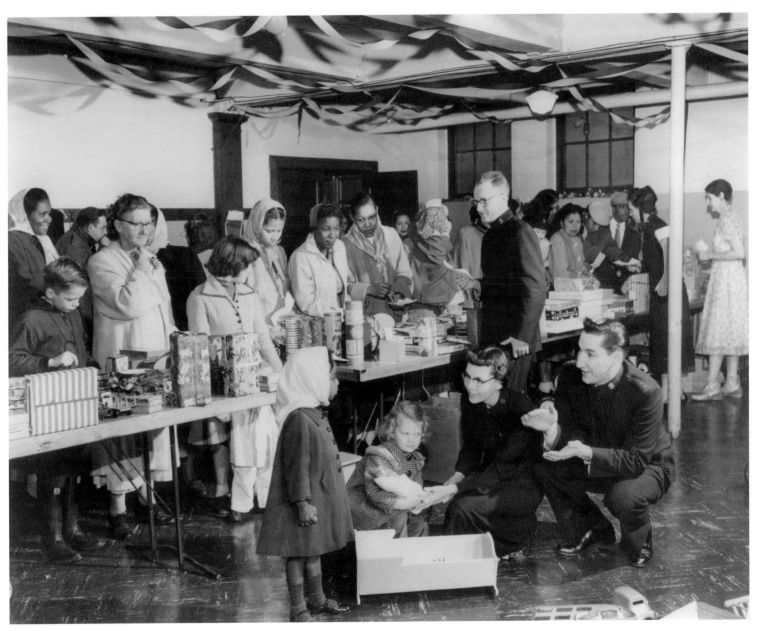

Bert Thomas, extreme right, is pictured in July 1955 with the official reception committee after swimming the Straits of Juan de Fuca in 11 hours, a distance of 18.3 miles, on July 8. Thomas was also the only man to swim from Seattle to Tacoma, a distance of 18.5 miles. He died at the age of 46 in 1972.

Congressman Thor Tollefson speaks at the ground-breaking of the U.S. Oil and Refining plant on the Tacoma Tideflats. In the third row is comedy film star Chico Marx, wearing dark glasses. In the second row are senators Warren G. Magnuson and Henry "Scoop" Jackson.

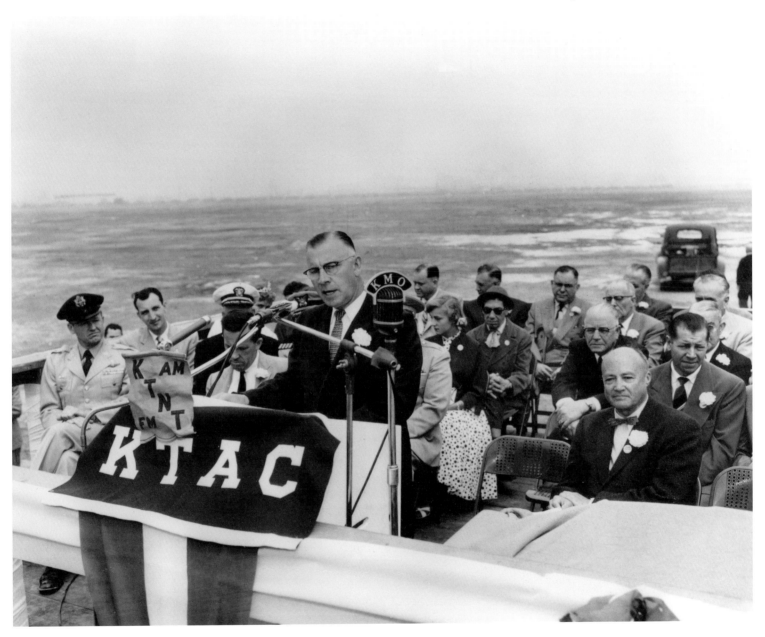

One of Tacoma's most beautiful apartment buildings, the Ansonia was designed by Heath & Grovel in 1914 at a cost of $135,000. The building featured burglar-proof vaults for jewels and other valuables and became famous for its lush rooftop garden and views of Puget Sound.

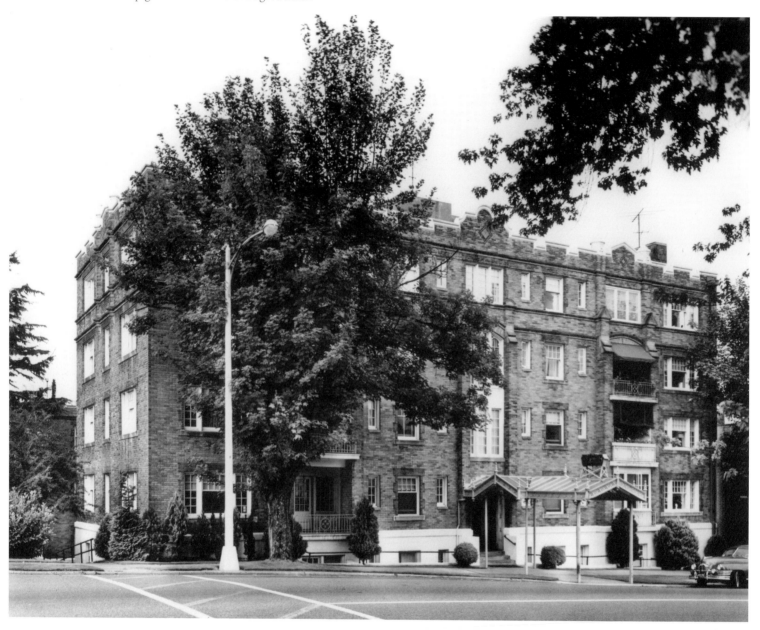

In front of the Cascade Electric exhibit booth at the 1959 Home show, the KTVW television camera focuses in as the man to the right counts off to airtime for an interview. Cascade Electric was located at 217 South 38th Street.

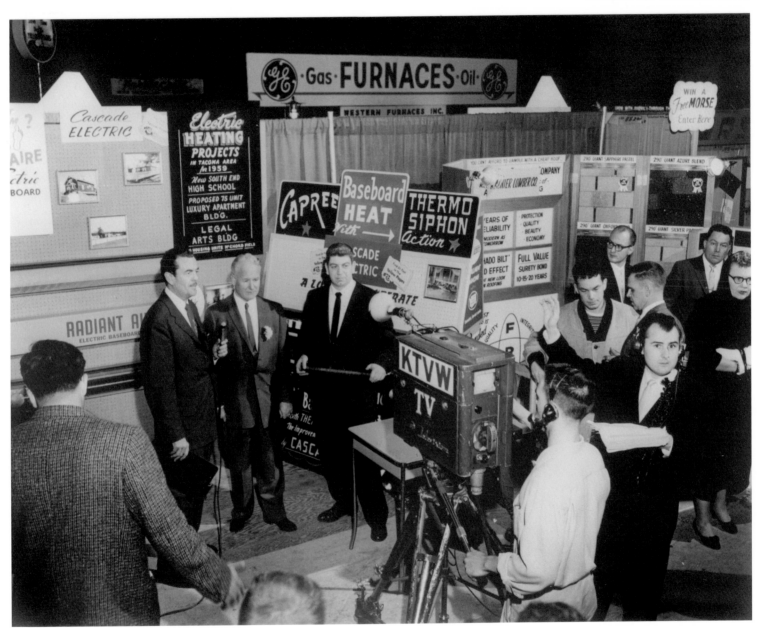

Governor Albert D. Rosellini cuts the ribbon to open the first
stretch of the Tacoma Freeway on October 10, 1959, extending from
Gravelly Lake Drive to 72nd Street. Holding the ribbon to the left is
Tacoma mayor Ben Hanson.

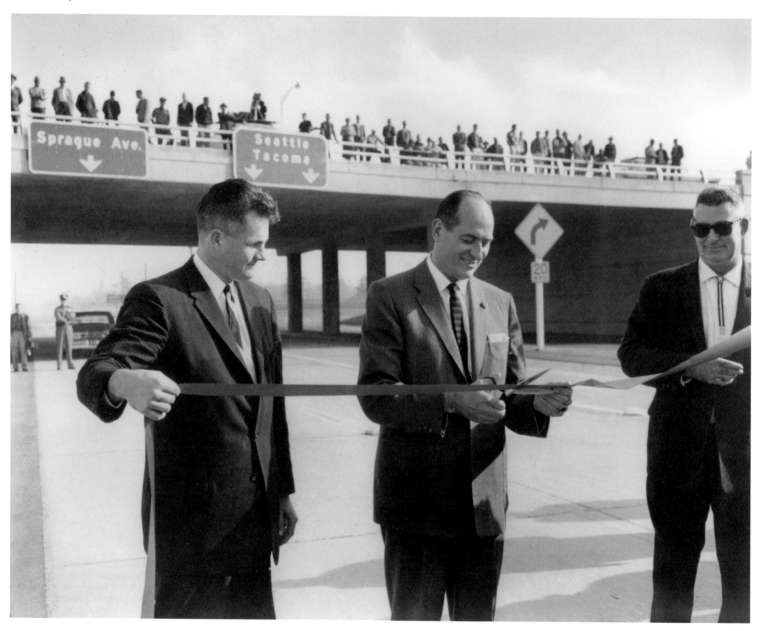

The Port of Tacoma from the air shows, to the right, Sitcum Waterway with its log booms, the port's grain elevators, and Time Oil Co., and to the left, Port Industrial Waterway with the Municipal Terminals and the mothballed fleet of the Pacific Reserve. Pier #1 was 165 feet wide and 1,200 feet long with berthage for 3 oceangoing vessels. Pier #2 was 180 feet wide and 1,040 feet long, also with berthage for 3 oceangoing vessels.

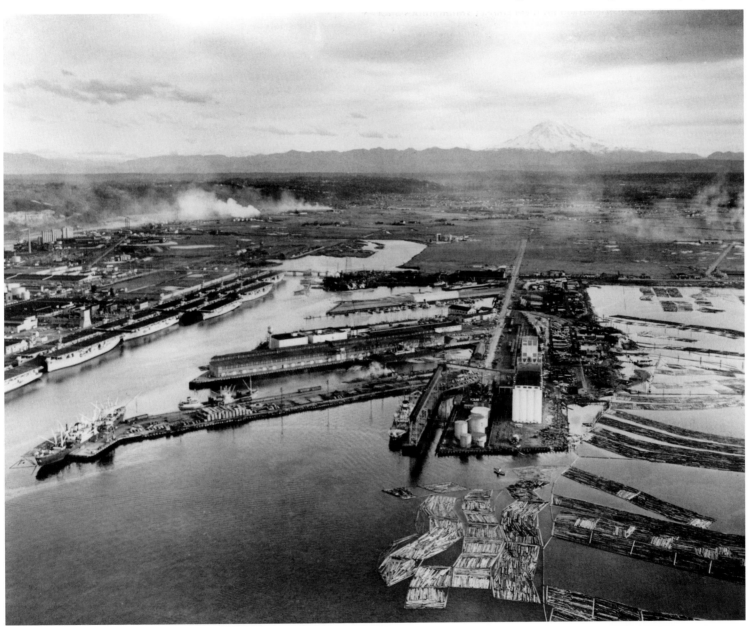

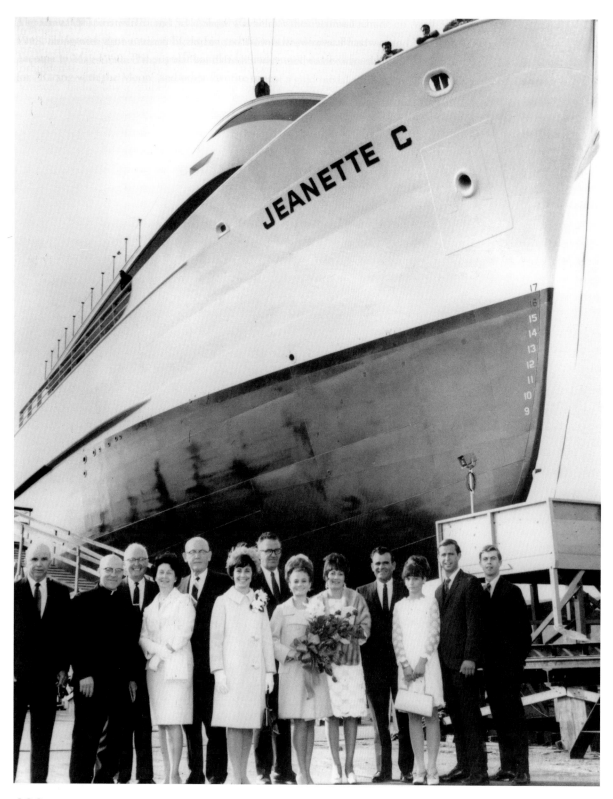

The *Jeanette C,* built by Tacoma Boat, is launched June 6, 1967. Jeanette Caboz, daughter of the skipper-to-be and part owner, Manuel Caboz, holds a bouquet of roses. She christened the ship named in her honor. Also present among attendees is Tacoma Boat's president Arnold J. Strom.

In 1961 an eager crowd gathers for the dedication of Tacoma's first "moving sidewalk." The city laid claim to being first in the nation with an escalade. Four ramps connected Pacific Avenue, Commerce Street, and Broadway. The escalade, troubled with vandalism and mechanical flaws, was shut down in 1983.

Upwards of 150,000 people, a few of them at rooftop, attended the grand opening of the Bon Marche at the Tacoma Mall on August 3, 1964. Eventually, the newly opened mall would have parking for 6,000 cars. Governor Albert D. Rosellini addressed the crowd before the store opened to a throng of shoppers.

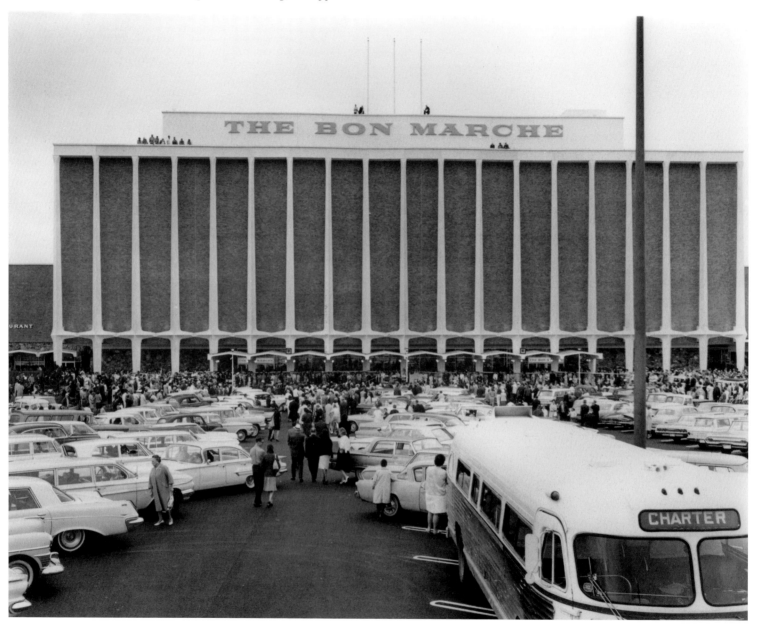

A log buyer, one of two en route to visit with Export Pacific president Chauncey L. Griggs, descends on company property in a helicopter in early June 1964. Griggs, a member of a well-known pioneer family, had previously been associated with the St. Paul & Tacoma Lumber Co.

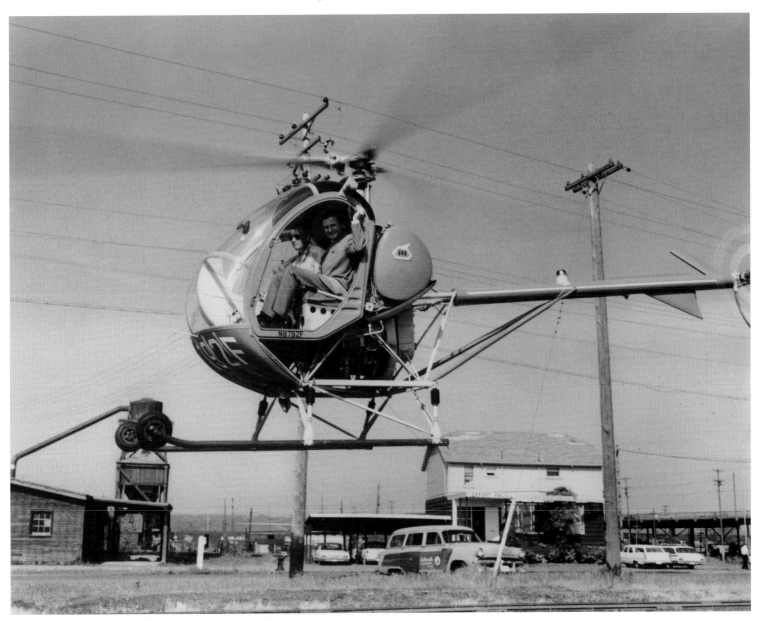

Star Iron & Steel Co. on Alexander Avenue in the Port industrial area custom designed and manufactured cranes, hoists, and special machinery. Founded in 1908, Star was one of the oldest steel-fabricating companies in the Northwest. Here in July 1964 they are busy constructing 50-ton and 350-ton gantry cranes.

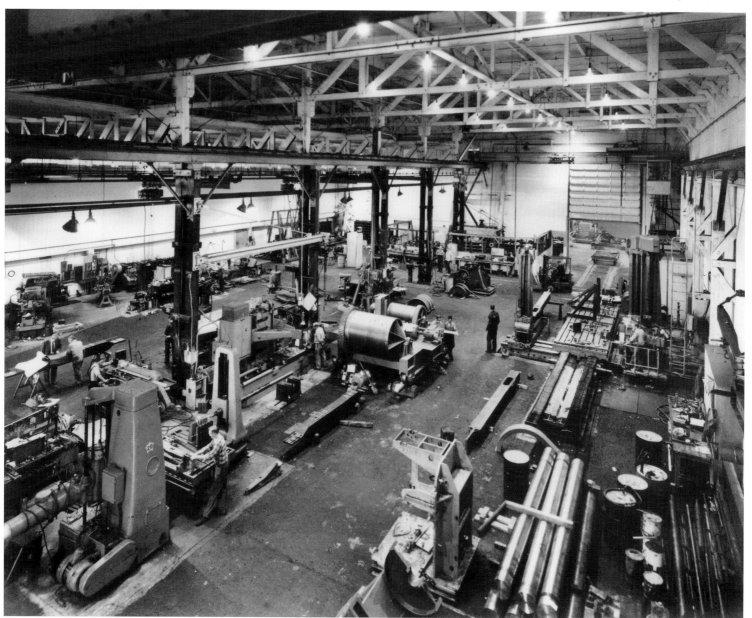

NOTES ON THE PHOTOGRAPHS

These notes, listed by page number, attempt to include all aspects known of the photographs. Each of the photographs is identified by the page number, photograph's title or description, photographer and collection, archive, and call or box number when applicable. Although every attempt was made to collect all available data, in some cases complete data was unavailable due to the age and condition of some of the photographs and records.

II COUNTY CITY PANORAMA
Tacoma Public Library
d157046-1

VI CENTENNIAL QUEEN
Tacoma Public Library
d156611-6

X FAWCETT AVENUE
Tacoma Public Library
c156427-1

2 DOCKSIDE
Tacoma Public Library
914-1

3 WOODEN STRUCTURE
Tacoma Public Library
bc-004

4 HALSTEAD HOUSE
Tacoma Public Library
tds-004

5 "THE TWENTY-SEVEN"
Tacoma Public Library
968-1

6 RAILWAY CAR
Tacoma Public Library
tds-006

7 PACIFIC AVENUE
Tacoma Public Library
tds-001

8 PUYALLUP INDIANS
Tacoma Public Library
g5.1-007

9 ST. LUKES
Tacoma Public Library
tds-005

10 HORSE-DRAWN STREETCAR
Tacoma Public Library
tpl-392

11 TWO SHIPS AT BAY
Tacoma Public Library
tds-013

12 FIFE HOTEL
Tacoma Public Library
tds-012

13 EAST J STREET
Tacoma Public Library
c22080-2

14 LOGGERS
Tacoma Public Library
tds-002

16 TACOMA NEWS
Tacoma Public Library
tds001

17 POLICE DEPARTMENT
Tacoma Public Library
c72137-2

18 EMERSON SCHOOL
Tacoma Public Library
c117132-29

19 STREETCAR 32
Tacoma Public Library
c117132-10

20 FIRE DEPARTMENT
Tacoma Public Library
tpl-4132

21 FIREMEN
Tacoma Public Library
tp-4117

22 PACIFIC AVENUE PARADE
Tacoma Public Library
c52158-1

23 FIRST BOATHOUSE
Tacoma Public Library
g14.1-001

24 BLACKSMITH
Tacoma Public Library
tpl-395

25 CALIFORNIA BLOCK
Tacoma Public Library
g19.1-004

26 WRIGHT SEMINARY
Tacoma Public Library
g10.1-091

27 DANCING MAIDENS
Tacoma Public Library
tpl-2870

28 "MY STORE"
Tacoma Public Library
c8771-2

29 POOR MAN'S CORNER
Tacoma Public Library
tpl-1730

30 THE PEOPLE'S STORE
Tacoma Public Library
c8575-2

31 GRIFFIN TRANSFER CO.
Tacoma Public Library
c8657-2

Built by Tacoma Boat, the *Anna Maria* was successfully launched in September 1969, and is shown here being maneuvered into Commencement Bay by three tugs. At 191 feet long and able to hold 1,100 tons of frozen fish, she was the largest tuna boat yet built. The boat would be operated out of the San Diego area.

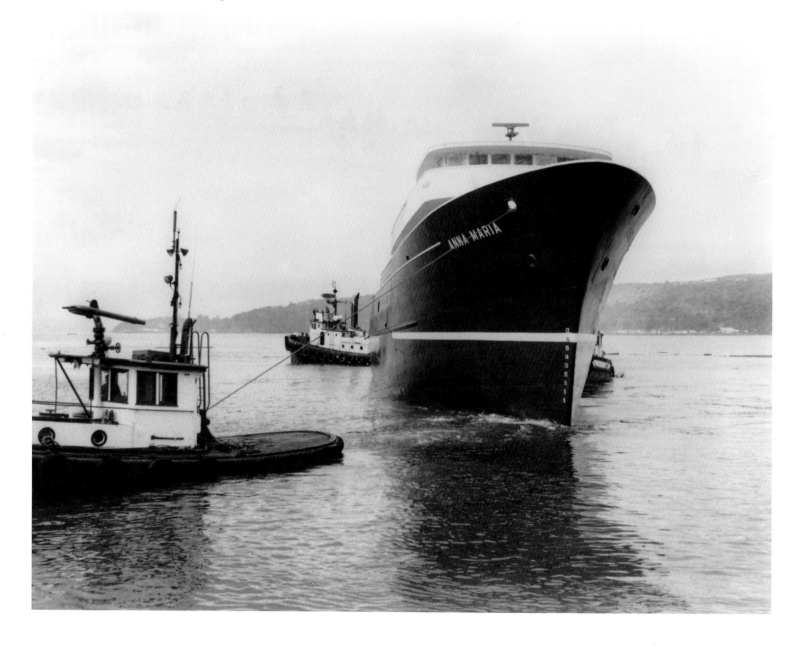